HISTORIC PHOTOS OF LONG ISLAND

TEXT AND CAPTIONS BY JOE CZACHOWSKI

Orient, New York, was initially called Poquatuck, after the American Indian tribe that lived there, then was renamed Oyster Ponds. In 1836 the settlement was separated into two communities, with Orient becoming the name of the easternmost point. This late-nineteenthcentury photo shows the layout of some of the ponds for which the town was once named.

HISTORIC PHOTOS OF LONG ISLAND

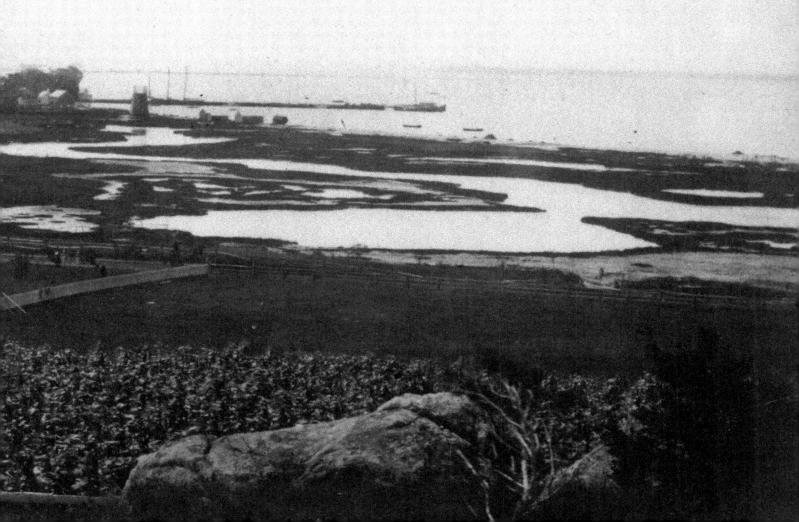

Turner Publishing Company www.turnerpublishing.com

Historic Photos of Long Island

Copyright © 2009 Turner Publishing Company

All rights reserved.

This book or any part thereof may not be reproduced or transmitted in any form or by any means, electronic or mechanical, including photocopying, recording, or by any information storage and retrieval system, without permission in writing from the publisher.

Library of Congress Control Number: 2008904904

ISBN-13: 978-1-59652-498-9

ISBN 978-1-68442-065-0 (hc)

CONTENTS

ACKNOWLEDGMENTSVII
PREFACEVIII
HARD WORK AND RAILROADS (1865–1899)
AUTOS AND AIRPLANES (1900–1939)
WORLD WAR II AND POSTWAR PROSPERITY (1940-1960s)
NOTES ON THE PHOTOGRAPHS

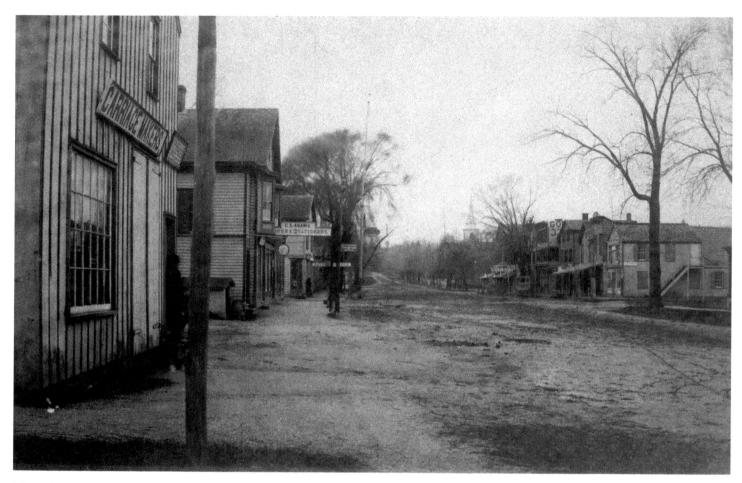

This is how Huntington's Main Street looked in the late 1800s. Huntington is on the Island's north shore in Suffolk County. It was settled in 1653 when Richard Holbrook, Robert Williams, and Daniel Whitehead purchased a plot of land from the Matinecock Indians then turned it over to a different group of settlers. Huntington became an officially recognized town on March 7, 1788.

ACKNOWLEDGMENTS

With the exception of cropping images where needed and touching up imperfections that have accrued over time, no other changes have been made to the photographs in this volume. The caliber and clarity of many photographs are limited to the technology of the day and the ability of the photographer at the time they were made.

This volume, *Historic Photos of Long Island*, is the result of the cooperation and efforts of many individuals, organizations, and corporations. It is with great thanks that we acknowledge the valuable contribution of the following for their generous support:

The Brooklyn Historical Society
Freeport Memorial Library
Library of Congress
New York State Archives

Our pets become an integral part of our lives. My cat certainly was. Her wry smile and wise eyes were a comfort in bad times. I will miss her most while doing this; she loved walking on the keyboard.

PREFACE

What's in a name? In the case of Long Island, both words are key. Long Island is long—118 miles. Its widest distance is 23 miles. And it is an island, the largest in the continental United States. Long Island is comprised of four counties, two that are boroughs of New York City (Queens and Brooklyn) and two that contain suburbs of the city (Nassau and Suffolk). This collection of historic images reflects all four, including sectors of Long Island that are now deep within the borders of New York City. Amazingly, Long Island hasn't sunk under the weight of its nearly eight million people. Though it is part of New York State, that hasn't stopped some from suggesting it should be the fifty-first state of the Union. It certainly has everything to thrive and survive on its own: industry, agriculture, natural beauty, and its most important attribute, its inhabitants.

As is emphasized by town names like Matinecock, Massapequa, and Quogue, American Indians inhabited the Island when the European colonists first arrived, and their impact on its culture has been lasting. The Dutch were among the Island's earliest settlers, spreading out from the growing town on the smaller island of Manhattan, while New England Puritans crossed Long Island Sound from Connecticut and Massachusetts. All embodied those "Yankee" ideals marked by hard work and religious conviction.

The British eventually dominated on Long Island, commanding trade and settlement. The farmland was rich and the sea was plentiful, with bountiful harvests of things common and exotic, potatoes and oysters. With sheltered harbors available, shipping became dominant both for building and for commerce. The area was settled slowly, and those who wanted a change and challenge found it a paradise. As was the case with other profitable colonies, people on Long Island had divided loyalties, and when the first shots were fired in the Revolutionary War, rebel and loyalist were firmly entrenched.

Commander George Washington had the Declaration of Independence read aloud to his troops on Long Island in that famous July of 1776. A defining battle erupted on the Island a month later. England won that round and retained the Island for the balance of the war, but the colonial militias learned how to fight delaying actions and

secure proper retreats, which bode well for later battles. When the Revolution was won, loyalists left for points north, and Long Island went about growing and becoming stronger as an important part of New York State.

New York City in the nineteenth century was the center of American commerce. The wealthy and powerful of the Gilded Age—names such as Morgan, Vanderbilt, and Roosevelt—began to see Long Island as a place to escape the grime of the city and to build lavish homes and estates. Nassau and Suffolk counties still boast some of the most expensive homes in the Northeast. Less affluent folk also began to appreciate Long Island's riches, and a constant flow of people and business expanded its population, a process accelerated by the railroads, which were shrinking distances between points on the Island.

At the turn of the century, with the influx of immigrants from Europe, the jump from Ellis Island to Long Island was inevitable as well as profitable. New life meant new business, new business meant more business, and more business meant more people. All forms of work were available—skilled and unskilled; shipping, farming, transportation—and with prosperity rising for many, something called leisure time entered the vocabulary, and Long Island's beaches, harbors, and forests were there to enjoy.

A relatively constant population growth continued throughout the succeeding decades up to World War II. Long Island went on a war footing in the 1940s and was a center for aviation technology, with the army, navy, and marines all having planes built there. When the war was over—and when most thought growth would be static—the modern suburb was born, and Long Island became its drawing board.

Taking advantage of the GI Bill, servicemen received an education, found profitable employment, and qualified for a mortgage. As varied businesses established bases for industry and technology on Long Island, the needed workforce was in place. Long Island grew from the 1950s to the 1990s, and while it did suffer some setbacks, tradition and an extremely strong sense of community permeate Long Island today.

Notables of Long Island have included the Baldwin family of actors (Alec, Daniel, Stephen, William); Tony Danza; Rosie O'Donnell; Captain Kangaroo (Bob Keeshan); musicians Billy Joel, Dee Snider (of the band Twisted Sister), and LL Cool J; star athletes Boomer Esiason and Carl Yastrzemski; and writers Doris Kearns Goodwin and Walt Whitman.

In the realm of fictional Long Island, the Hardy Boys, Frank and Joe, do their youthful sleuthing in Bayport; the shark in Peter Benchley's *Jaws* plies the waters off Long Island Sound; the Marx Brothers film *Animal Crackers* is set on Long Island; and, of course, Ray Romano's television family lives in Lynbrook.

—Joe Czachowski

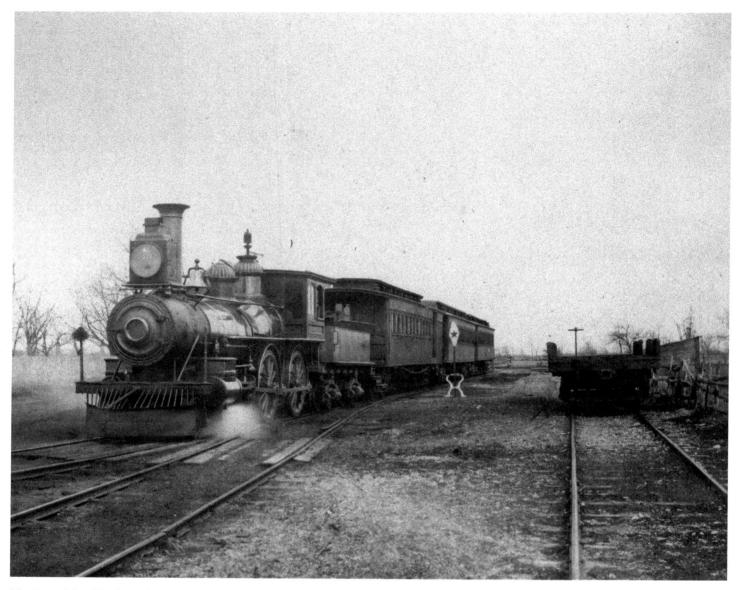

The Long Island Rail Road began operations in 1836 to open the vastness of Long Island to the rest of New York State. The LIRR established the Smithtown and Port Jefferson line, a 59.4-mile trip to and from New York City, in 1868. Here, in 1878, a locomotive is pulling into the Port Jefferson Station.

HARD WORK AND RAILROADS

(1865 - 1899)

By the mid-1800s, many towns on Long Island were well established. Religious tolerance was always fostered there. Presbyterians, Jews, Episcopalians, and even the beleaguered Quakers and Catholics found homes. The first wave of immigrants from Europe who came through New York City to Long Island found comfort in established congregations and courage to found new ones. Traditional employment options, such as farming, were abundant. The Island had fertile potato farms. Fishing for shellfish and Atlantic staples such as cod was also a profitable way of life.

While employment was always available, markets were distant. The single most important development on Long Island was the railroad. On April 24, 1834, a charter was granted for the Long Island Rail Road Company (LIRR). Ferry boats had been the usual means of transportation and would remain important, especially with the likes of Cornelius Vanderbilt as owners, but rail in conjunction with ferries became more important. Vanderbilt would eventually become a member of the LIRR Board of Directors. Major D. B. Douglass was the pioneer for this new "mass transit" system. While most of the rail traffic centered around the outskirts of New York City, additional track was laid to the hinterlands.

Year by year, mile by mile, the LIRR would expand: Mineola to Glen Head in 1865, Glen Cove in 1867, Locust Valley in 1869, and on and on. Every mile meant more people and commerce. Competition ensued from the likes of the Flushing and Central railroads, but one way or another, compromises and mergers came about. Austin Corbin's stint as head of the LIRR from 1881 until his death in 1896 ensured its eventual success. Sleepy hamlets did exist, and the pace of life was still slow in the outlying areas, but things were changing. Bridges and tunnels were being constructed, and the mix of the Island's productivity with New York City's financial muscle was too potent to ignore.

Traditional values such as hard work had always exemplified Long Island communities. Now, close-knit families and neighbors were solidifying even more. Tough, rugged workers rubbed elbows with those who used the Island as a playground, but all had a single purpose, to be successful and make a home for themselves.

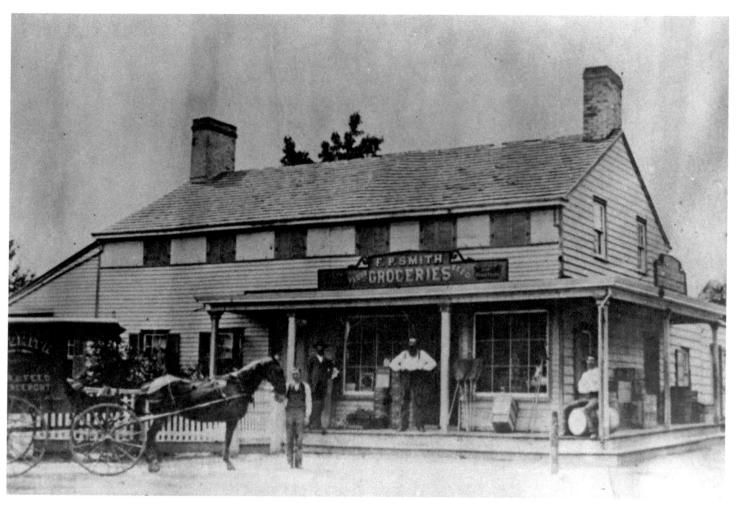

The F. P. Smith Grocery and General Store is seen here at the corner of Main Street and Merrick Road in Freeport in 1865. It appears to be a large, two-story building with two fireplaces. Mr. Smith had a delivery wagon to bring flour and feed to his customers. A good-size porch, with two entrances, and a hitching post in front suggest a welcoming atmosphere.

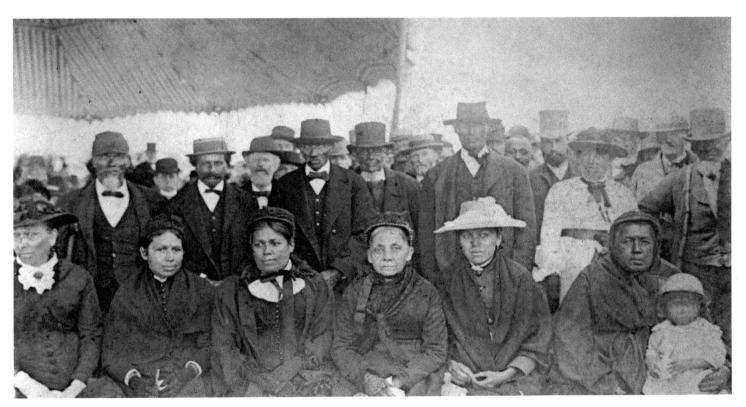

These Shinnecock Indians were photographed on their Southampton reservation in 1884. Descendants of the Algonquin tribe and, according to legend, named from a pattern on the back of a great turtle, the Shinnecocks lived on the shores of Long Island and hunted whales from dugout canoes. The Shinnecocks are one of the oldest self-governing tribes, with a tribal government that was recognized by the New York state legislature in 1792. From their dress, we can infer the impact of "civilizing" programs by the 1880s.

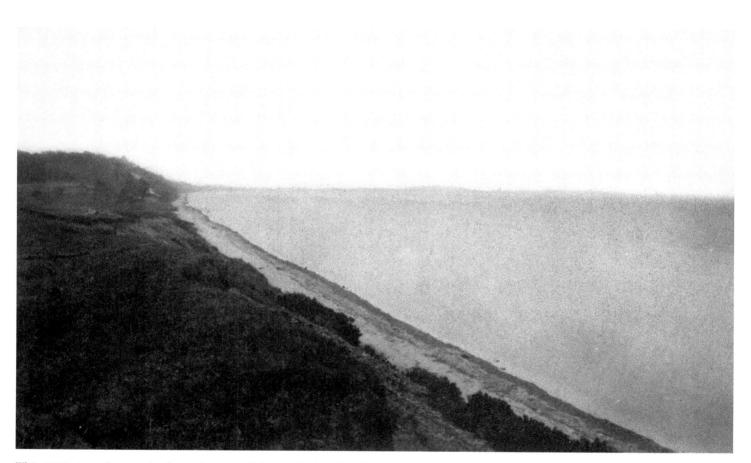

This 1878 view of a stretch of coastline near Osborn's Neck in Southampton suggests the vastness of the Long Island shore. One can almost sense the vulnerability of the land to the ravages of storm and sea.

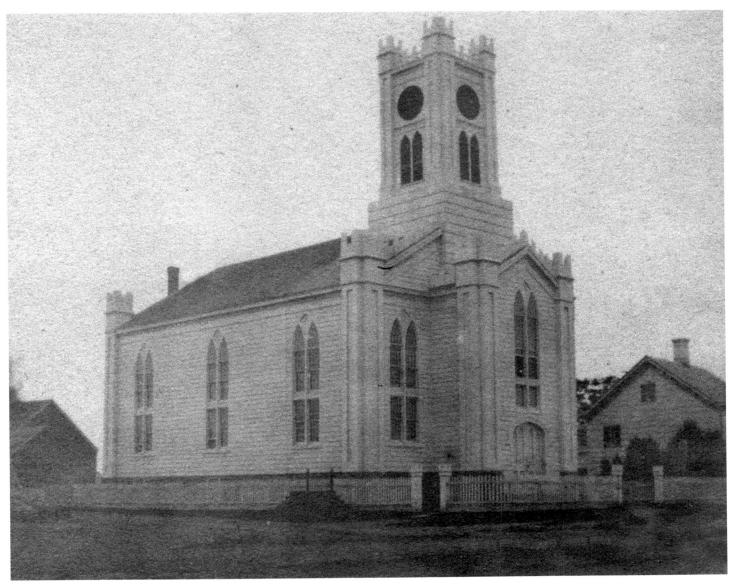

In the age-old struggle for religious freedom, English Presbyterians built a meetinghouse in Southampton in 1640. They erected their first church in 1716. This church at Jobs Lane and Main Street, built in 1843 and photographed in 1878, was the congregation's fourth home.

Historical legend has two liberated British cannon being stored in the bell tower of the 1716 church during the Revolution.

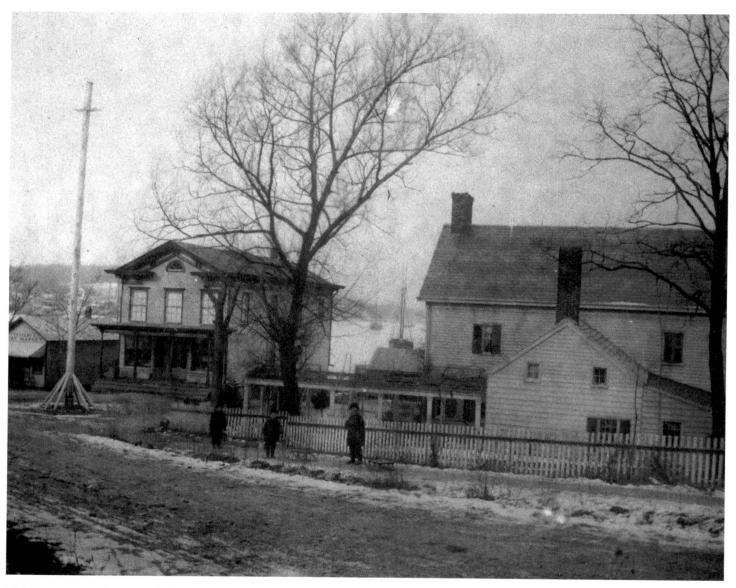

The house on the right, seen in the 1870s, was the residence of James M. Bayles in Port Jefferson. The unsightly original name of the town was Drowned Meadow. Bayles' father, Elisha Bayles, suggested the name change to honor Thomas Jefferson in 1836. The Bayles family were well-known shipbuilders in New York. The picturesque natural-harbor village in Suffolk County was a perfect place for the Bayles Shipyard, which rivaled the Mather Shipyard for business.

At center in this 1878 photo is the Inebriates Home in Bay Ridge. As the name implies, it was where alcoholics were sent when they became a burden to their families or society. In an era when the temperance movement was active as a social conscience, these homes were established to make an attempt to help those in need regain a decent place in society.

Seen here in the late 1870s, the sleepy hamlet of Stony Brook was another town that prospered because of a sheltered harbor that serviced the burgeoning shipping and whaling industries. It later became the home of the renowned Stony Brook University.

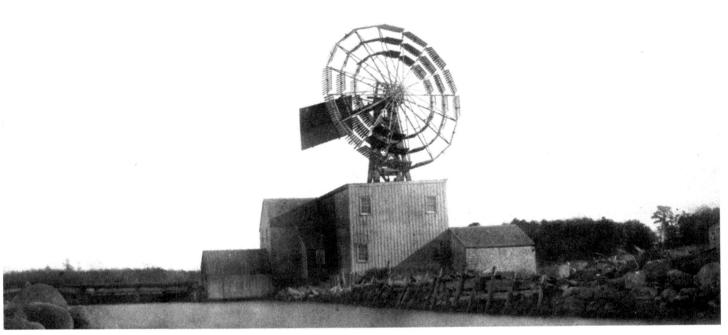

Man can harness nature, sometimes. This 1878 photo shows a tide mill and windmill at Goldsmith's Inlet, Southold. At high tide, water rushes in, and the mill gates close when it recedes. The held water is released into a sluice to run the machinery. The windmill powers a second apparatus. The inhabitants of Long Island were industrious.

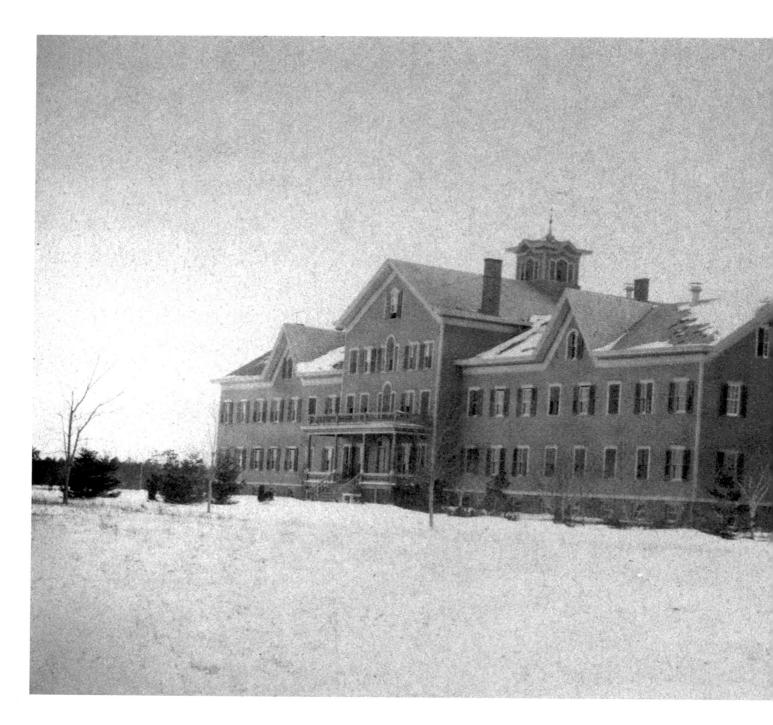

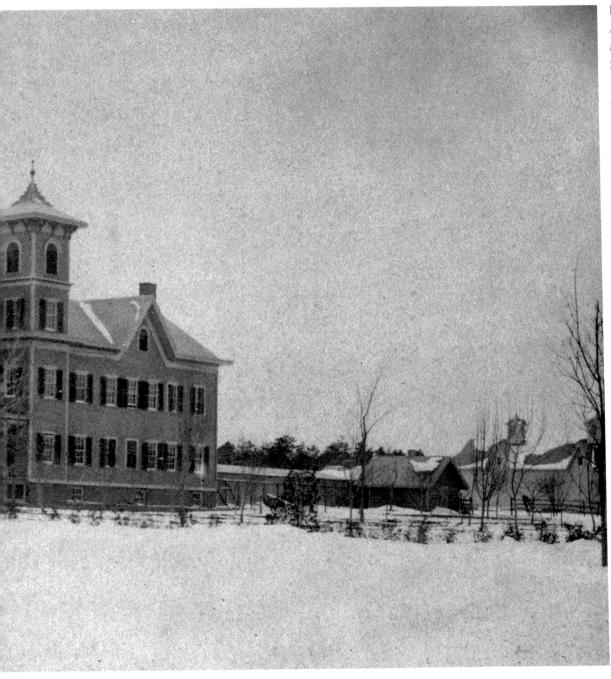

Here is shown the Asylum for the Poor and Insane in Yaphank, Suffolk County, in 1878. The "Gospel concerning Wealth" of Andrew Carnegie with its "survival of the fittest" themes didn't filter down to everyone, and it was left to the efforts of a dedicated few to provide shelter for those less fortunate in the age of expanding industrialization.

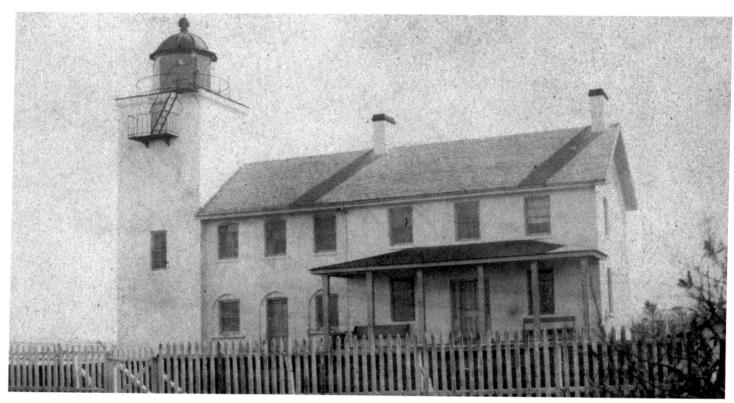

Suffolk County, Long Island, has more lighthouses than any other county in America. This 1878 photo shows the light at Horton's Point. In 1790 George Washington commissioned a lighthouse to be built at the location, but bureaucracy being what it was, the land couldn't be acquired until 1855. In 1857, under the supervision of William Sinclair, the house was finished and he became its first light keeper. It was decommissioned in 1932 and recommissioned in 1990.

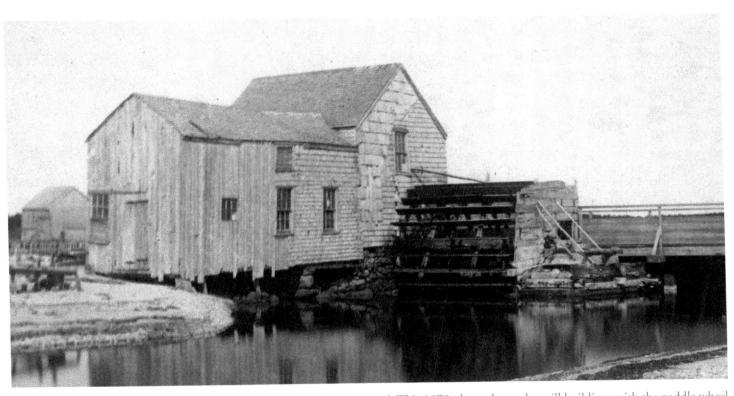

With Orient's proximity to the Atlantic, a tide mill was constructed. This 1878 photo shows the mill buildings with the paddle wheel which would turn as the captured water flowed. Also shown is a wooden bridge across the mouth of the pond.

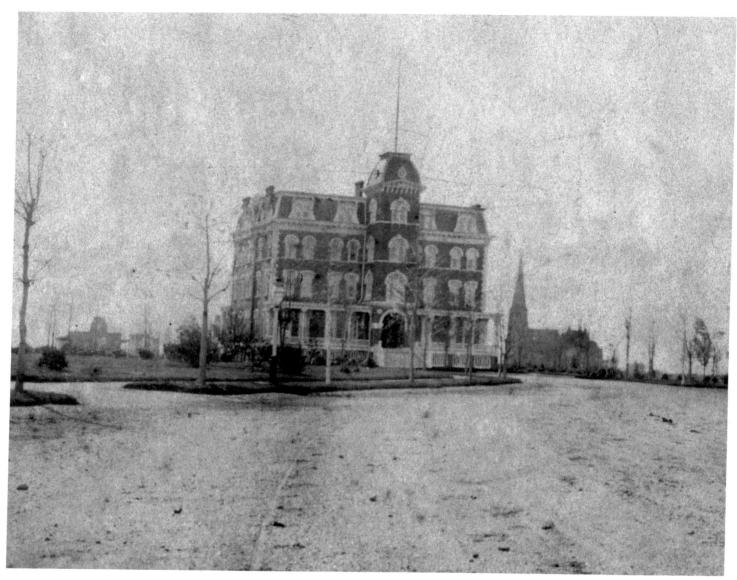

Built by Alexander Stewart for \$150,000, the first in a succession of Garden City Hotels opened in 1874 and is seen here four years later. A second Garden City Hotel opened in 1895 but burned in 1899. A 1901 version was constructed to house wealthy families such as the Vanderbilts. Bankruptcy caused demolition in the 1970s, only for the hotel to rise again in 1980. Through the years, famous clientele have included John F. Kennedy, Margaret Thatcher, the Clintons, and on the eve of his historic transatlantic flight, Charles Lindbergh.

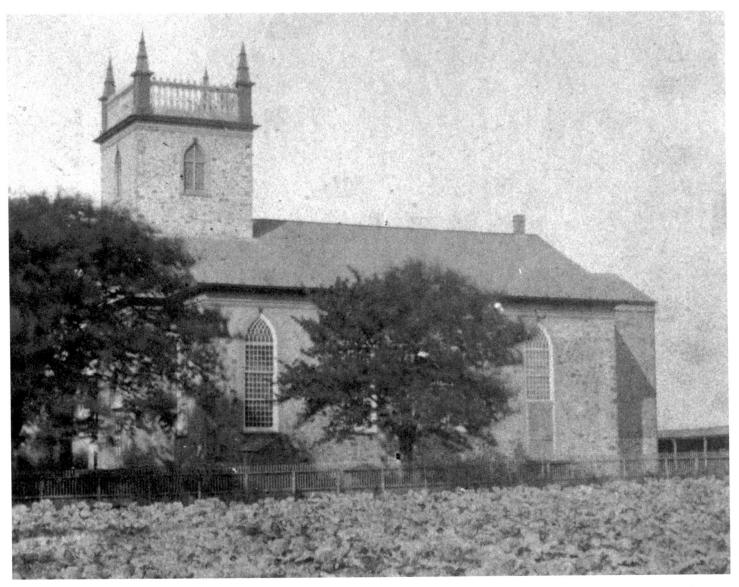

This late-1800s photo shows the Old Dutch Reformed Church, first located in a settlement known as New Utrecht. Cornelius van Woerckhoven purchased the land from the Nyack Indians in 1652. He died in Holland in 1655 while enlisting settlers, so the town was named after his hometown. In 1677 settlers formed the first congregation, and the structure was built in 1700. In 1828 it was dismantled and moved to its present site in what is now Brooklyn.

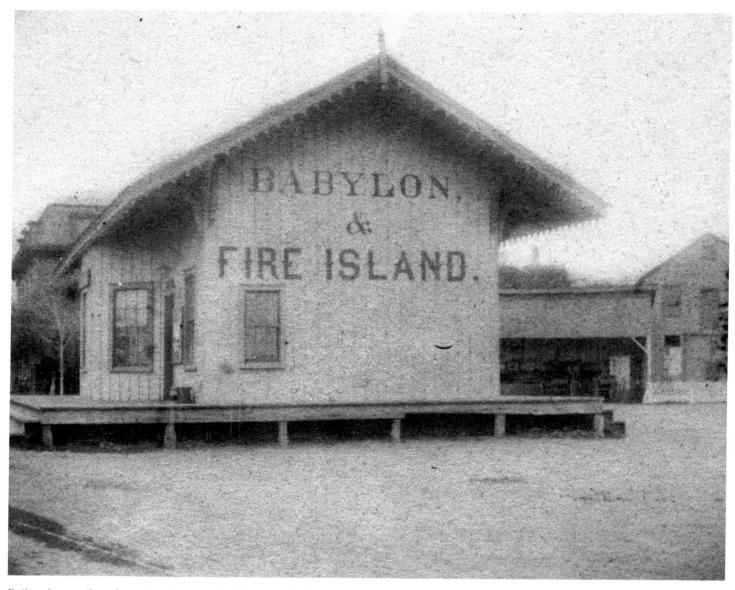

Railroads contributed much to the growth of the Island. This 1878 photo shows the connecting station for the LIRR train to Babylon and ferry access to the resort destination of Fire Island.

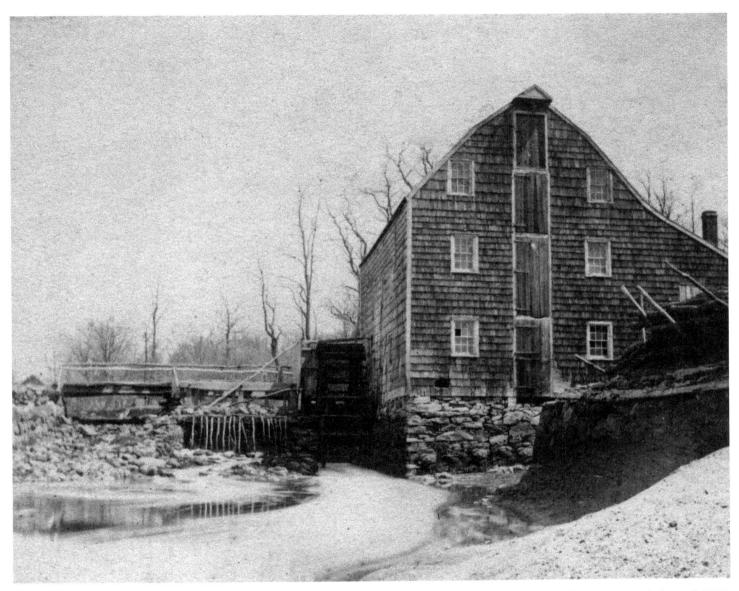

Shown here in 1878 on Udall's Pond in Great Neck is the Saddle Rock Grist Mill, built around 1700 and operated regularly until 1940. Louise Udall Eldridge was the last private owner. The mill pond was formed from the last receding glaciers on the Island. One of the few remaining tidal grist mills in the United States, the Saddle Rock structure has been historically preserved.

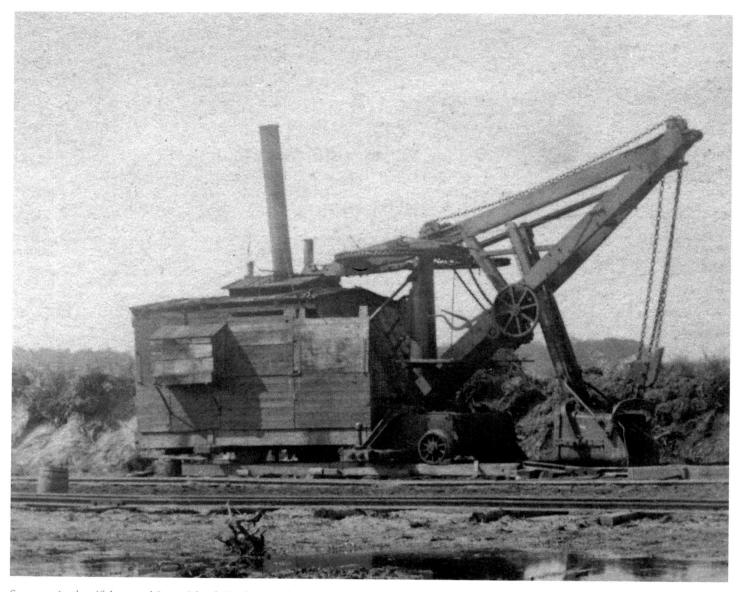

Seawater is plentiful around Long Island. Fresh water had to be kept and stored for a growing population. In this late-1800s photo, a huge steam-powered excavator is working hard at a storage reservoir in Hempstead.

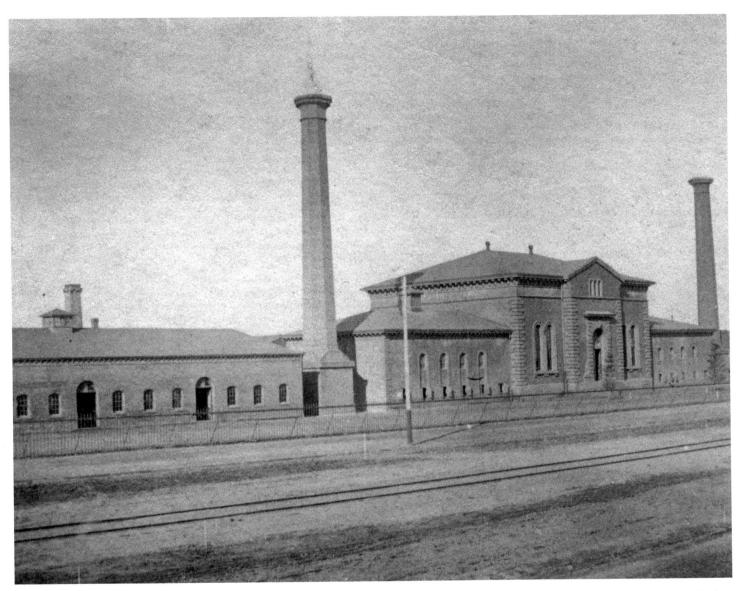

This is the engine house of the Ridgewood Water Works located at Atlantic and Logan streets in Ridgewood. Seen here in the late nineteenth century, it remained operational until the 1960s. The facility had three reservoirs which supplied drinking water to the surrounding communities. During hot and humid summers, nearby residents would sleep at night around the rims of the reservoirs.

This is the stately Keeper's House at the Ridgewood Water Works, also seen in the late 1800s.

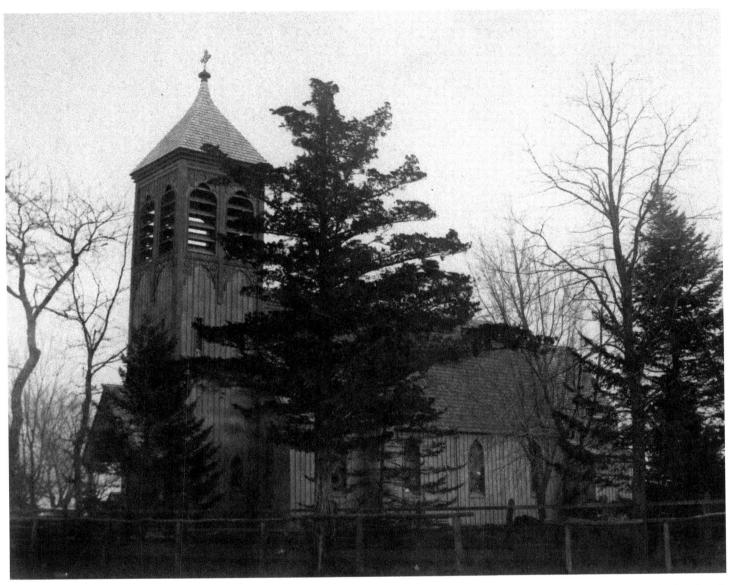

St. James is a hamlet in the township of Smithtown. This 1878 photo shows the Episcopal Church completed there in 1854. The church has three stained-glass windows designed by the famous architect Stanford White and constructed by the equally famous John La Farge. Not to be completely outdone, La Farge rival Louis Comfort Tiffany designed another of the windows. White is buried in the church cemetery, having been murdered under scandalous circumstances.

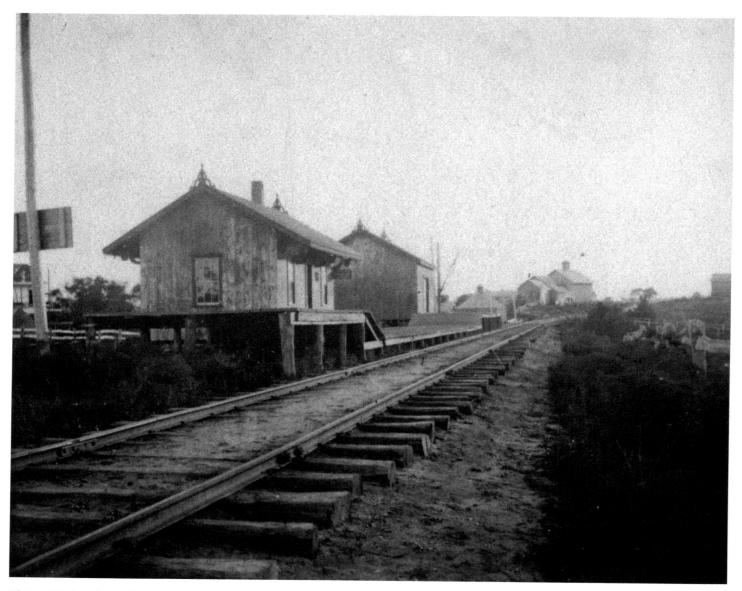

This 1878 view shows the LIRR station in Bridgehampton, a town centrally located on the Island, settled in 1656. Large potato farms dot the surrounding area. Some 30 years after settlement a bridge was built across nearby Sagaponack, or Sagg, Pond, hence Bridgehampton's name. Its most famous resident is Baseball Hall of Fame member Carl Yastrzemski.

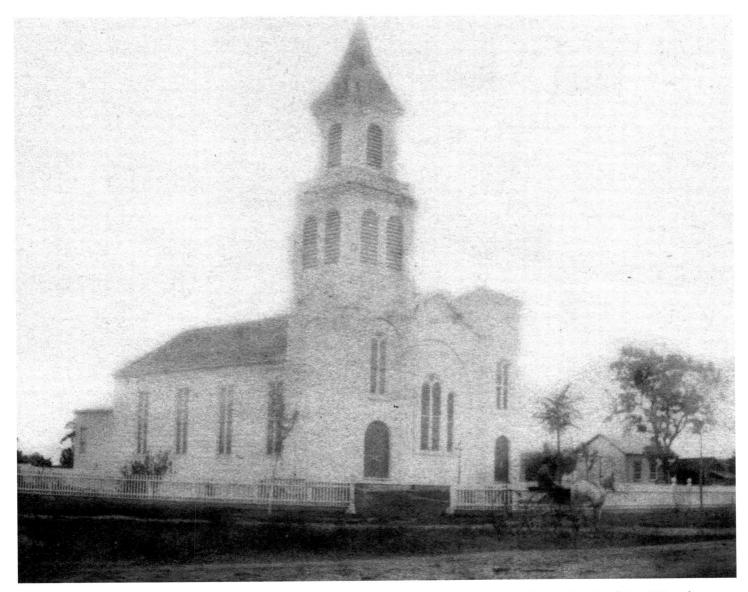

The town of Bridgehampton was settled in 1656, but the Methodists didn't arrive until 1832. They built a church in 1838 at the corner of Church Lane (or Halsey Lane) and Main Street (or Montauk Highway). It was enlarged in the 1860s but burned and was rebuilt in 1906. This photo was taken in 1878.

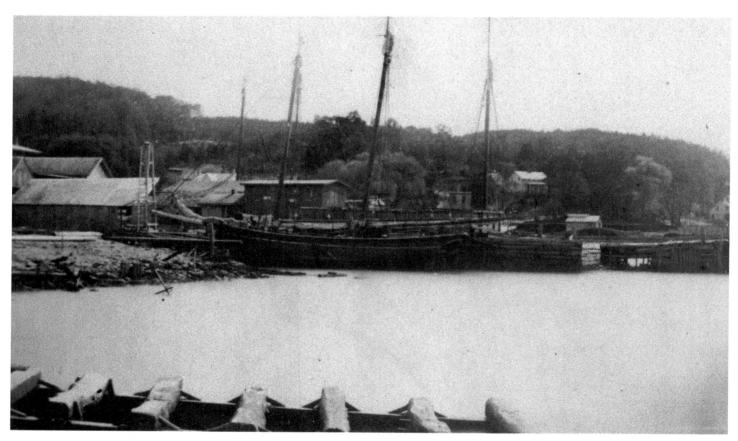

This 1878 view shows the east side of Northport Harbor. The steep hills in the background make the harbor snug and safe. Northport was purchased from the Matinecocks in 1656 and became a village in 1837. It was a bustling port for commercial vessels coming in off Long Island Sound and for shipbuilding as well. Note the launch ramp in the foreground.

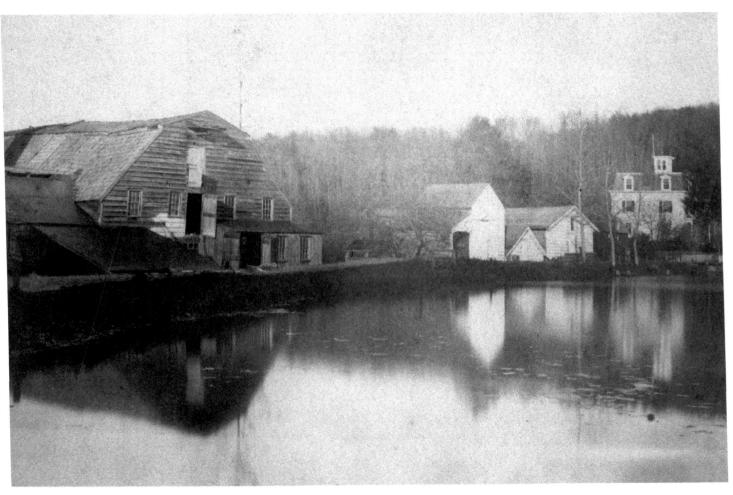

Roslyn, originally Hempstead Harbor, had a paper mill owned by a successful merchant named W. M. Valentine. The mill, seen here in 1878, was built in 1770. The pond area is notorious for an assault on Valentine in 1882. He was accosted and robbed and never completely recovered from his wounds. The amateur thieves emptied his pockets of a small sum, overlooking a much larger amount in his coat pocket.

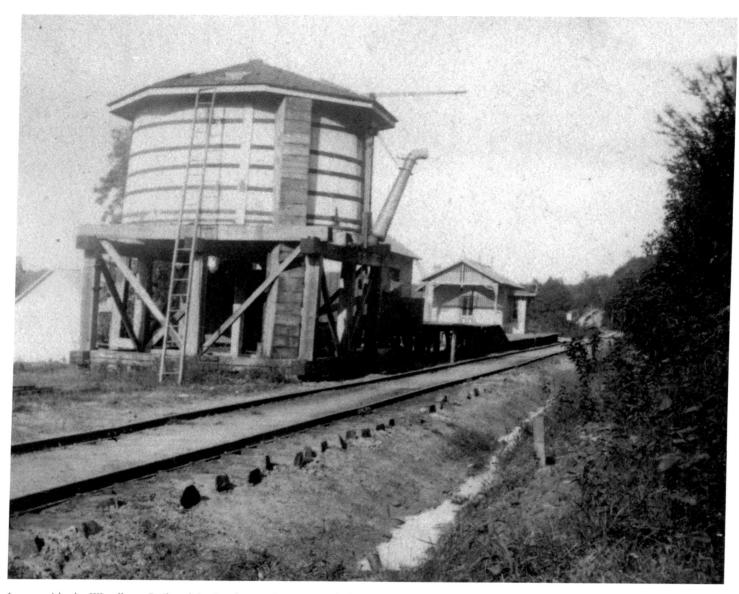

Just outside the Woodbury Railroad Station looms the water tank for the hulking steam locomotives of the LIRR. Woodbury is strategically located in the center of the Island, and so became an important hub for the railroad.

The Delaplaine family house sits atop a small hill on Yellow Hook in this 1880s view. The area was named Yellow Hook by Dutch settlers because of the yellow clay near the beaches, but was later changed to Bay Ridge to avoid the negative connotations of yellow fever.

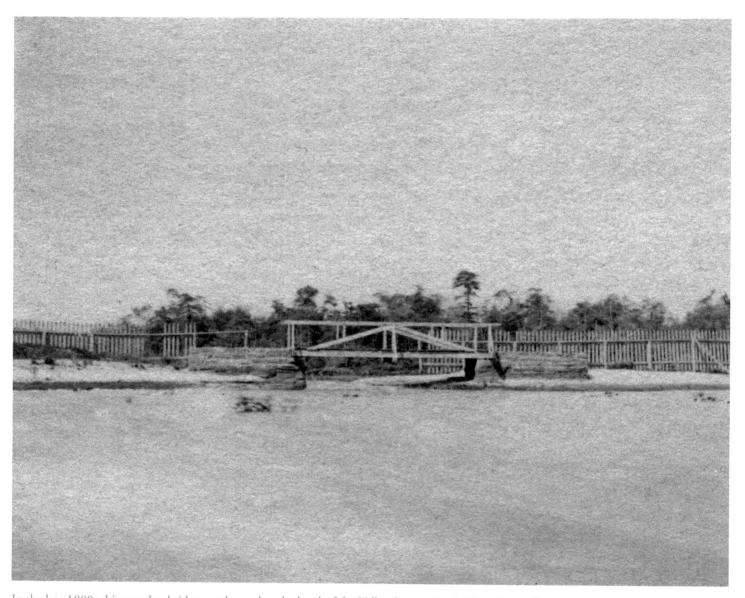

In the late 1800s this wooden bridge was located at the head of the Valley Stream Pond. This Nassau County reservoir was used, as it is in the present, as a popular recreational spot for hikers, nature lovers, and especially fishermen.

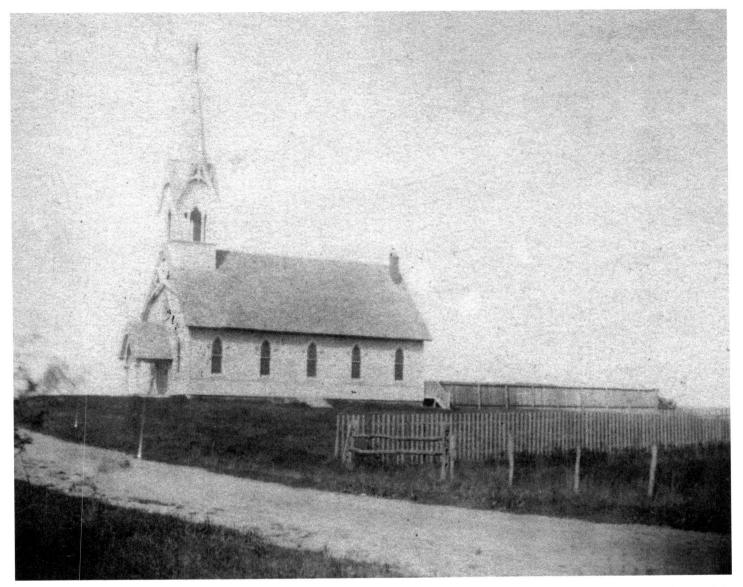

St. Mary's Episcopal Church on Shelter Island, completed in 1874, is seen here some years before a fire that destroyed the building on July 26, 1892. The fire started when the spire was struck by lightning.

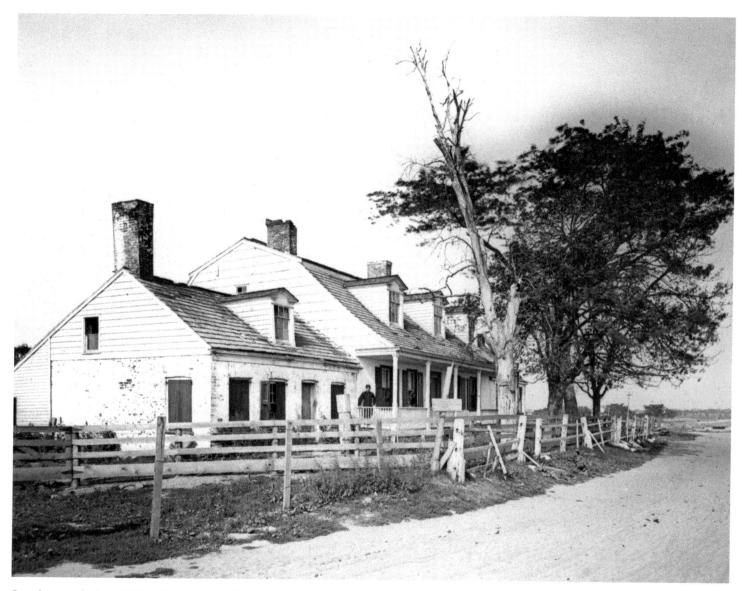

Seen here in the late 1800s, this house was in Bay Ridge in an area close to where the Revolutionary War's first significant engagement, the Battle of Long Island (also known as the Battle of Brooklyn) was fought in August 1776.

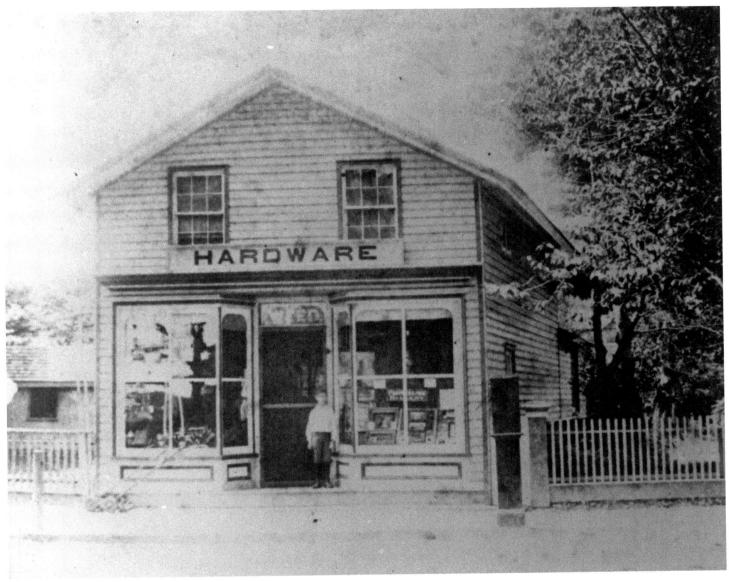

In 1885, Weed's Hardware and Photographic Shop was on South Main Street near Merrick Road in Freeport. Photography was still young, but Mr. Weed appears to have set aside a large portion of his right front window as a photo gallery. Perhaps he intended the newfangled invention to supplement his hardware business or eventually replace it.

This was the Freeport Post
Office in 1891, located on
South Main Street. While
posting a letter, one could
shop for boots, shoes, hats,
and caps at D. B. Raynor's
store, or visit the dentist.
As with many business
establishments of the time,
there was a hitching post
for a horse and a step stone
for exiting a carriage.
Note the shy little girl on
the left peering at the day's
goings on.

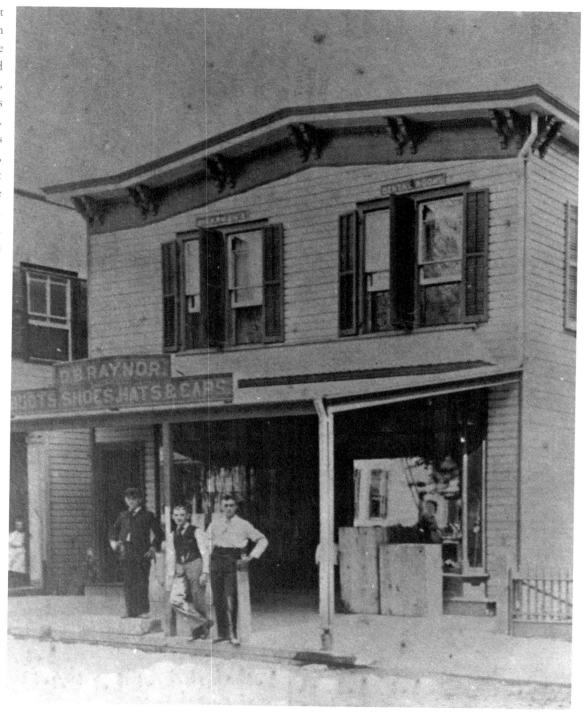

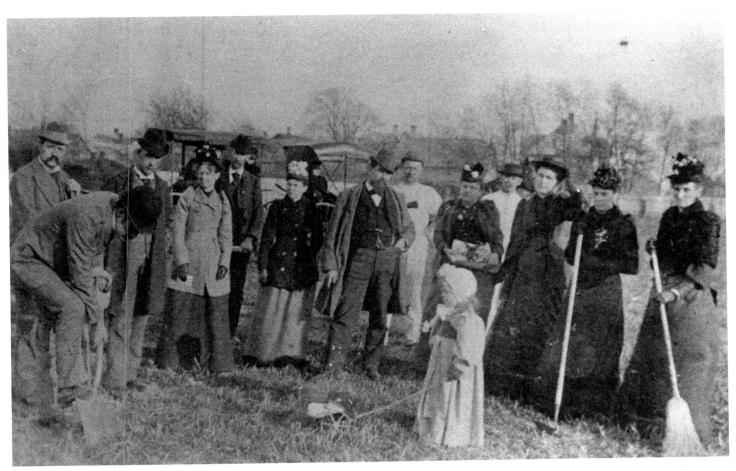

Here is the ground-breaking ceremony for the Grove Street School in Freeport in 1893. Perhaps the little girl in front is a prospective student? The Freeport Public Library was started by the school's principal, and for a time the library's books were kept in his office clothes closet.

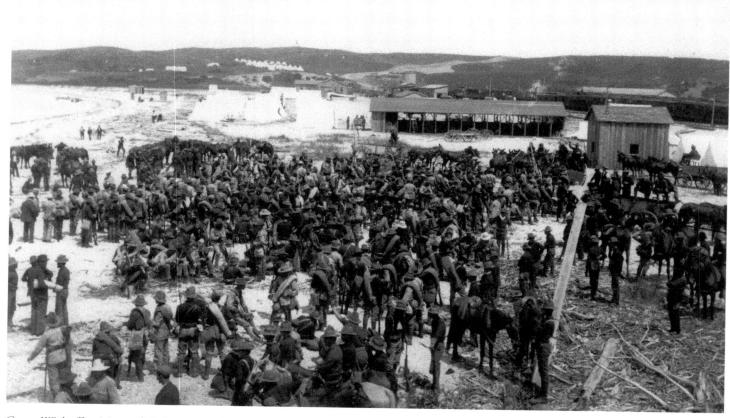

Camp Wickoff at Montauk Point was established as a base where soldiers returning from the Spanish-American War could be quarantined and recuperate from any tropical diseases they might have contracted in Cuba. This 1898 photo shows Colonel Theodore Roosevelt's Rough Riders arriving. Initially conditions at the camp fell short of expectations, prompting President William McKinley to set up a commission to expedite a cleanup. More than 20,000 soldiers disembarked there before its closure.

AUTOS AND AIRPLANES

(1900-1939)

A symbol of the new century was exemplified by the Long Island Rail Road being taken over by the Pennsylvania Railroad. Long Island was growing muscle. New terminals were constructed, and it was a back-and-forth proposition. City dwellers wanted to move to the "country," and inhabitants of Long Island wanted to go to the "big city."

Another Long Island market that began to flourish was real estate. Land values began to increase in the 1910s and 1920s. World War I caused a minor setback, but a new allure anchored in the Roaring Twenties took shape. F. Scott Fitzgerald set his 1925 novel *The Great Gatsby* on Long Island. Yacht clubs were built on Long Island Sound, and the prosperity continued until the Great Depression.

While the railroads were still king, something happened in 1904 that would again transform Long Island: William K. Vanderbilt drove his Mercedes from Garden City to Hempstead Plains. The automobile officially arrived, in the context of a road rally. The Vanderbilt Cup Race was the first international auto race in the United States and would launch Americans' long love affair with their cars. While the myriad of highways would not be constructed for a decade or so, a seed was planted in fertile ground. By 1906, the "Long Island Motor Parkway" was promoted as an essential idea.

By 1929, Robert Moses, whose projects would become integral to the growth of Long Island, began construction of the Northern State Parkway, literally altering the landscape. At the same time, aviation was becoming a new source of inventiveness and pride. The New York–New Jersey area became a testing ground for this pioneering industry. Charles Lindbergh began his 1927 solo flight over the Atlantic from Roosevelt Field in Garden City. Dedicated in 1931, Floyd Bennett Field in Brooklyn was New York City's first commercial airport, and Grumman Aeronautical Engineering Company, which opened its doors in 1930 in Baldwin, was a mainstay of Island employment for years.

School construction boomed, addressing all levels of education. As the communities improved, so grew their desire to be recognized for superior school systems. Higher education increased as well, and institutions from Adelphi University to Webb Institute offered a variety of programs. Leisure time increased, and resort areas such as Fire Island and Jones Beach welcomed tourists. The Hamptons became synonymous with the rich and famous. Long Island became a hot spot.

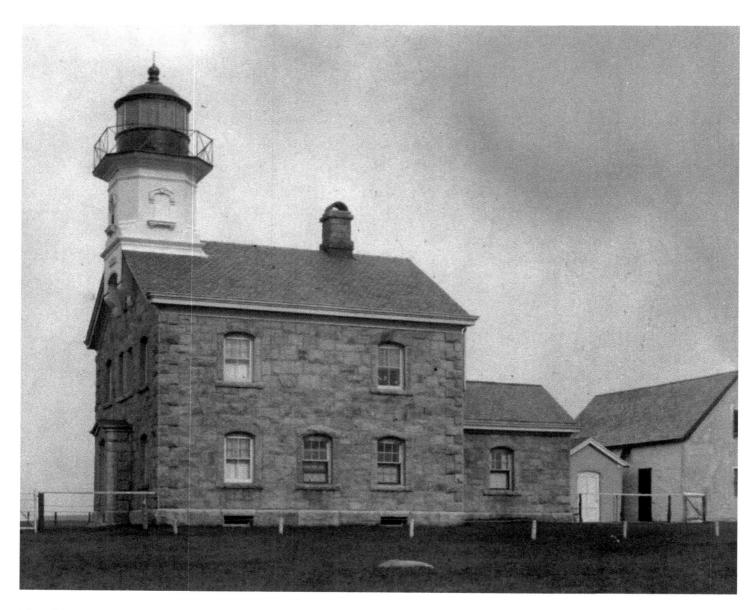

The Old Field Point Light guards the entrance to Port Jefferson Harbor. Seen here around the turn of the century, the station was established in 1823 and the light first activated in 1868. Edward Shoemaker was the light's first keeper. The dwelling was also used as a town hall and town offices, and was originally a wood tower on a granite house. It was automated in 1933.

A solitary dinghy bobs in the surf off Amagansett Beach. Though taken at the turn of the century, the photo is timeless in its representation of the shores of Long Island.

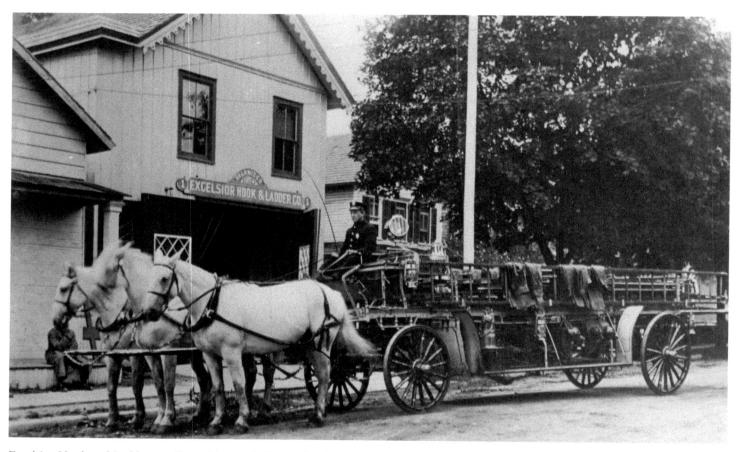

Excelsior Hook and Ladder was formed in 1874. Originally, the apparatus relied on manpower, not horses, to move it. Buckets adorned the sides and would be dropped into wells for filling. The Freeport Fire Station was also used as a voting place and meetinghouse. The photo is from the early 1900s.

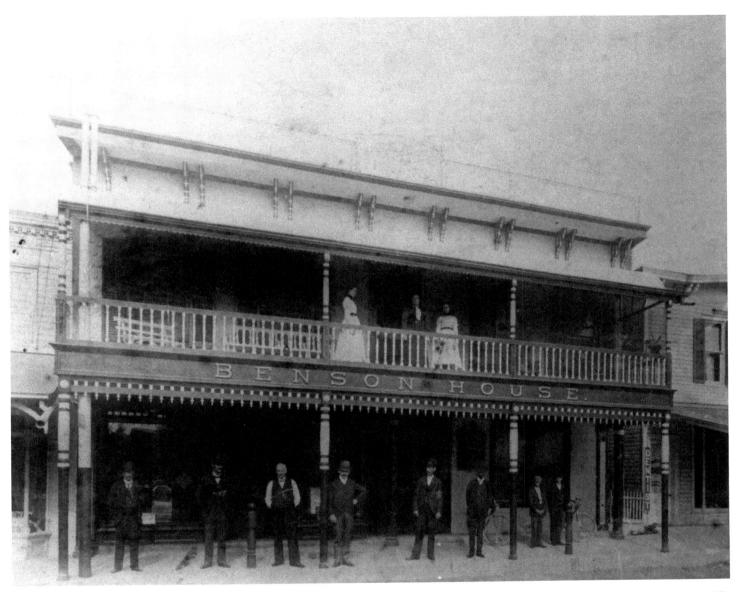

The Benson House, photographed in 1902, was a commercial travelers' hotel on South Main Street in Freeport. It appears to be quite spiffy and even has female lodgers on the second floor. It was probably a welcome relief from long, tedious travel on Long Island's early roads.

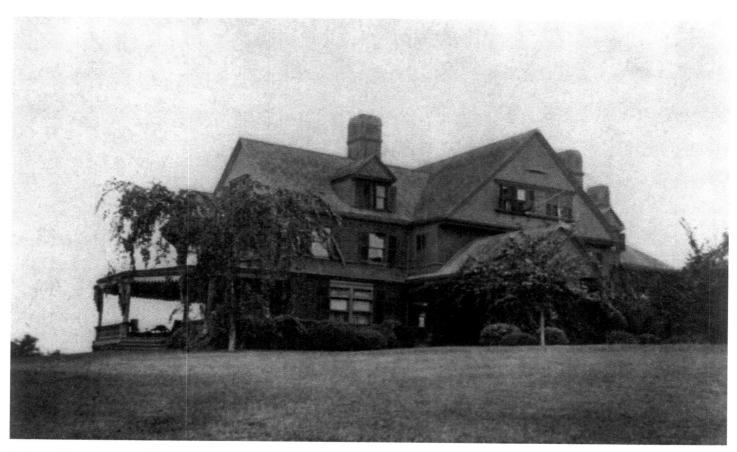

Built in 1884, Sagamore Hill was the residence of Theodore Roosevelt. Architects Lamb and Rich designed the Queen Anne–style house, which overlooks Oyster Bay and the surrounding countryside. It was a place of triumph and tragedy for Roosevelt. His first wife, Alice, died before they could move in. He married his second wife, Edith, in 1887, and they raised six children there. The house, seen here in 1902, provided Roosevelt a welcome retreat from his political chores, but also served as the "Summer White House" during his presidency.

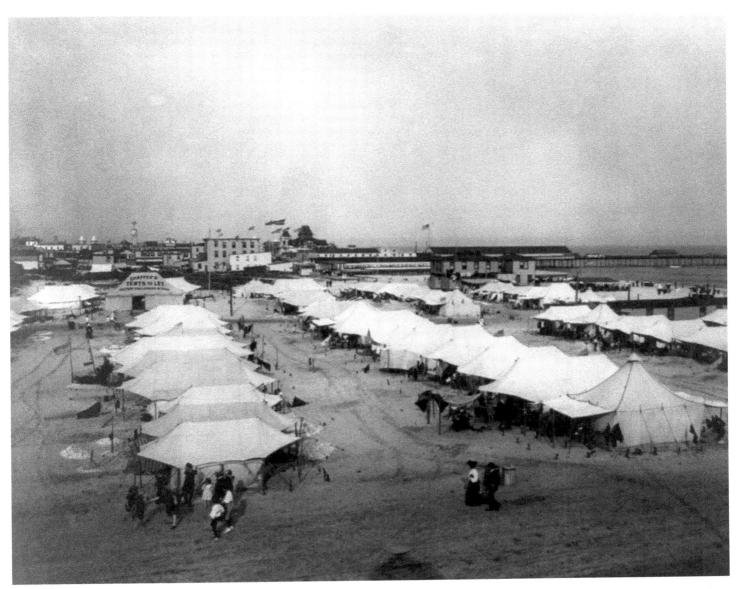

This tent city at Rockaway around 1903 is most likely the setting for a religious revival, popular during the era. In the background are hotels, amusements, and a long fishing pier. During the summer the beach towns came alive.

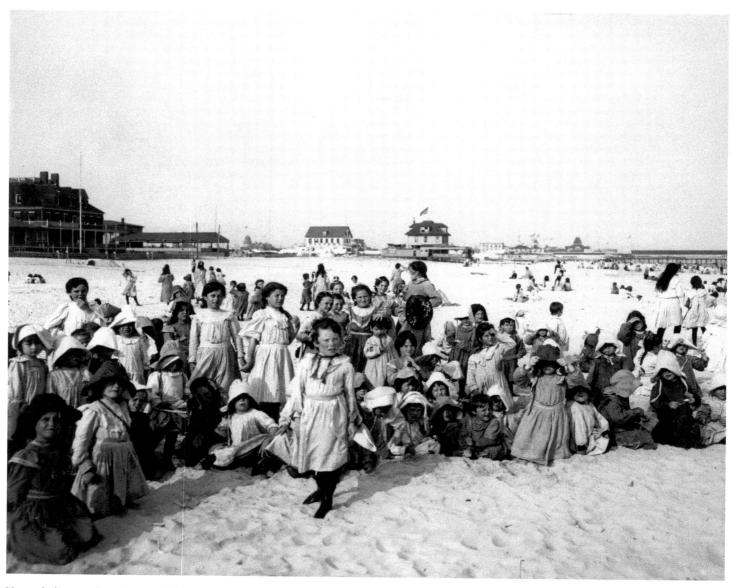

Young ladies are dressed properly for the beach on Rockaway around 1903. While sea air and salt water were deemed healthful, apparently the sun was not.

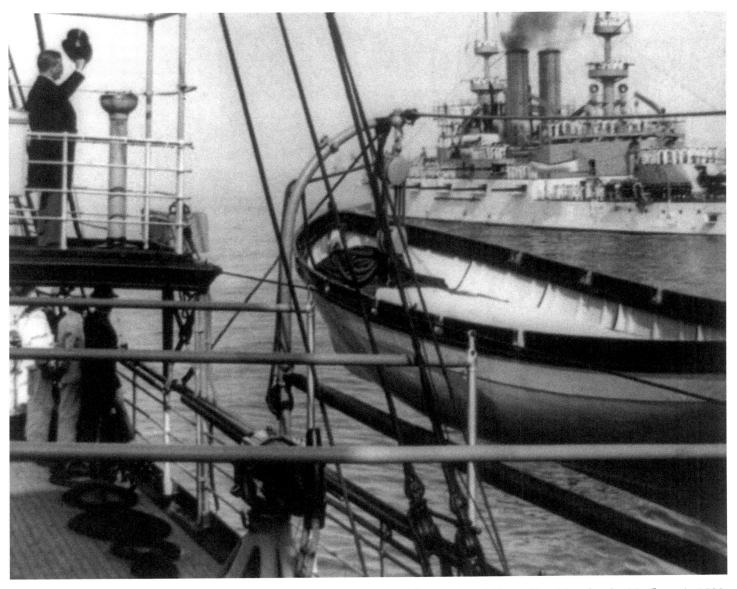

President Theodore Roosevelt salutes Admiral Dewey's fleet off Long Island from on board his presidential yacht, the *Mayflower*, in 1903. The yacht, built in 1896 in Scotland, had been used by the U.S. Navy during the Spanish-American War. Roosevelt used it as the setting for peace negotiations during the Russo-Japanese War.

The youngest child of Theodore and Edith Roosevelt, Quentin Roosevelt is seen here at the family home in Sagamore Hill in November 1904, shortly before his seventh birthday. A pilot in the Army Air Service during World War I, he was killed in an aerial battle behind German lines. An airfield outside Garden City was renamed Roosevelt Field in his honor, and it was from that field that Charles Lindbergh would take off on his historic transatlantic flight in 1927.

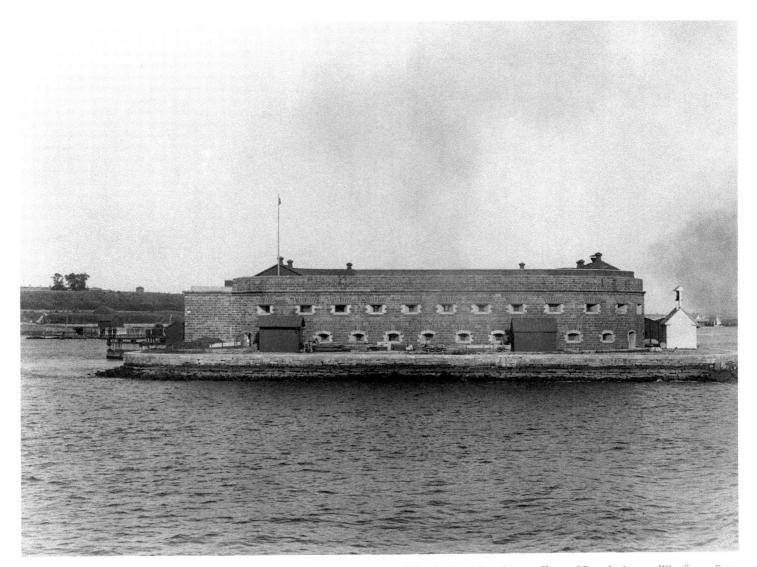

Named Fort Diamond when built in 1822, Fort Lafayette was renamed for the French military officer of Revolutionary War fame. Seen here around 1904, the fort was located between Long Island and Staten Island. Its good view of the channel into New York Harbor gave it strategic value. The fort housed Confederate prisoners during the Civil War. It fell into disrepair and eventually was razed to become one of the "feet" for the Verrazano-Narrows Bridge in 1960.

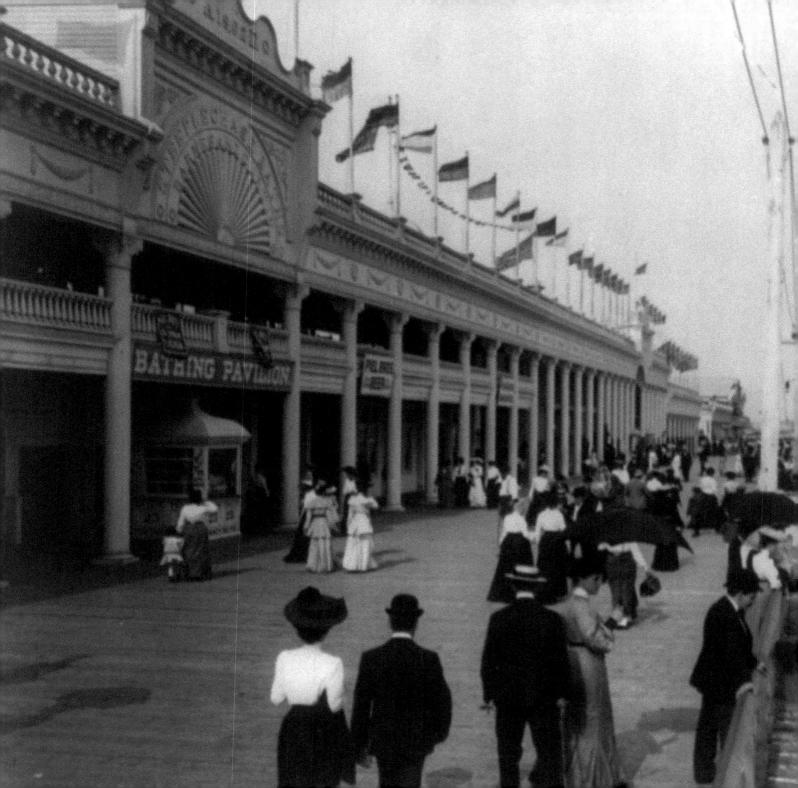

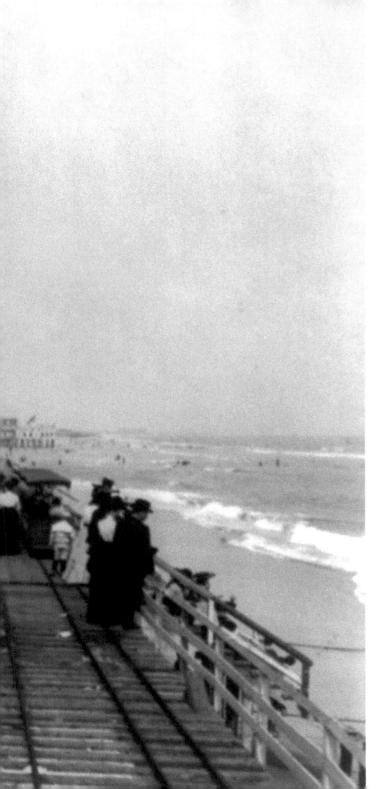

Purchased from the Canarsie tribe by an English colonist in 1685 and developed as a resort area as early as the 1830s, Rockaway had been attracting beach excursionists for decades by the time this group of strollers were photographed on the boardwalk circa 1904.

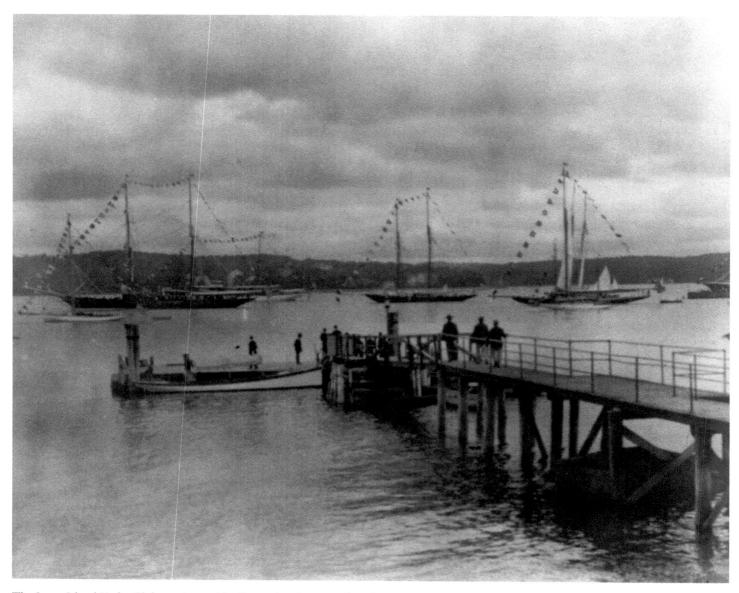

The Long Island Yacht Club was located in Oyster Bay in 1905. Seen here is the main pier, with several yachts proudly flying their pennants in the background. Skiffs like the one tied up at the end of the pier would ferry the rich and famous ashore. Oyster Bay, called Seawanhaka by the Native Americans, was settled in 1653, its sheltered cove being a haven for seamen.

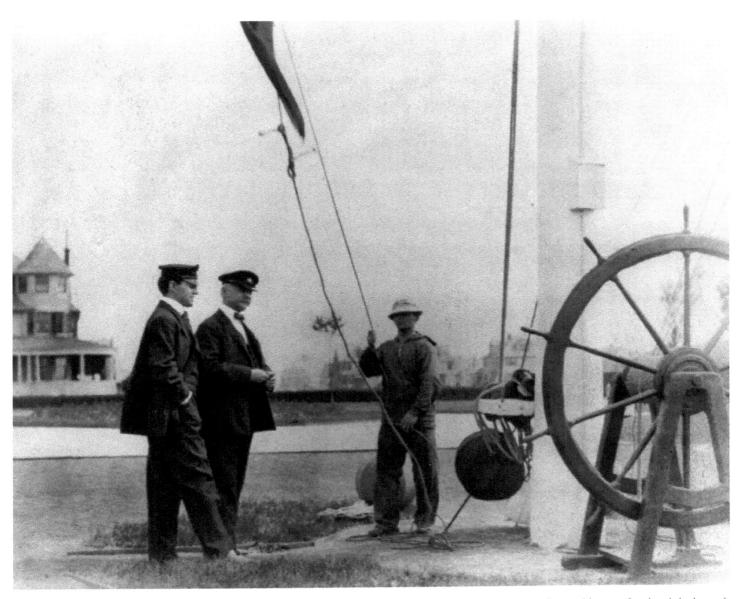

A flag is hoisted up a sturdy pole at the Long Island Yacht Club in 1905. Oyster Bay was one of several homes for the club through the years. Others included New York City; Mystic, Connecticut; and Hoboken, New Jersey. To paraphrase financier J. P. Morgan, the club's commodore from 1897 to 1899, if you had to ask how much a yacht cost, you probably couldn't afford one. Lucy Carnegie became the first female member in 1894.

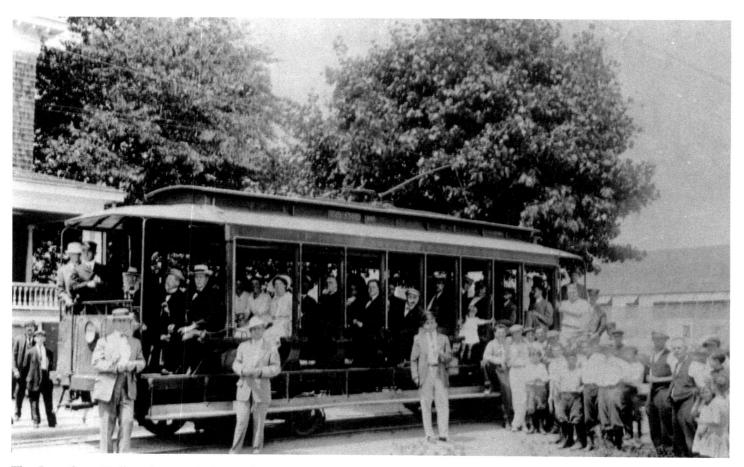

The Grove Street Trolley, photographed around 1908, was operated by the Long Island Traction Corporation. This Freeport route was called the "Fisherman's Delight" because it ran along Grove Street to Front Street and down to the docks at the foot of Woodcleft Channel. The line was shut down around 1923.

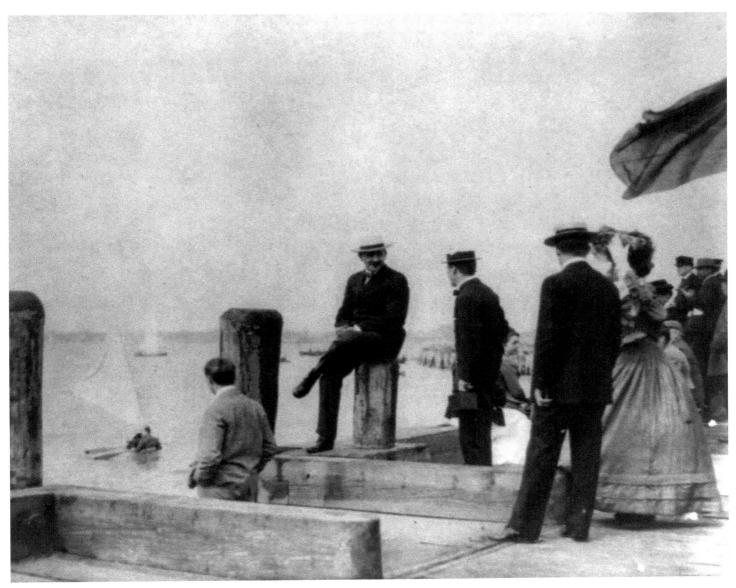

People in small sailboats dot the cove of Oyster Bay in 1905 while stylishly attired members of the upper class wait for transportation to a party aboard a luxurious yacht anchored in the harbor.

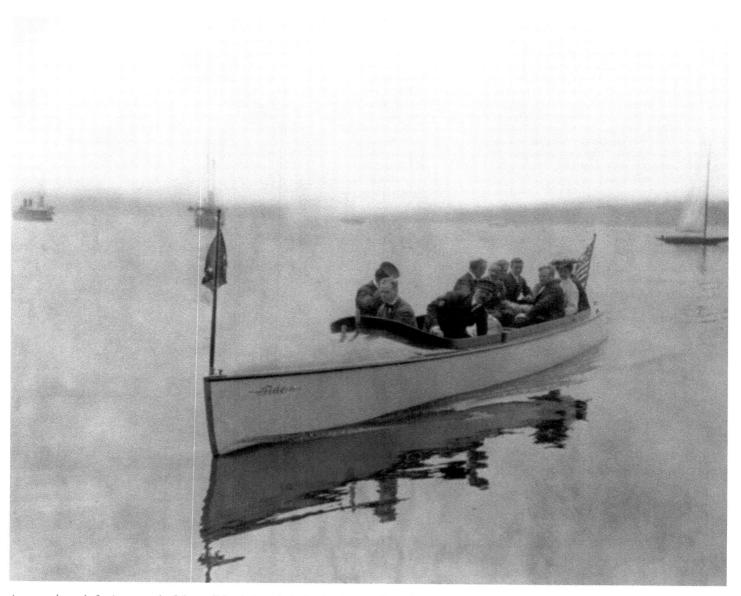

A motor launch ferries several of the well-heeled to their destination on the calm waters of Oyster Bay in 1905.

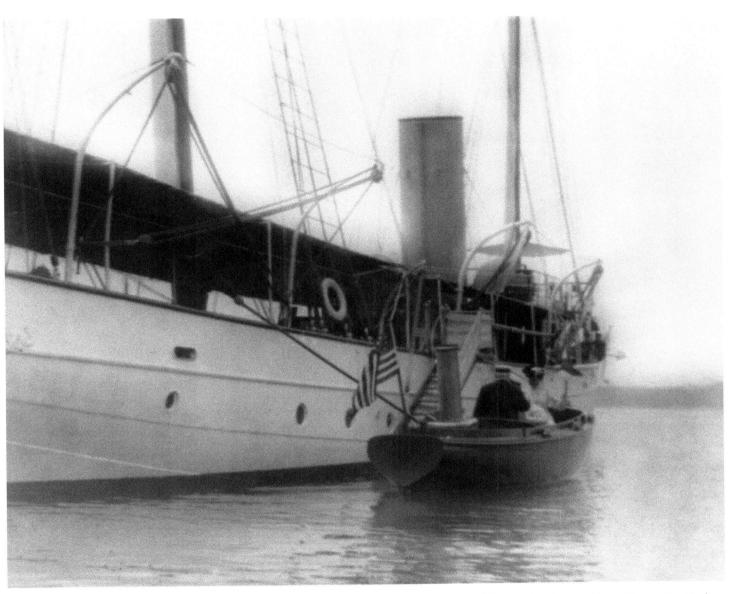

A larger launch complete with American flag and smokestack brings some folks to a handsome ship in Oyster Bay Harbor, a water playground of the rich and famous during this gilded age of finance, industry, and such philanthropic endeavors as the vast library system financed by Andrew Carnegie.

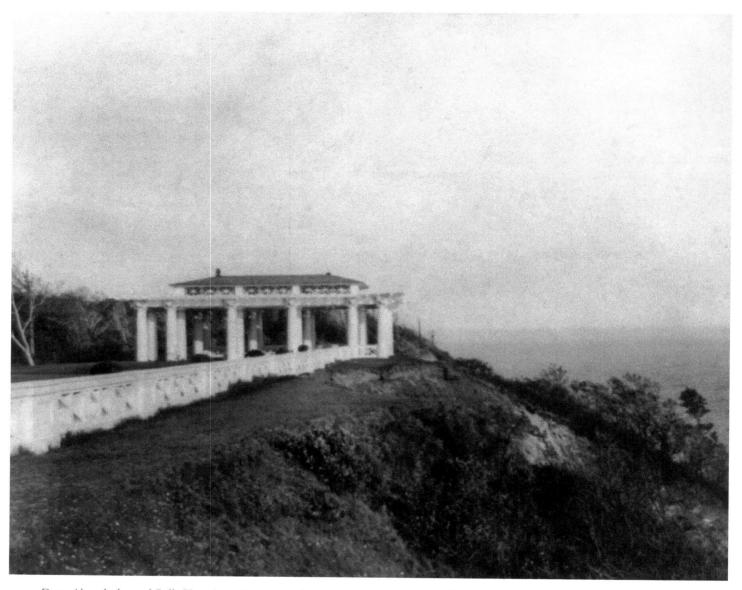

Dean Alvord planned Belle Terre in 1902 as an exclusive community in Port Jefferson. In 1906 a three-story clubhouse was built, and in 1908 the golf course opened with John H. Hogan as first golf master. Pictured is the pergola with its projecting roof and parallel colonnades providing an open-air shaded observation point overlooking Long Island Sound. The community's name became synonymous with luxury. The LIRR had a Belle Terre car to transport residents to and from the estate.

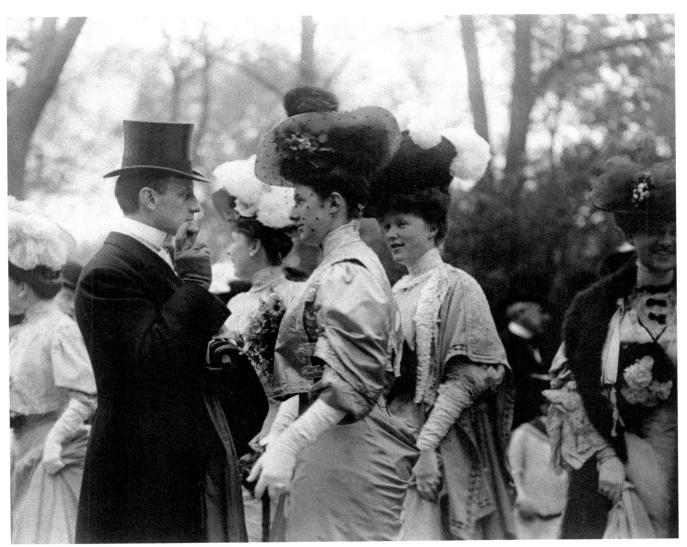

Mr. and Mrs. Goodhue Livingston and Mrs. Alfred Gwynne Vanderbilt are among the fashionable set gathered at Montauk in May of 1906 for the coaching club's parade. Livingston was the architect who designed the famous St. Regis Hotel in New York City. Mrs. Vanderbilt's father was Captain Isaac Emerson who owned the company that produced Bromo-Seltzer. Alfred Vanderbilt would die a hero aboard the ocean liner *Lusitania*.

Following Spread: This scene is at the steamboat dock in Port Jefferson in August 1908. In the background is the legendary ferry Park City, which plied the waters year-round between Port Jefferson and Bridgeport, Connecticut, starting in 1883. The ferry was the brainchild of P. T. Barnum, who saw success transporting mostly vacationers back and forth. The Park City was built on the Island at the famed Mather Shipyard.

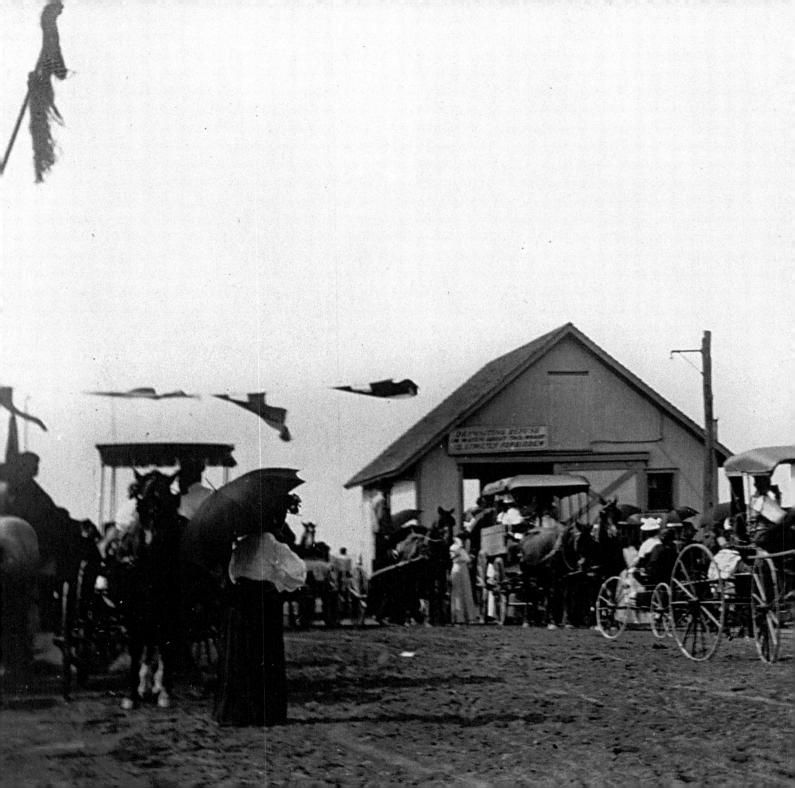

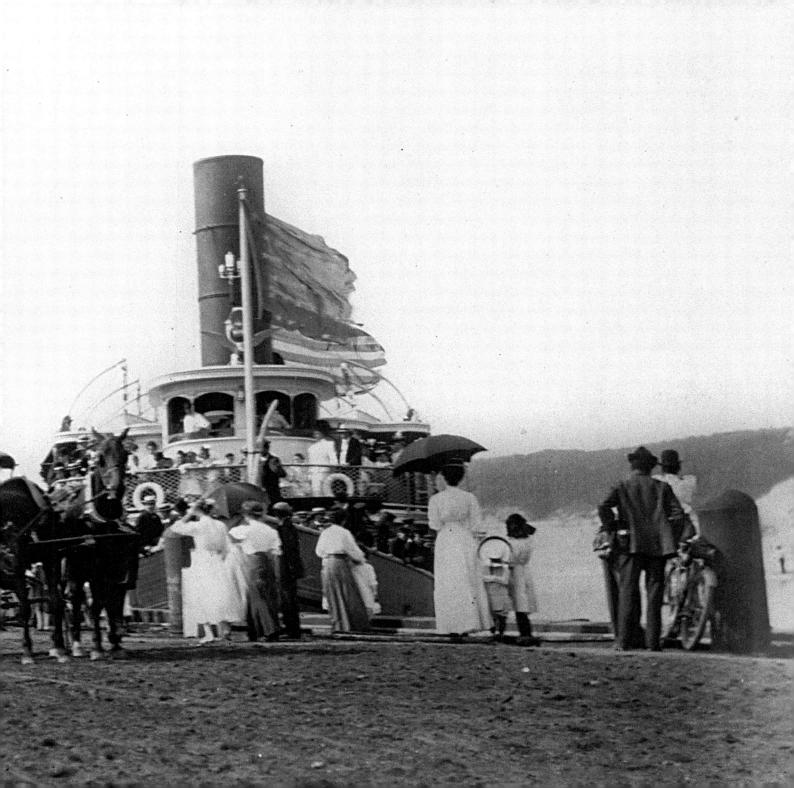

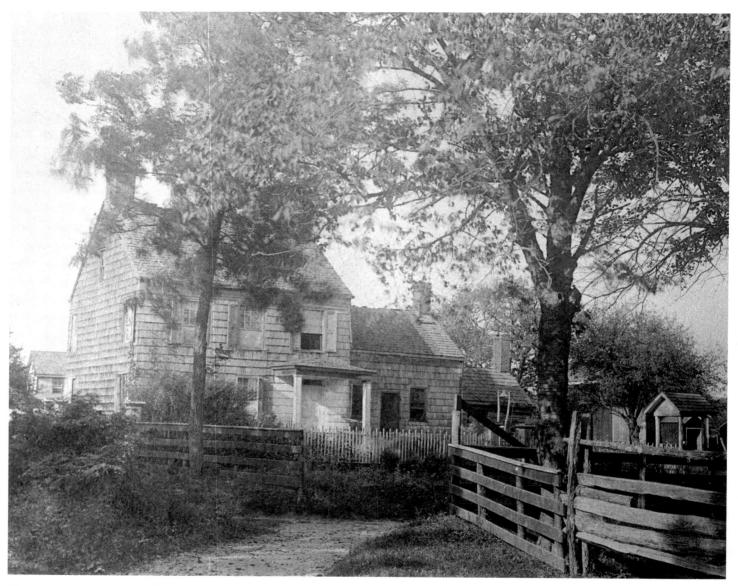

The great American poet Walt Whitman, author of *Leaves of Grass* and other works, was born in this three-section house on May 31, 1819, and lived here the first four years of his life. Located in West Hills, south of Huntington, the house is seen here before 1910, the year a fire destroyed the third section at right.

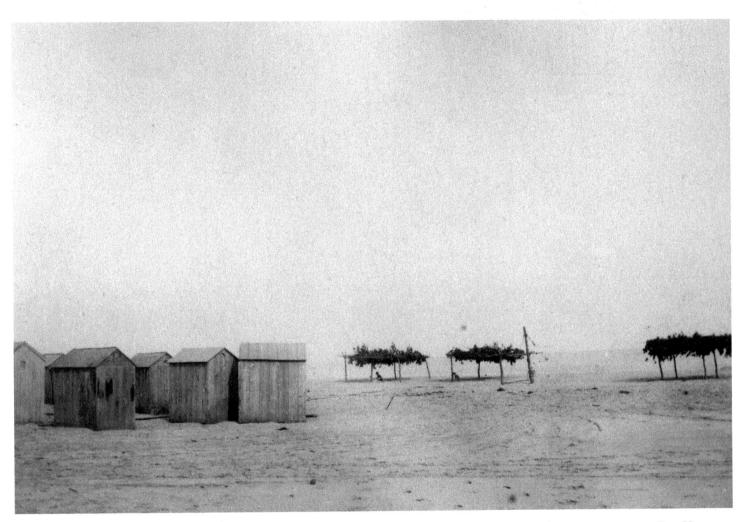

With the small beach houses for changing still clustered together in this early 1900s view, it appears the summer season at East Hampton has not yet arrived. The shaded areas along the beach will provide relief from the sun when the time comes.

A couple of homes in oyster-rich Oceanside, earlier known as Christian Hook, are seen here in 1905.

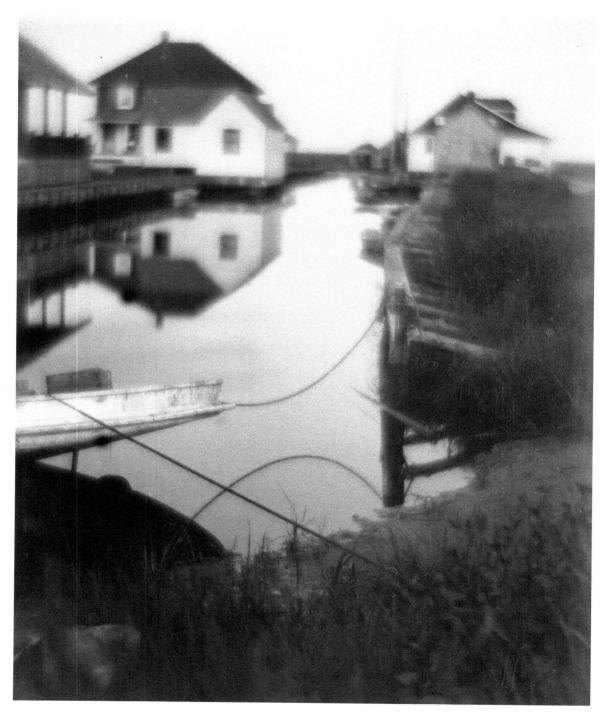

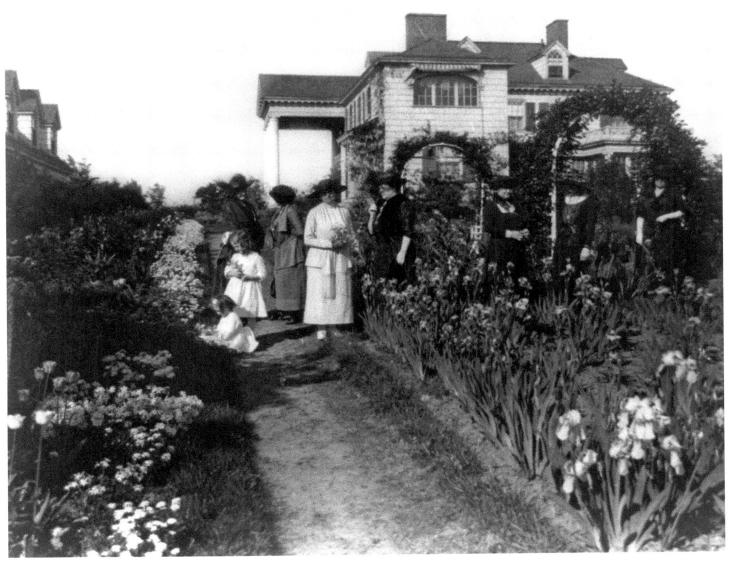

A group of women and two small girls enjoy the splendor of the garden of Frances Johnston Paris in Flushing around 1910. The wife of John W. Paris, she was an activist for social causes and woman suffrage. She lobbied for expanded women's employment opportunities, and for day nurseries for women who did find employment. She belonged to the Good Citizenship League of Flushing.

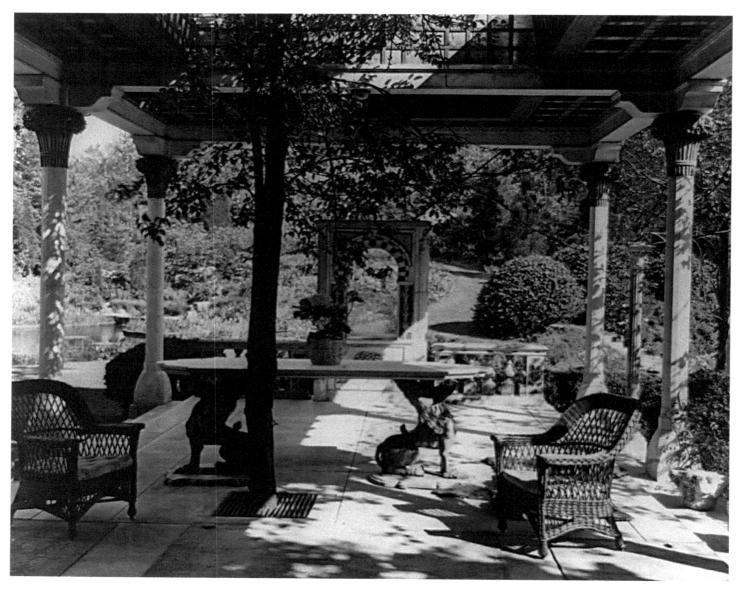

Photographed in 1911, this outdoor room at Laurelton Hall in Cold Spring Harbor was designed by the estate's owner, the designer and artist Louis Comfort Tiffany. In 1918 Tiffany, whose father founded Tiffany and Company, dedicated 60 acres of Laurelton Hall to foster growth in the arts. He felt a summer retreat providing uninterrupted enjoyment of nature would nurture the creative process. Tiffany died in 1933, and the focus of the foundation he established was later changed to funding grants for the arts.

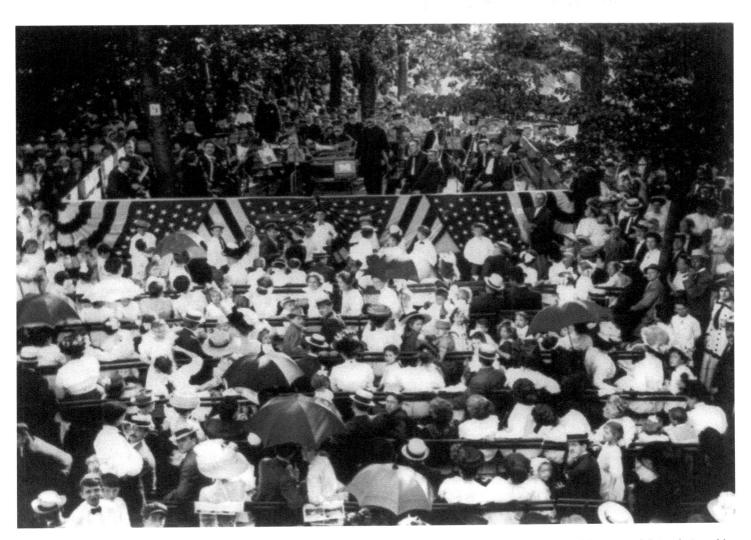

Forest Park, a wooded region with hilltop views of Long Island Sound, was established in Queens in 1898 with a central drive designed by the famous landscape architect Frederick Law Olmsted. That year bandleader George Seuffert, Sr., gave the first of his many free concerts at the park. The bandstand seen here in 1910, possibly with Seuffert and his band performing, was replaced in 1920 by a bandshell now named for him. In later years his son, George Seuffert, Jr., would continue the Sunday afternoon music tradition.

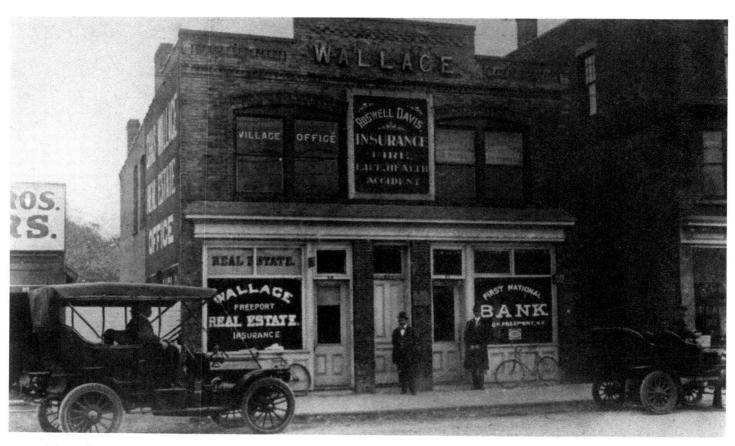

The Wallace Building housed the Freeport Village office, the First National Bank, Wallace Real Estate, and Roswell Davis Insurance.

Rents in the building ran to \$15 a month (including light and heat), a tidy income for the owner.

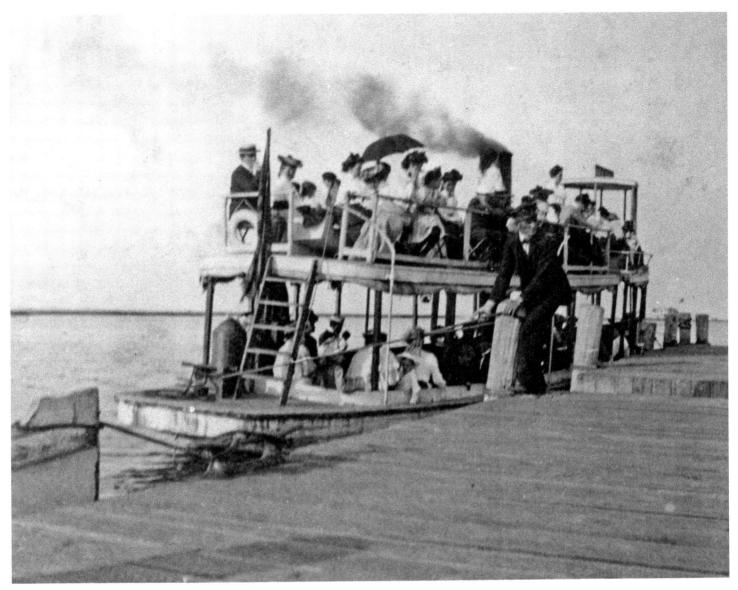

In 1912, before Jones Beach State Park was developed, the closest beach for the people of Freeport to enjoy was at Point Lookout. Operated by Ellison's Ferry, vessels such as this one, the *Sea Gull* (looking a bit top-heavy) would transport beachgoers from the dock at Woodcleft Avenue.

Following Spread: Well-dressed spectators gather at Music Park in Long Beach in 1911. The bandstand and music pavilion were near the Hotel Nassau and undoubtedly provided entertainment for guests. The stand was gone by the early 1920s, however, to make way for the Castle by the Sea Baths and a theater.

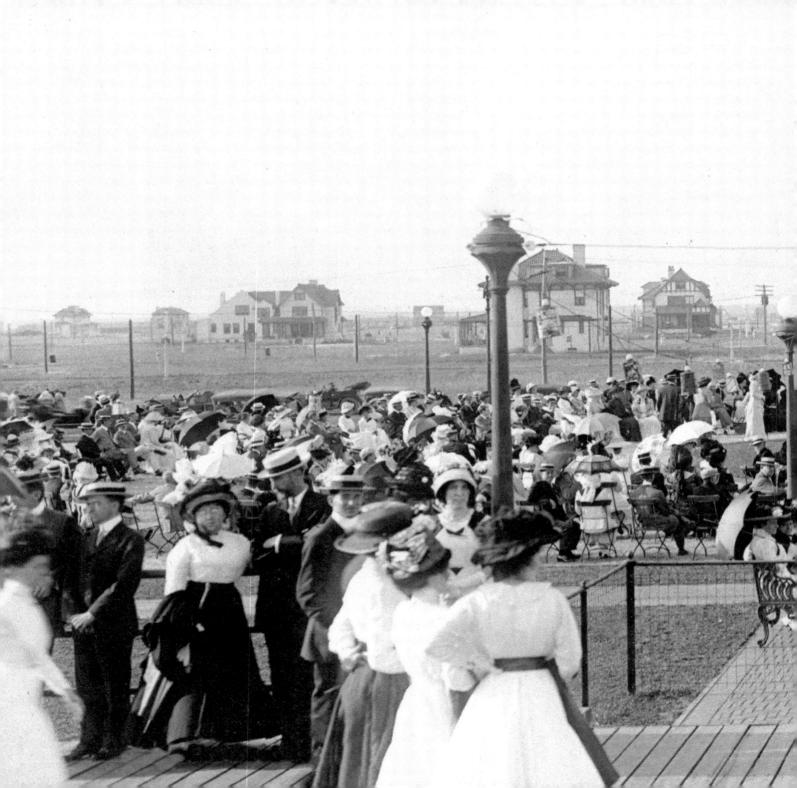

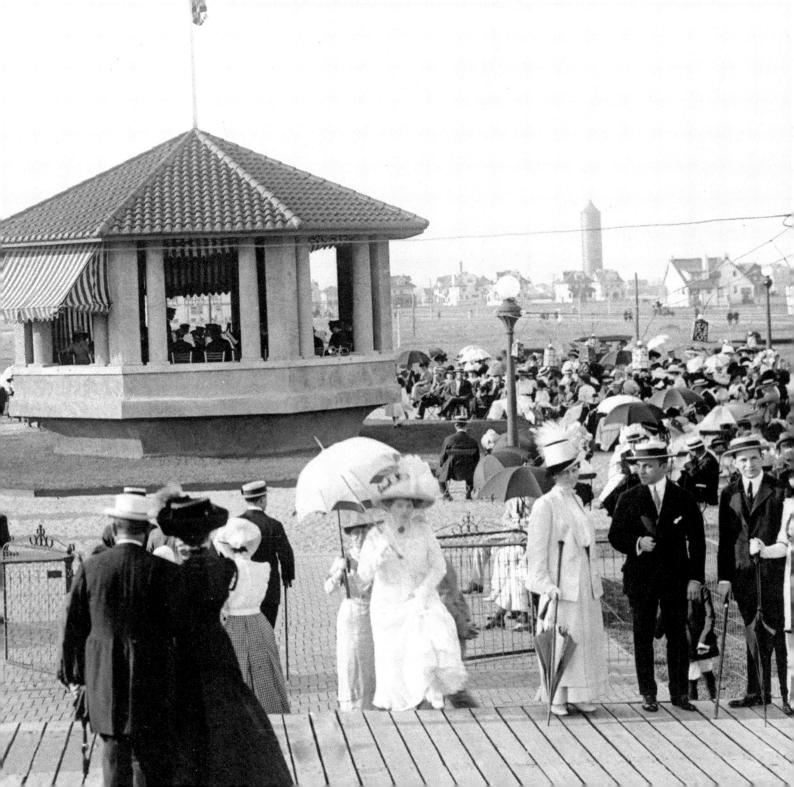

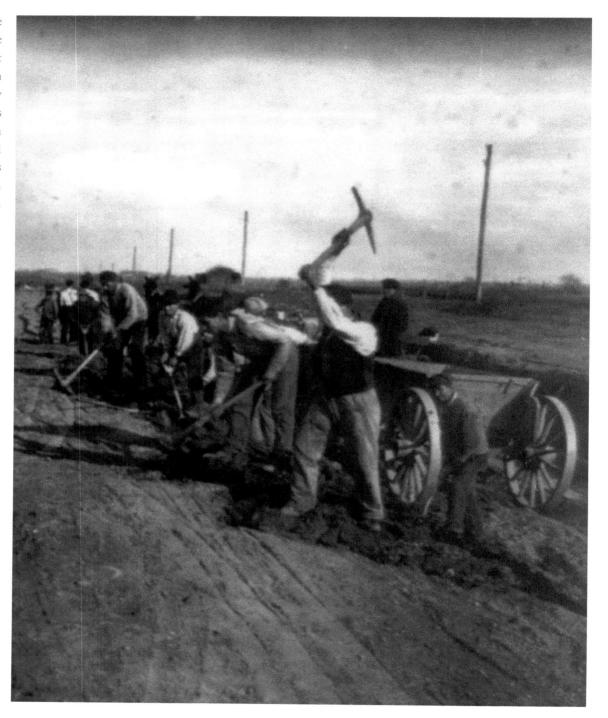

Laborers prepare the terrain for a future Garden City street around 1911. By then the area was already attracting aviators as well as drivers, and in 1911 the first official U.S. airmail flights took off from Garden City's Nassau Boulevard airfield.

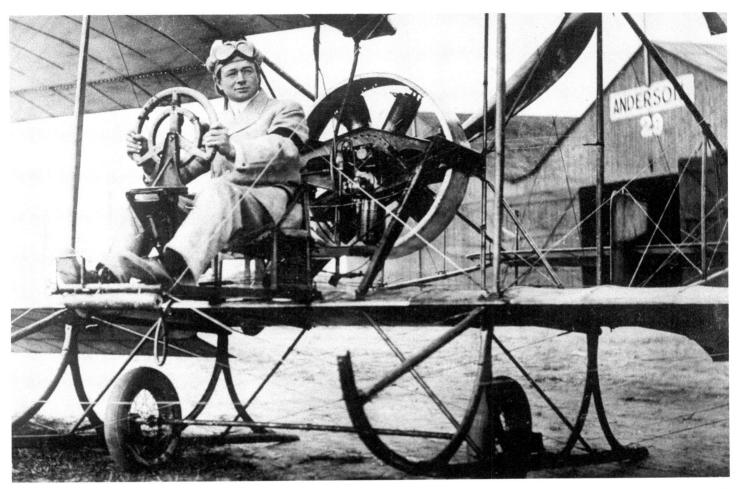

The first U.S. authorized airmail runs were made from Garden City to Mineola during an aviation meet in September 1911. The honor of serving as pilot for the first delivery was given to Paul Peck. Seated at the controls in his "gyro type" airplane, Peck is seen here in Mineola in 1911, almost certainly on or near the occasion of his historic flight.

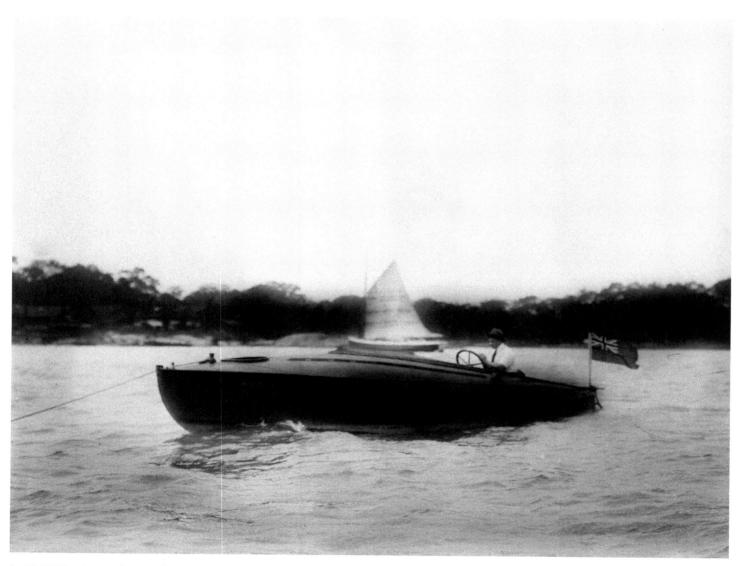

In 1912 Huntington hosted the Harmsworth Cup motor boat race, with contestants hoping to best the fastest time recorded in a U.S. race the previous year—40.4 miles per hour. England's Royal Motor Yacht club sent two boats, *Maple Leaf IV* and *Mona. Maple Leaf IV* carried home the trophy, but *Mona* broke an oil pipe and caught fire, the *New York Time*s reported, and failed to finish the race. The ailing *Mona* is seen here.

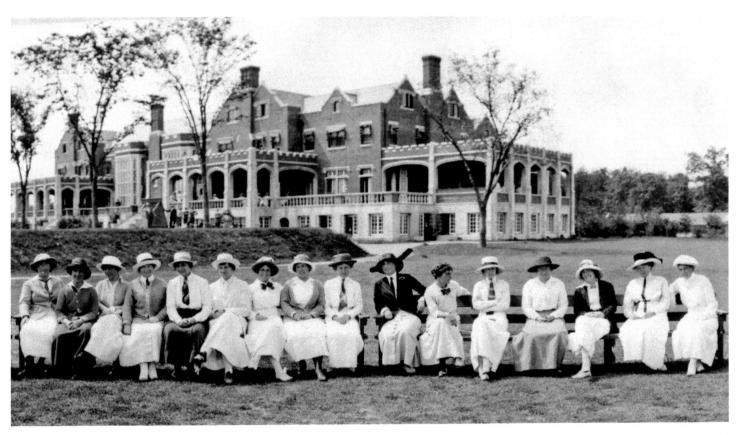

As a rule in the late 1800s, women couldn't play golf at private clubs on weekends and were not allowed to be full members. Signs would read "Gentlemen only, ladies forbidden." But that began to change, and the Nassau Country Club opened its course in 1899. Participants in the Women's Metropolitan Golf Championship at the Nassau Country Club pose here in 1913. Women who played the course through the years included Nona Barlow, Fanny C. Osgood, and Marion Hollins.

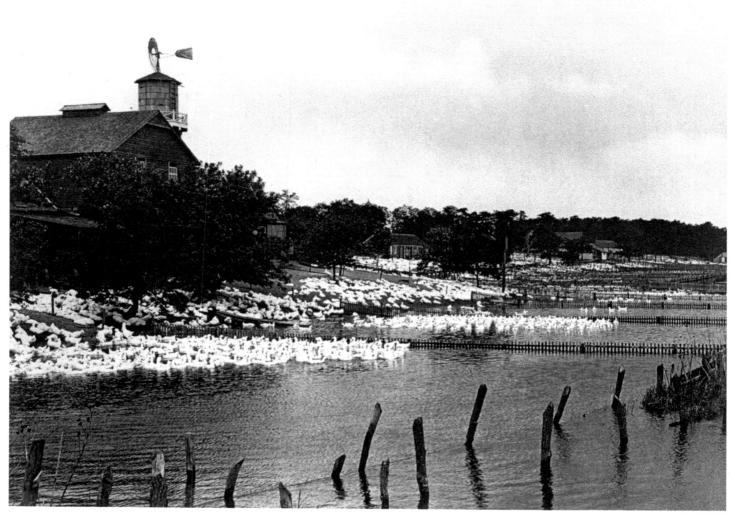

At this duck farm photographed in Speonk in 1914, rectangular pens separate the ducks on land and in the water. The vast enterprise includes barns, sheds, and a water tower.

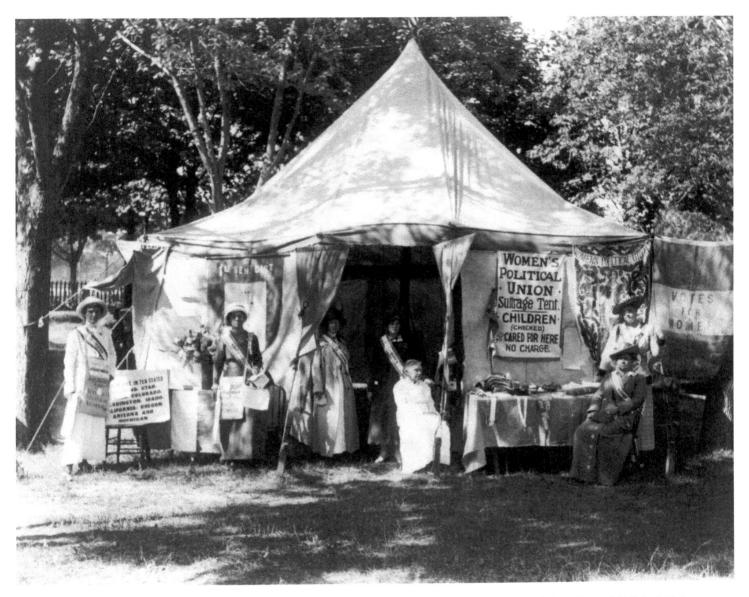

Harriet Stanton Blatch and Carrie Chapman Catt, leaders of the woman suffrage movement, occupied this Women's Political Union tent at the 1914 Suffolk County Fair. To collect signatures for a petition to put woman suffrage on the state ballot in 1915, they embarked on an Empire State tour that started with a summer tour of southern New York. Free child care was offered at the rallies.

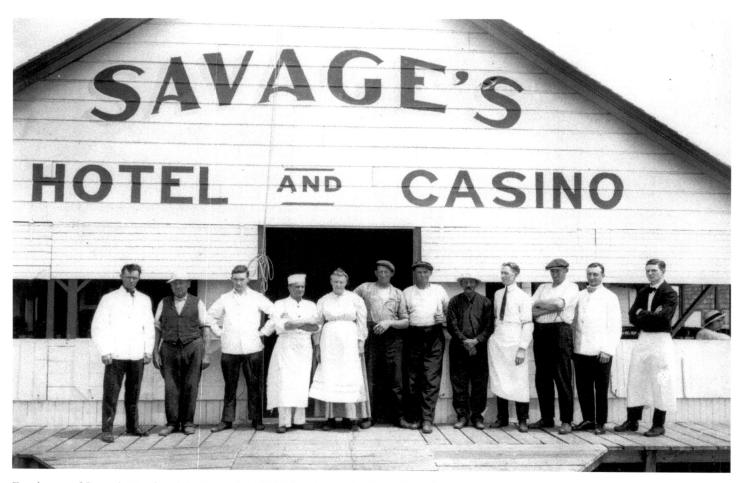

Employees of Savage's Hotel and Casino in High Hill Beach pose in 1915. Open from May to October, the hotel was a well-known establishment with a private beach, large dance hall, baseball field, and 40 rooms facing the ocean. Savage's also had a colony of bungalows and cottages for rent. With gaming offered in the casino, Savage's was considered a "sportsman's paradise."

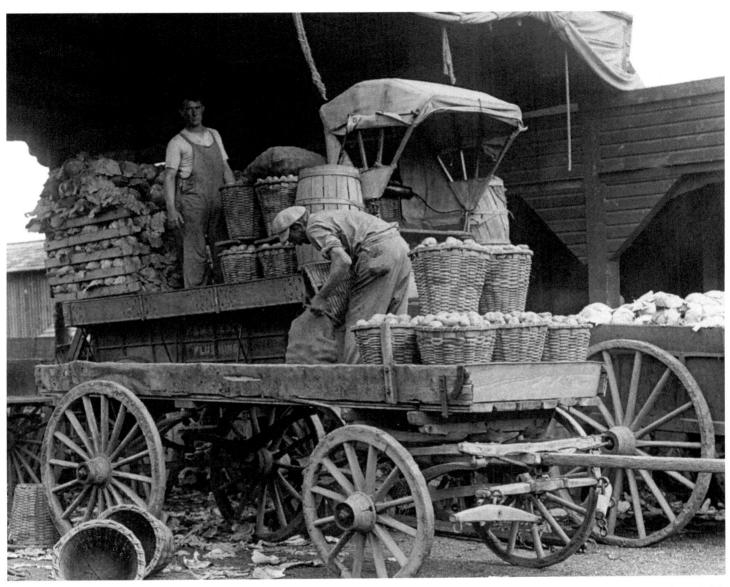

At a truck farm near Jamaica, Queens, two men ready a wagonload of potatoes and cabbages for transport and sale. In 1916 large fields were still producing harvests of crops to be brought to market and sold by the side of the road. Hard, honorable work could be found.

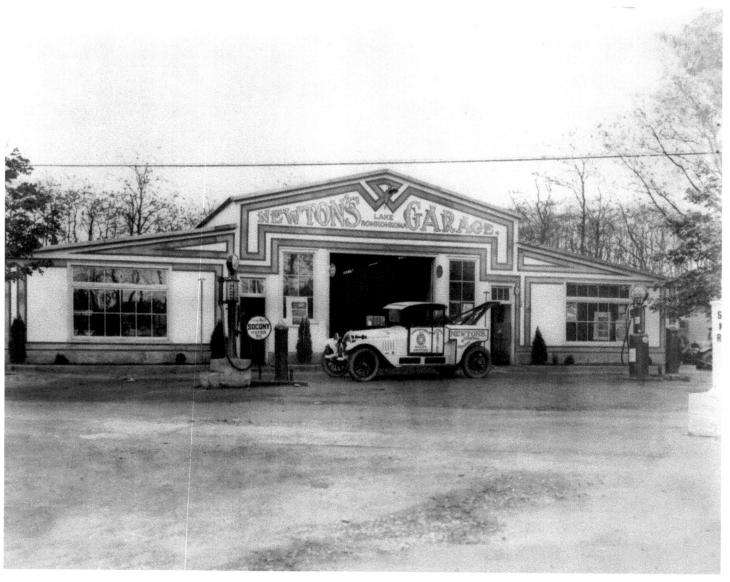

Newton's Garage at Rank Avenue and Portion Road in Lake Ronkonkoma, with its modern gas pumps and tow truck, serviced automobiles in this summer resort town. Ronkonkoma is Long Island's largest freshwater lake. According to popular legend, the lake, formed by a retreating glacier, is bottomless. After the turn of the century, fashionable lakefront dwellings began to dot the area.

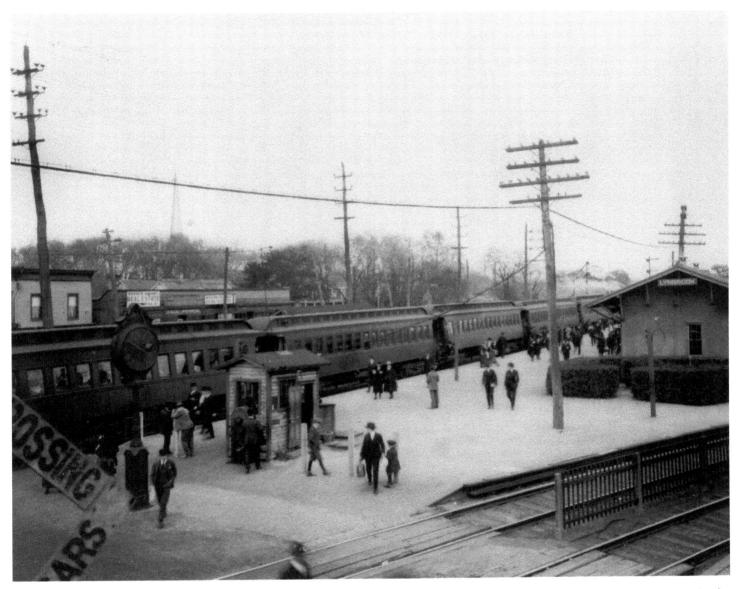

The Lynbrook station of the LIRR isn't quite bustling yet in this scene from around 1915. A fair number of people were commuting by then, but ridership would grow exponentially through the remainder of the century. Routes continued to be established throughout the Island with the final destination being New York City.

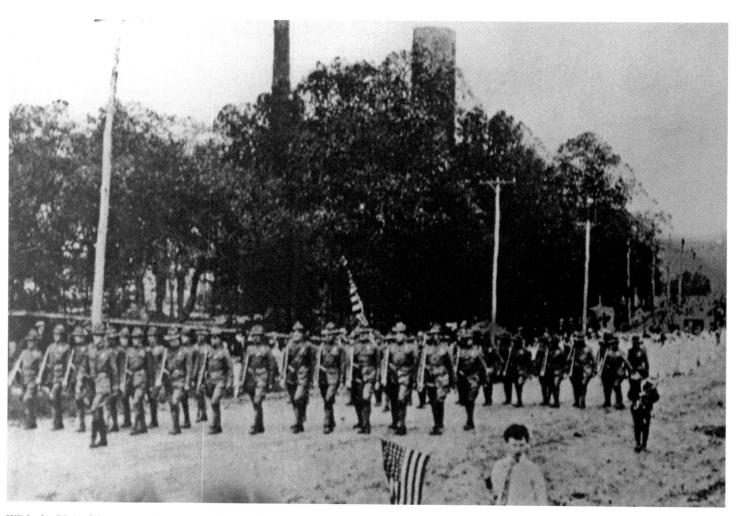

With the United States entering World War I in 1917, American towns and cities established volunteer Home Guard units. The entire force was 10,000 strong countrywide. In Freeport, the local unit was photographed drilling on Oliver Boulevard. Such demonstrations calmed fears of sabotage.

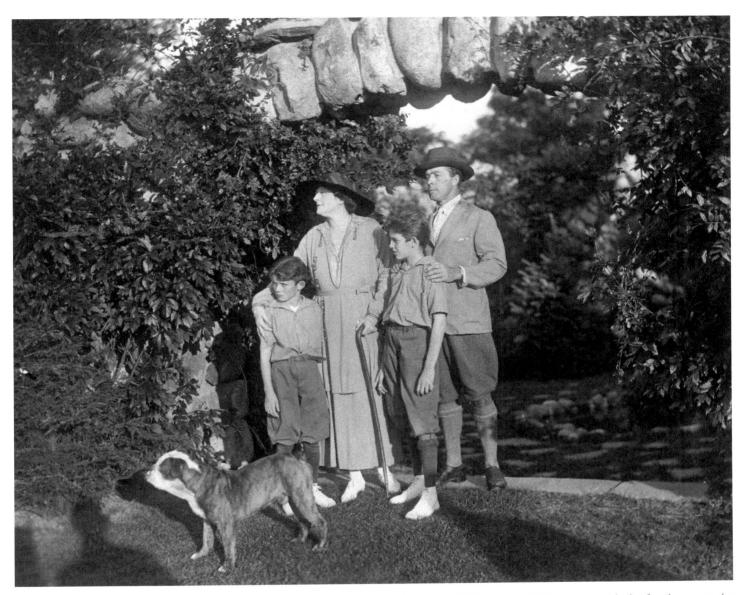

Broadway star William Faversham; his wife, actress Julie Opp; and their sons, William Jr. and Philip pose with the family pup at the entrance to Huntington's Rosemary Open Air Theatre. The theatrical family was on hand to help with a national pageant put on by the Red Cross on October 5, 1917, to raise funds for overseas victims of the war.

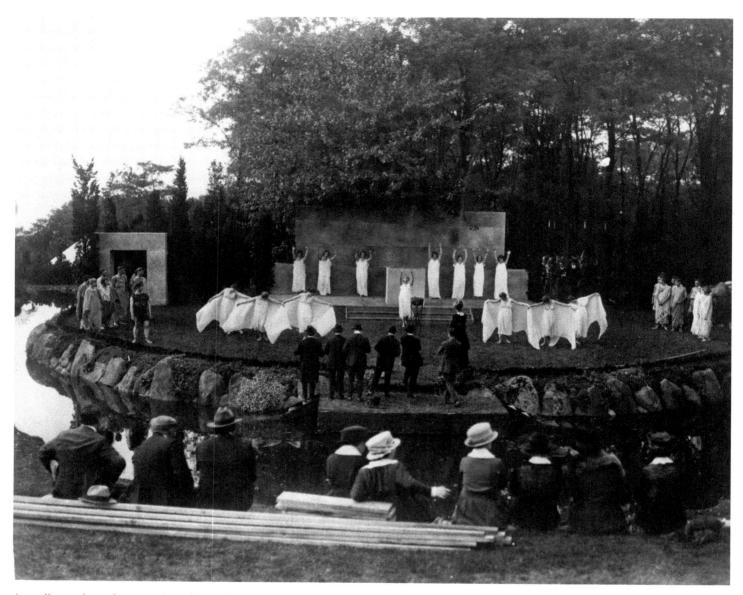

A small crowd watches morning rehearsal for the National Red Cross Pageant of October 5, 1917. Later that day, 5,000 people attended the show to see the likes of John and Ethel Barrymore, Clifton Webb, Tyrone Power, and even New York's famed Fighting 69th Division. The orchestra was hidden in the trees on the estate of financier Roland B. Conklin. The event raised \$50,000.

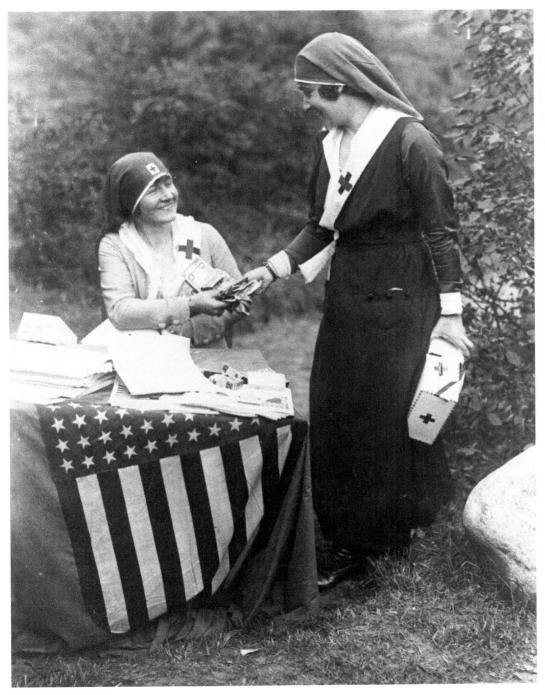

Actresses Frances Starr and Bijou Fernandez display a portion of the \$50,000 raised at the National Red Cross Pageant in Huntington. Both were well-known veterans of the theater, Fernandez having reportedly debuted onstage at the age of three.

Following Spread: A section of Camp Upton in Suffolk County, where 40,000 American soldiers trained during World War I, is seen in 1919. The Brookhaven National Laboratory now occupies the site.

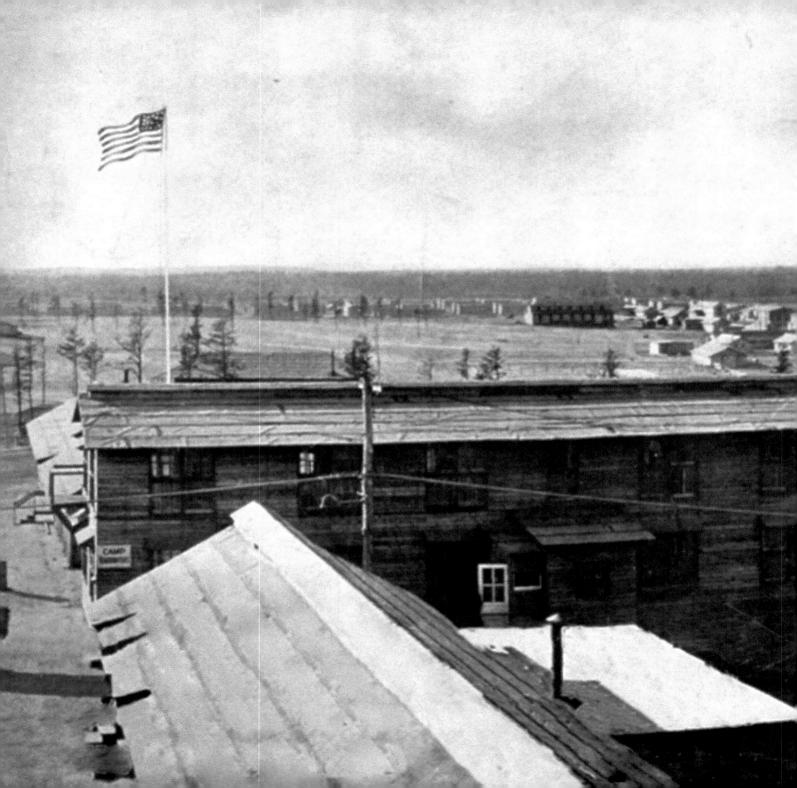

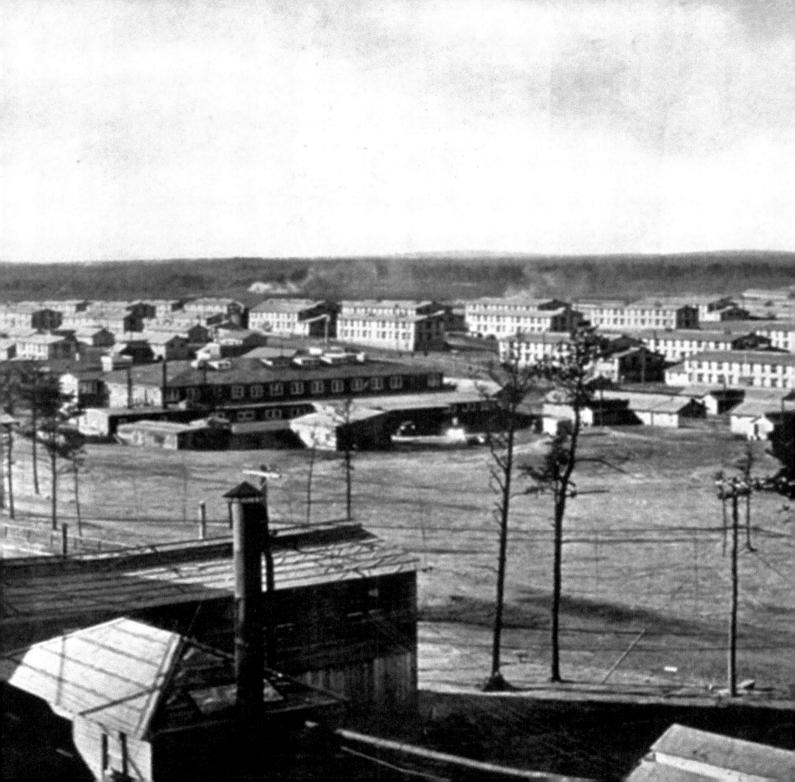

This 1918 photo shows the Bowne Homestead at Bowne Street and 37th Avenue in Flushing. John Bowne built the wood-frame English colonial saltbox structure in 1645. He raised the ire of Peter Stuyvesant by defying an edict to stop harboring Quakers. The house kept its air of defiance through the years, as it is said to have also been a station of the Underground Railroad during the era of slavery.

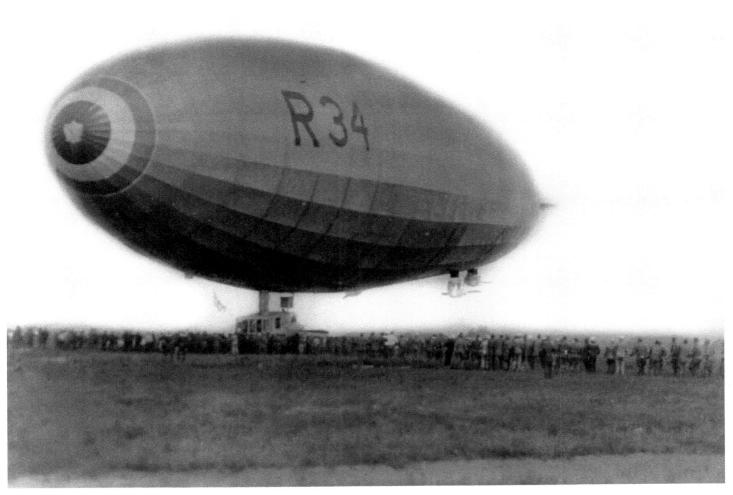

British dirigible R-34 is shown touching down in Mineola on July 6, 1919, after the first transatlantic crossing of an airship. The landing was a short stop for regassing, refueling, and reballasting since there were no hangars on the East Coast able to house the huge ship—it was 640 feet long, 79 feet wide, and 92 feet high. The R-34 had five motors and five cars that carried 30 people. Germany, negotiating the Versailles Treaty at the time, was upset with the publicity of the crossing.

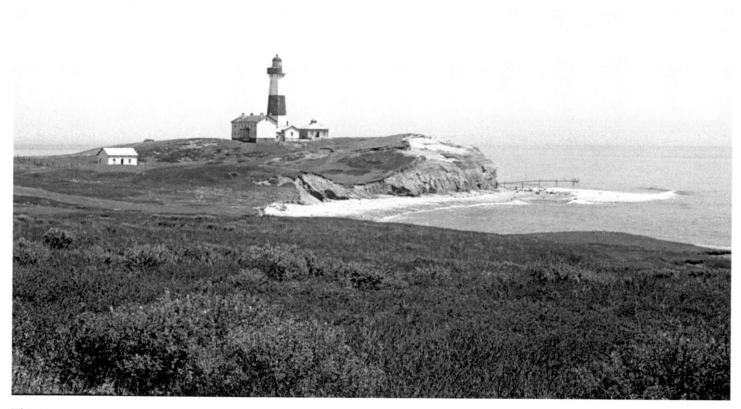

This picturesque 1919 view is of the famous Montauk Lighthouse at the tip of Long Island on the eastern shore. The first lighthouse in New York, it was authorized by Congress in 1792, during George Washington's administration, and constructed four years later. Still active today, the lighthouse stands where Block Island Sound meets the open Atlantic.

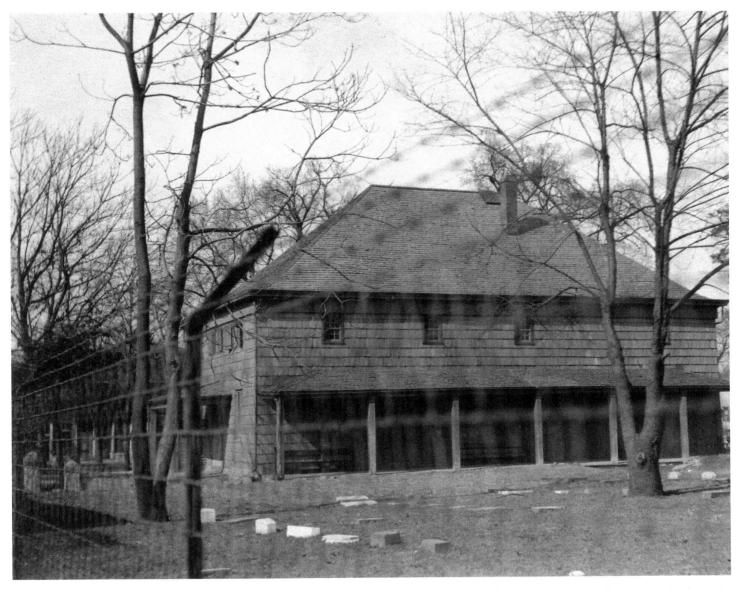

This is the Quaker Meeting House in Flushing in 1918. It was built in 1694 and is said to be the second-oldest Quaker meetinghouse in the nation. It was designated a Historic Landmark in 1967 and is still in use today.

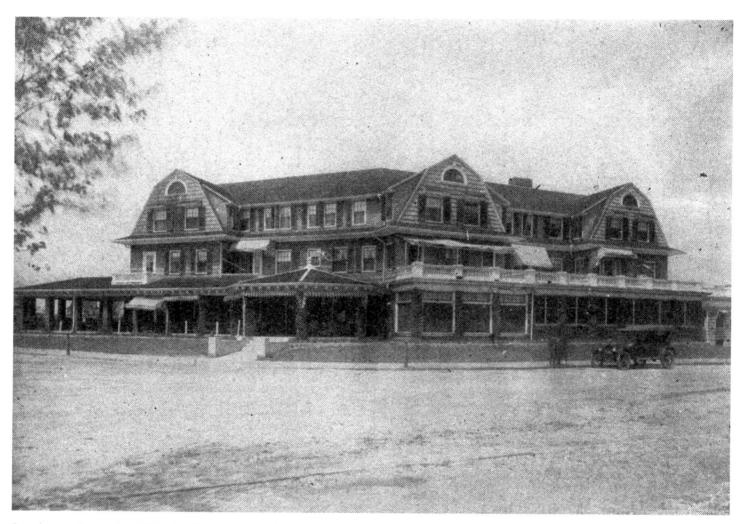

Seen here in September 1918, the Whittier Inn in the gated community of Sea Gate was popular for weddings and advertised "special fall rates." Frank P. Williams was the manager.

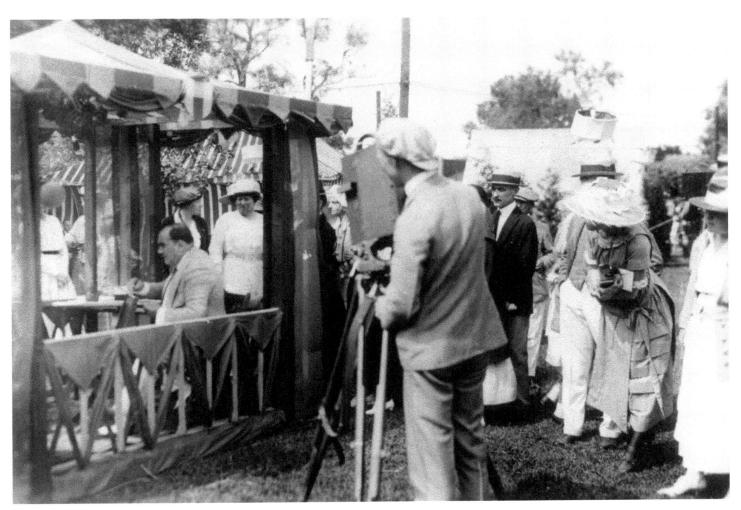

Renowned for his dramatic opera voice, Enrico Caruso, seated at left, is shown drawing sketches for people at a Southampton charity fair in August 1920. Caruso was a pioneer in the recording industry, promoting the phonograph and making recordings as early as 1902. His vocal accomplishments need no lavish descriptions; he is widely considered the greatest and most influential tenor of the twentieth century.

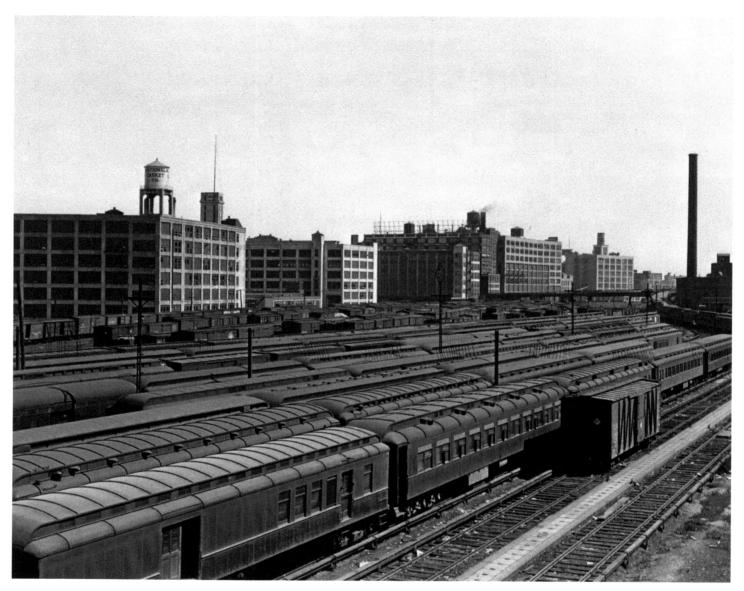

The number of trains and factories visible in this view of Long Island City suggests the area's commercial strength in 1922. Formed of four small communities in 1870, Long Island City became part of New York City in 1898 and grew by virtue of its advantageous location across the East River from Manhattan. The water tower at top-left advertises the National Casket Company.

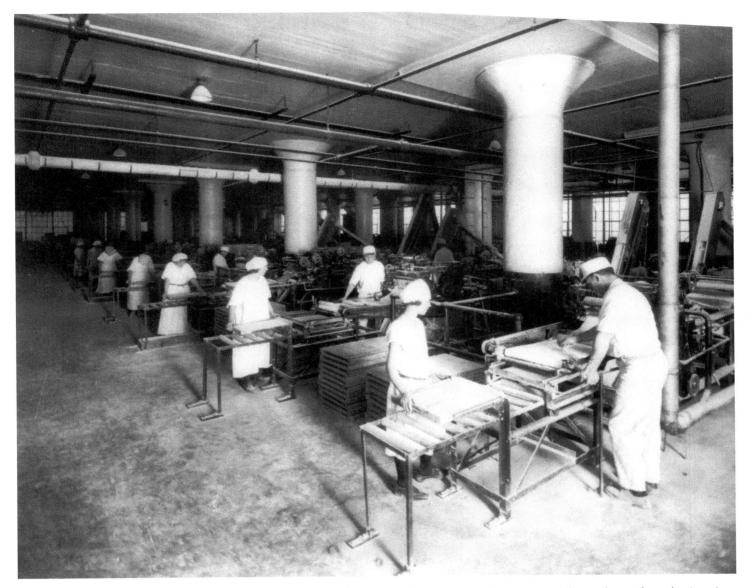

In 1899 William J. White and Dr. Edwin Beeman managed to get six other gum manufacturers to stick together to form the American Chicle Company. They had a plant in Manhattan but moved to Long Island City, where this photo was taken, in 1923. The firm imported gum from Central America to make such brands as Black Jack, Dentyne, and of course the familiar Chiclets. The Chicle Company was one of nearly 1,400 factories that solidified the area's economy.

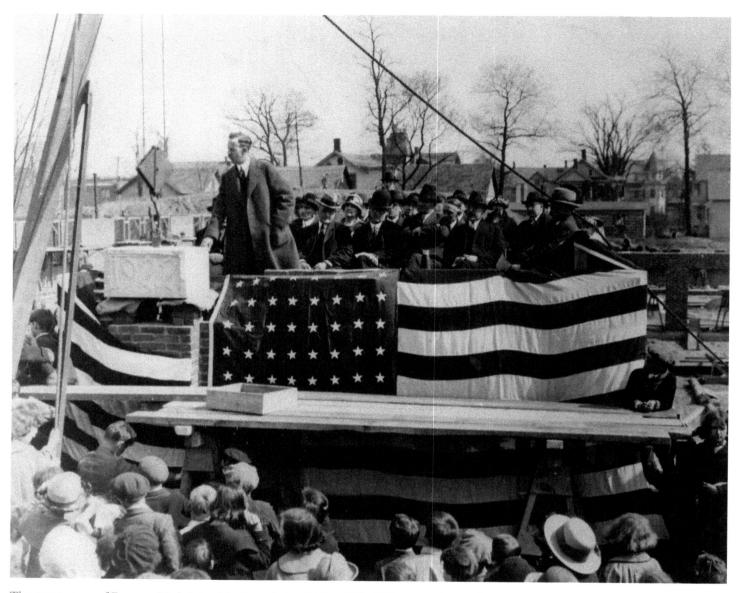

The cornerstone of Freeport High School is shown being laid in 1922. Village president Hilbert R. Johnson gave the keynote speech from the flag-draped dais as onlookers celebrated a symbol of community growth. Undoubtedly, many other politicians, educators, and town fathers spoke at the event.

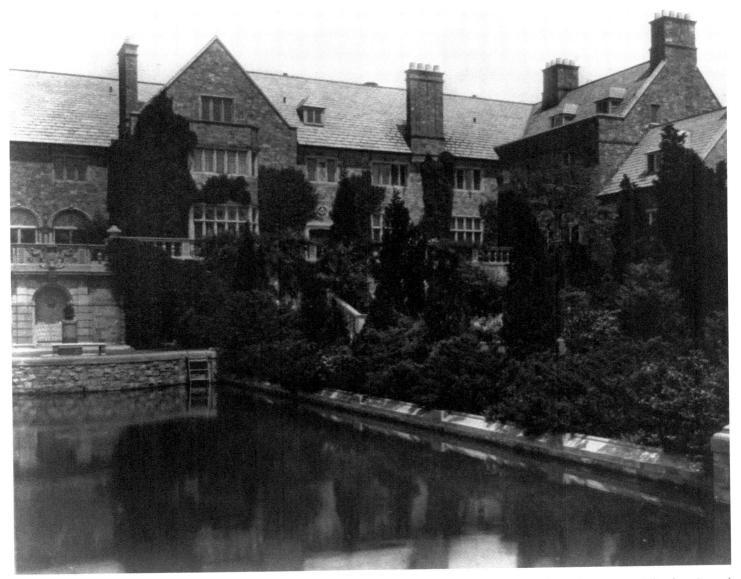

Welwyn, the 204-acre estate of Mr. and Mrs. Harold Irving Pratt, is shown here in an early 1920s photo. Pratt was a philanthropist and director of Standard Oil. His wife Harriet was appointed by Calvin Coolidge in 1925 to become the first presidential advisor on White House decor. Welwyn is now the home of the Holocaust Memorial and Educational Center of Nassau County.

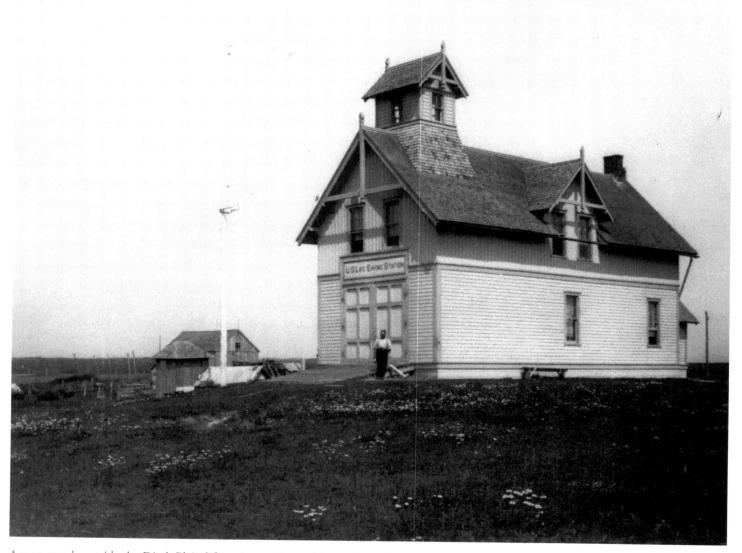

A man stands outside the Ditch Plain life-saving station at Montauk. Walter R. Jones, who owned a whaling fleet, established the Life Saving Benevolent Association of New York and constructed ten such stations, staffing them with volunteer crews to assist ships that foundered due to weather or accident. The stations were equipped with boats, wagons, rope, and an assortment of other life-saving gear.

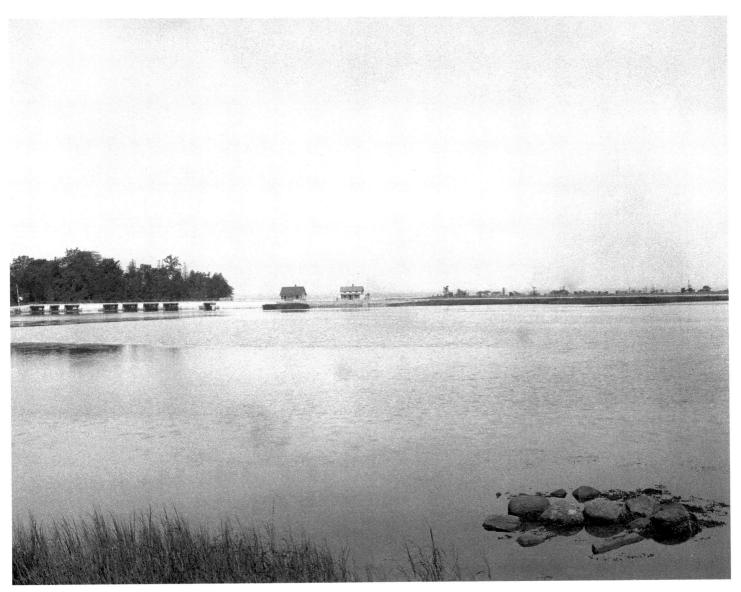

This view shows the Glen Cove experimental sea farm, established in 1922 as a component of the Bayville Bridge hatchery. Oysters were cultivated at Glen Cove under controlled conditions. The fishing and shellfish industries contributed significantly to Long Island's economy.

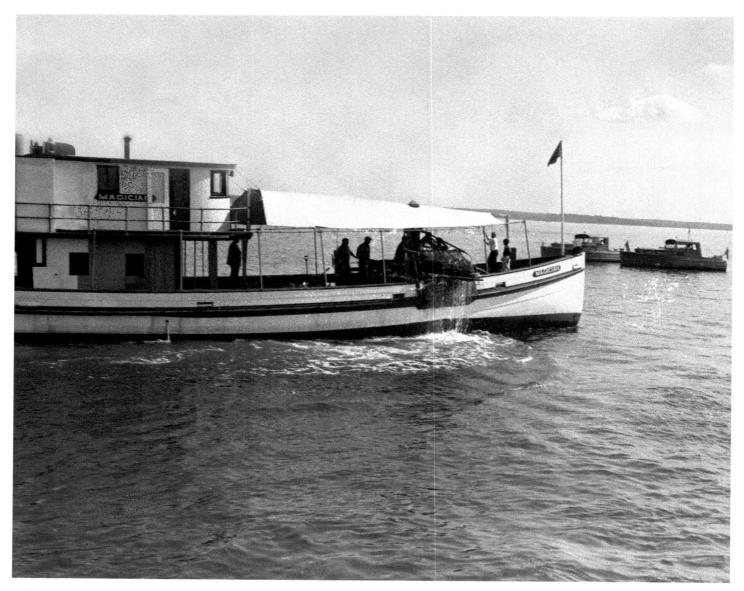

Sailors on the oyster dredger *Magician* haul aboard a day's catch around 1924. Such boats operated by dragging a dredge, a toothed bar with a bag attached, through an oyster bed. The near-pristine waters at the time gave up a bountiful catch on what was aptly named Oyster Bay.

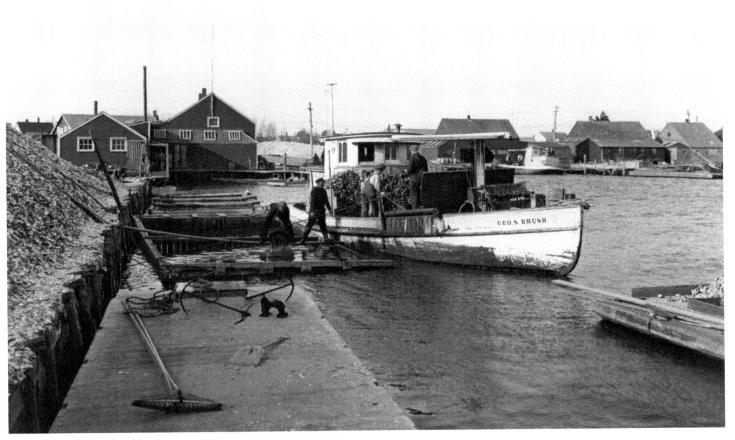

Crewmen unload a day's work from an oyster boat in Sayville. Floating docks were used to tie up the boats and transport the oysters to processing buildings. Oysters could be shipped whole to retail markets or processed. Shells would be ground and used for fertilizers; nothing was wasted.

Individuals could also make a living in the Long Island shellfish industry, as is evidenced by this 1924 photo of William Stevens, who carries the proud title of "oysterman." He has his boat and his tongs and has arrived at the Bayville hatchery with the day's catch.

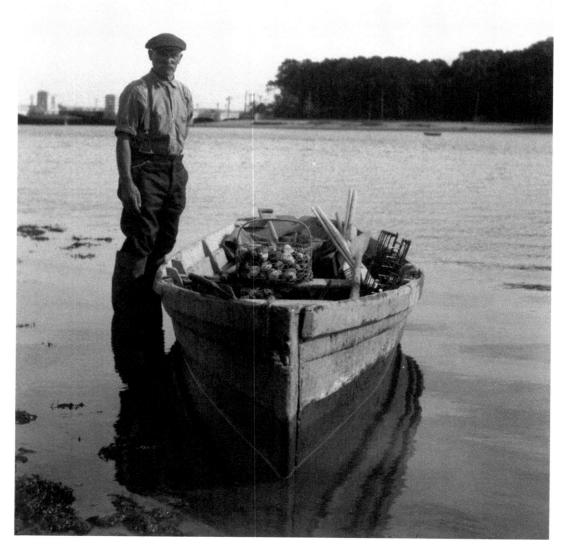

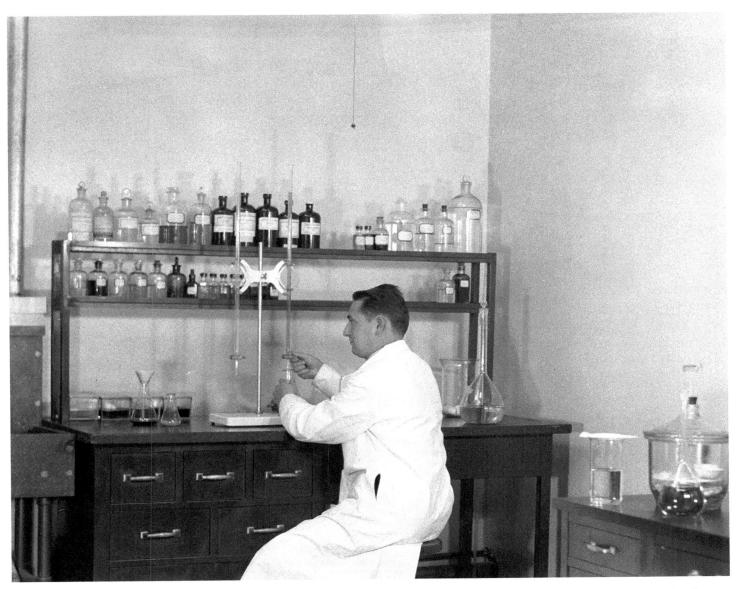

A scientist conducts research at the Bayville Bridge experimental shellfish hatchery around 1926. When established in 1922, the hatchery hoped to improve techniques for producing seed oysters on a large scale. The seed oysters would be planted in the beds to replace those harvested.

Jimmy Walker, mayor of New York City, was among the thousands waiting at Mitchel Field on Long Island for the arrival of the Bremen flyers who completed the first east-towest crossing of the Atlantic in 1928. Herman Koehl, James Fitzmaurice, and Baron Ehrenfreid Guenther von Huenefeld were forced down on Greenly Island near Newfoundland. Their landing on a frozen pond caused damage to the plane, delaying their arrival on Long Island. Aviator Bernt Balchen led the rescue effort. From left to right are mayoral aide Charles Kerrigan, Mayor Walker, Captain Bender, and Grover Whelan.

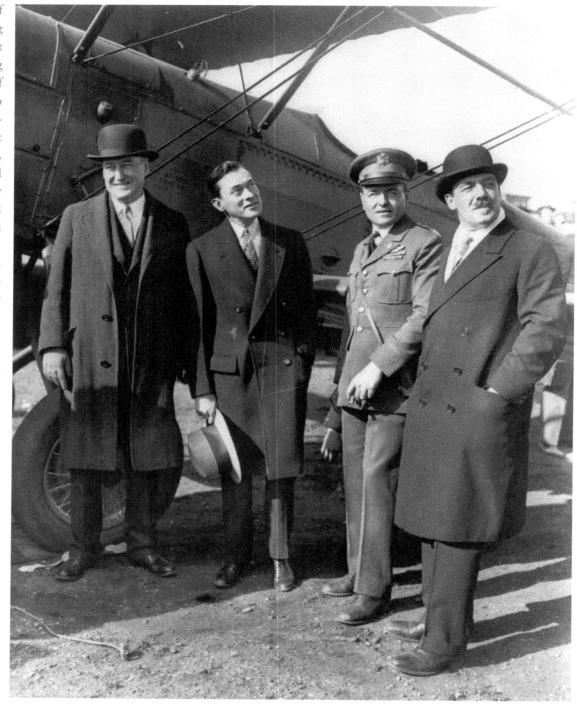

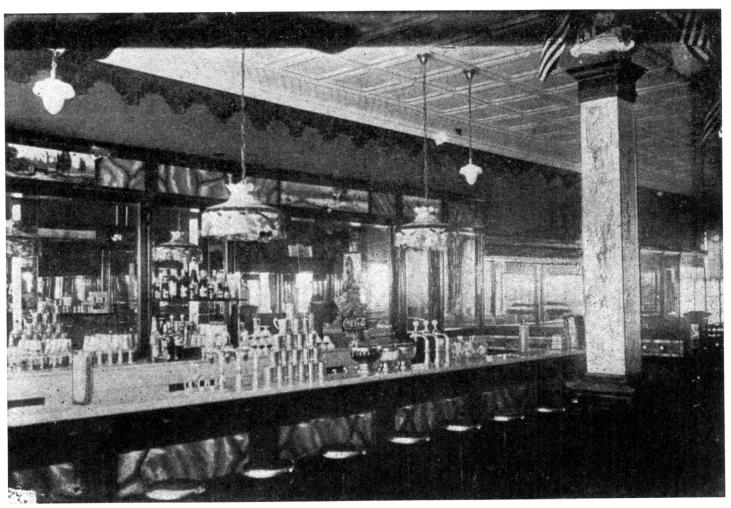

The Olympia Ice Cream Parlor was located at 32 Ocean Avenue in Patchogue. The parlor served the "best quality confections" and "pure and refreshing drinks," most likely to bathers just off the hot beaches. This 1920s view shows the beautiful decor, including Tiffany-style lamps. Cups are neatly stacked and stools are shiny, waiting for the first customer.

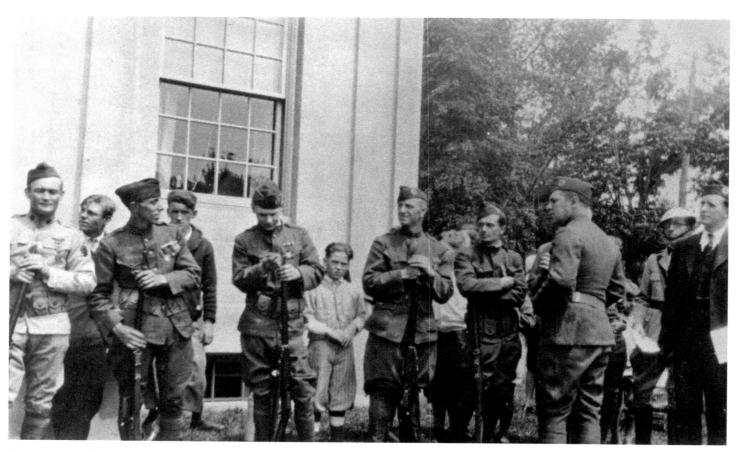

Veterans and soldiers from the American Legion Post 342, Freeport, gather outside the Freeport Memorial Library in 1928. Four years before, the library had been designated the first war memorial library in the state of New York. A plaque was later dedicated honoring those from Freeport who died in the Civil War, the Spanish-American War, and World War I. The places where the battles were fought were also inscribed.

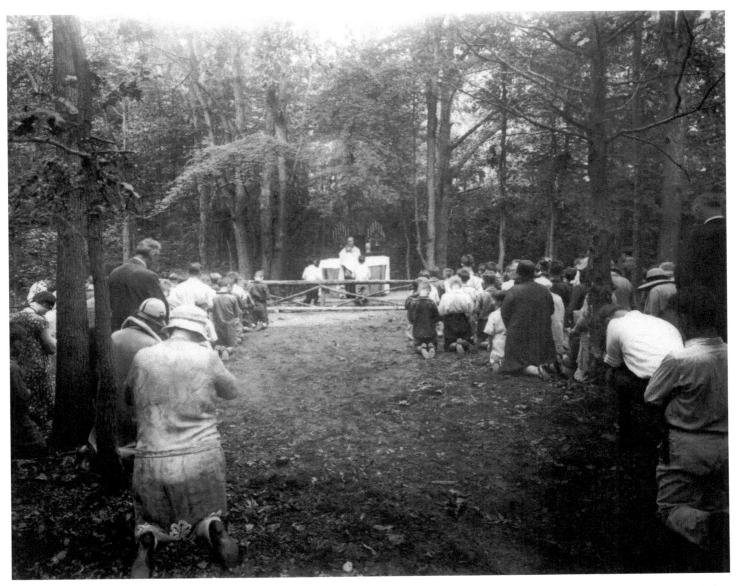

Father Thomas E. Molloy was archbishop of Brooklyn for 35 years. Among his many accomplishments was the founding of a Catholic sponsored camp named after him and located in Mattituck. Catholic Youth Organizations, or CYOs, would attend Camp Molloy for summer fun. Spiritual needs were ministered to as well, as is shown here in this 1928 photo of a benediction.

Planting Fields, so named by the Matinecock Indians because of its fertile soil, became the location of the home of William Robertson Coe and his wife Mai. Coe loved the area, and after he deeded the 400-acre property to the state, it became Planting Fields Arboretum State Historic Park. It is home to hundreds of trees such as juniper, pine, and spruce, as well as orchids, poinsettia, hydrangea, and azaleas. This photo of the Oyster Bay estate was taken in the mid-1920s.

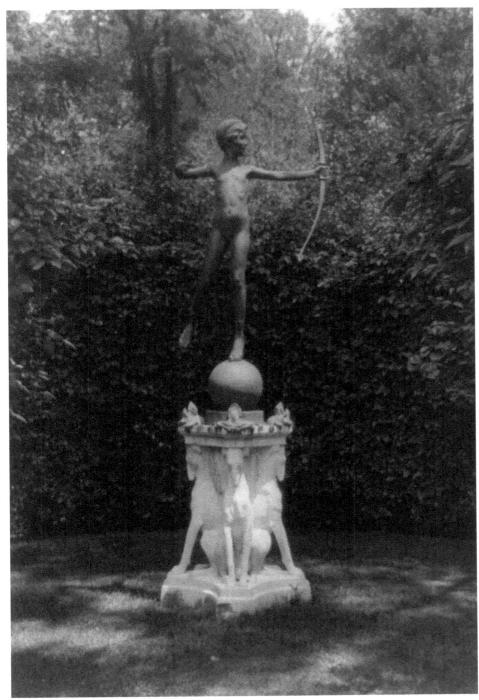

This statue of Diana, Roman goddess of the hunt, stood on the Pratt estate grounds in Glen Cove. The prolific photographer Frances Benjamin Johnston captured this image and numerous others collected here.

Long Island is relatively flat, and blowing winds could power windmills like this one at Hayground. Windmills served as gathering places for farmers while they had their grain ground. The fantail design dates this windmill to the early 1800s. Seen here in 1930, it had lately served as a tearoom and as an artist's studio. It was moved to East Hampton in 1950 and placed on the National Register of Historic Places in 1978. The south fork of Long Island has the greatest number of surviving windmills in America.

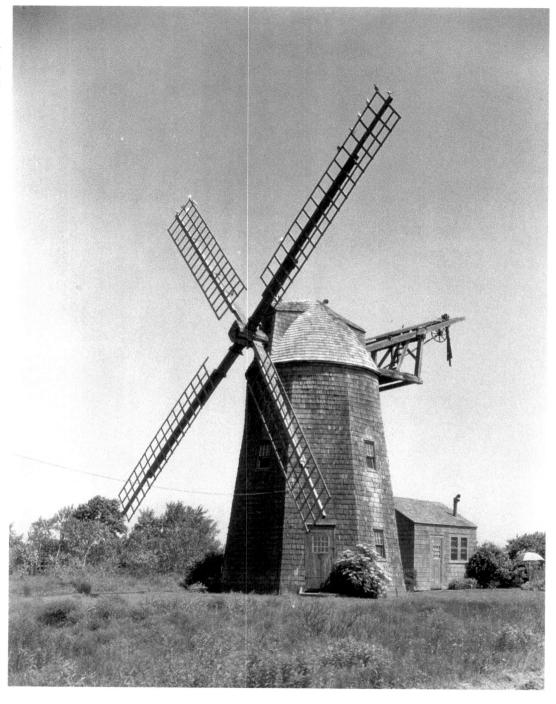

This is a 1920s photo of the Jericho home of Elias Hicks and his wife Jemima. Born in 1748, Hicks was a Quaker who opposed the evangelicalism of his sect and formed a splinter group who came to be known as "Hicksites." An abolitionist, he published *Observations on the Slavery of the Africans and Their Descendants* in 1811. The book was influential in leading to the adoption of a state act freeing slaves after 1827. Some had been freed after a similar act in 1799.

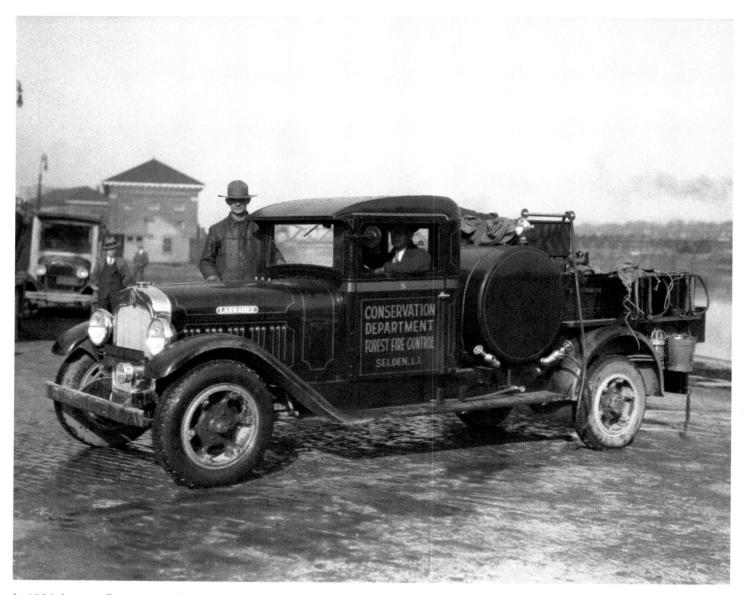

In 1924 the state Conservation Department provided Long Island with its first truck for fighting forest fires. Not yet fully developed, Long Island had large amounts of forest. Fire could be devastating because of winds coming off the ocean. Fire towers were also built to observe over large distances. These men were photographed with a Conservation Department forest fire truck in 1930.

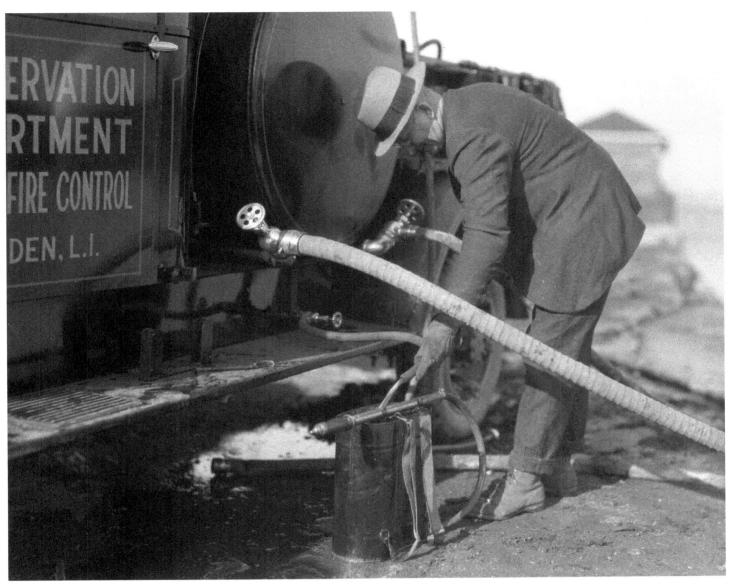

A man probably affiliated with the Conservation Department uses water from a department truck to fill the tank of a fire extinguisher to be worn on one's back. There were two primary fire seasons on the Island. The spring season was from March 1 to May 31. The summer season was from June 1 to September 15.

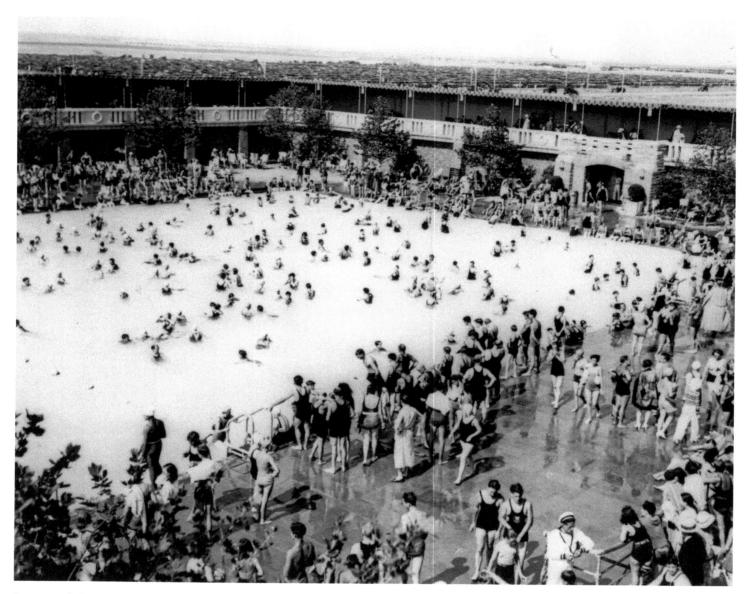

Jones Beach State Park opened in 1929 with fanfare and speeches from Al Smith, Robert Moses, and Franklin Roosevelt. A bathhouse with the pool seen here followed in July 1931, when this photo was taken. The state park was one means to protect the beautiful beaches of the Island, to keep them for the enjoyment of local residents as well as the thousands of visitors that still flock to the area year after year.

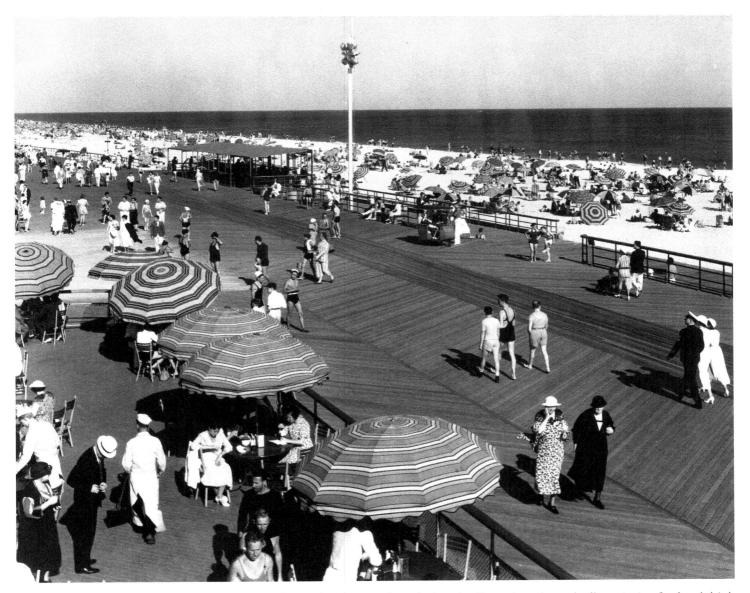

At Jones Beach in July 1934, people enjoy the beach, take a stroll on the boardwalk, or sit under umbrellas enjoying food and drink on what appears to be a glorious summer day.

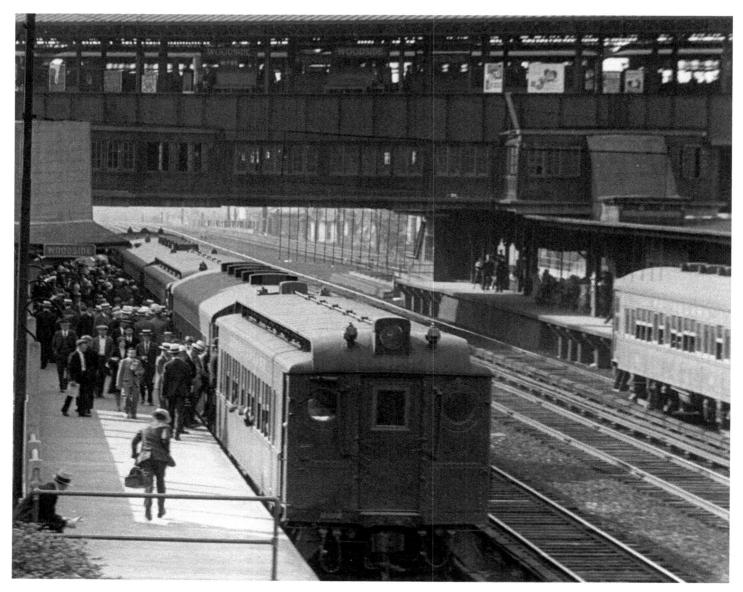

A crowd of commuters, nearly all men, board a train at Woodside in 1934. Most were probably among the estimated three million workers who made the daily journey to Manhattan that year.

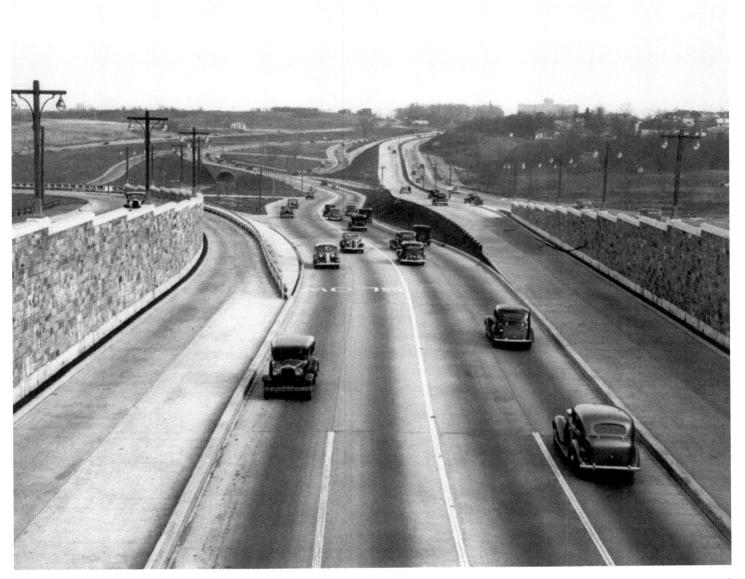

This relatively placid highway view in 1936 shows the junction of the Interborough Parkway, Grand Central Parkway Extension, and Grand Central Parkway. Confused? Try driving it today. The Interborough (now the Jackie Robinson Parkway) reaches from New York City into Nassau County. The Grand Central emerges from deeper in the city, allowing easier access to Island residents, and the extension was a widening and improving of existing roads.

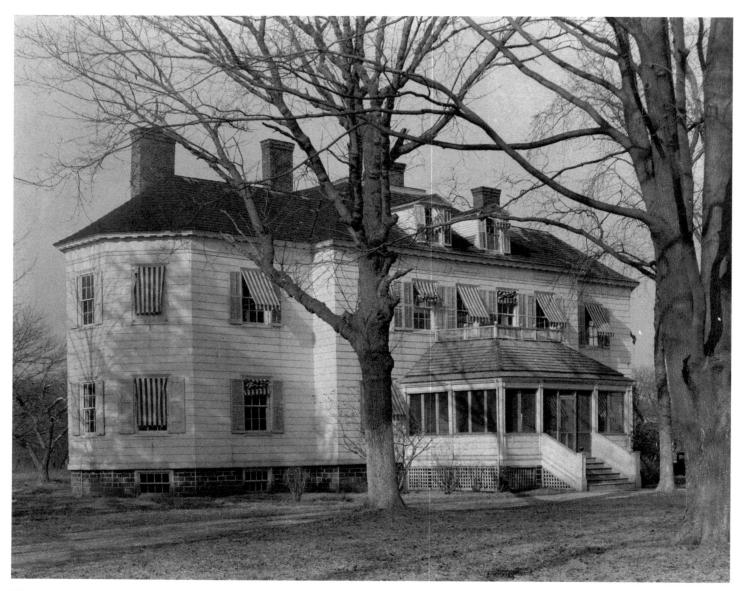

Thomas and Freelove Jones lived in Massapequa in the 1700s and became prosperous. Jones Beach takes their family name. In 1770 son David built a house at the head of Massa Creek that was the first "mansion" in the area. Originally called Tyron Hall, it later became known as Fort Neck House and is seen here in the early 1930s. Unfortunately, the house burned later that decade.

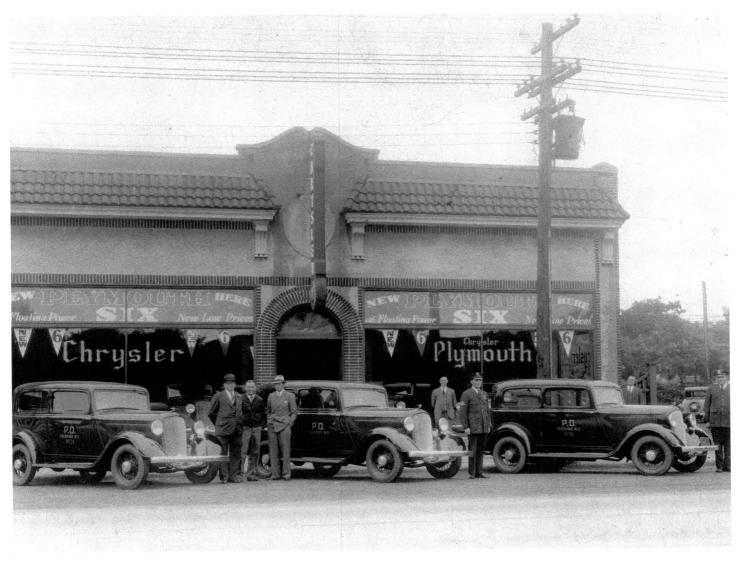

Outside a Chrysler-Plymouth dealership in Freeport, three brand-new police cruisers sit ready to be manned by uniformed personnel and detectives. The Freeport Police Department was established in 1893.

Wildwood State Park in Riverhead, Suffolk County, provided fun for the entire family in 1936 as it does now. The park begins on a high bluff overlooking Long Island Sound, and its 600 acres include campsites, beach access, and hiking and biking trails.

The Conklins were among the first English settlers to arrive in what became Amagansett in Suffolk County. This Main Street house, built around 1700, belonged to Ananias Conklin.

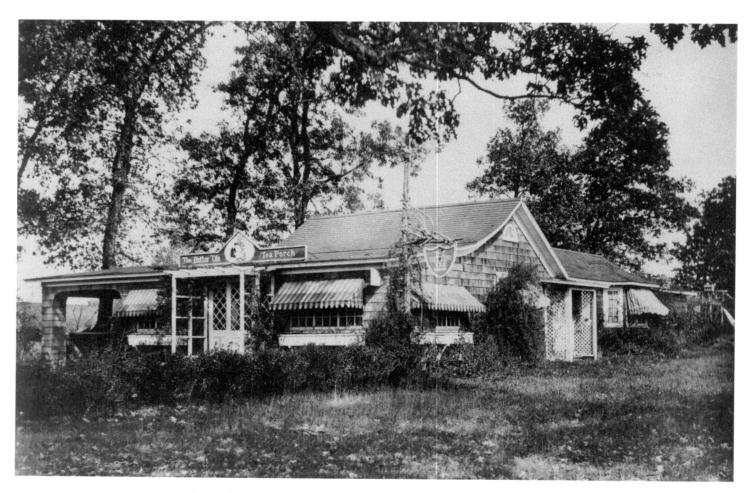

Located in the Town of Brookhaven, the Better 'Ole Tea Porch looked like it had perhaps seen better days by the time this photograph was taken.

Dating to the early years of the nineteenth century, the First Congregational Church on Middle Country Road in what is now Lake Grove, near Centereach, was chosen to be the image to appear on the Lake Grove official seal.

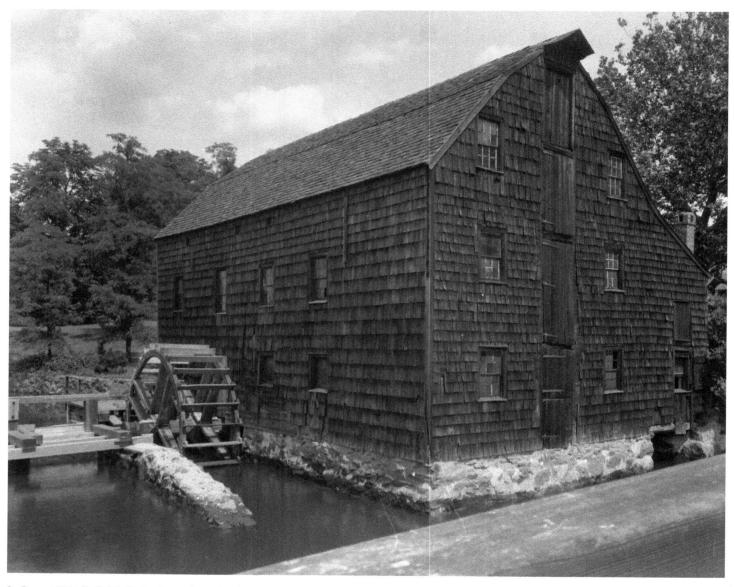

In June 1937, E. P. McFarland, working for the Historic American Buildings Survey, photographed the Eldridge Mill at Great Neck. A federal project inaugurated in 1933, the survey and its affiliated programs have documented more than 38,000 sites and structures.

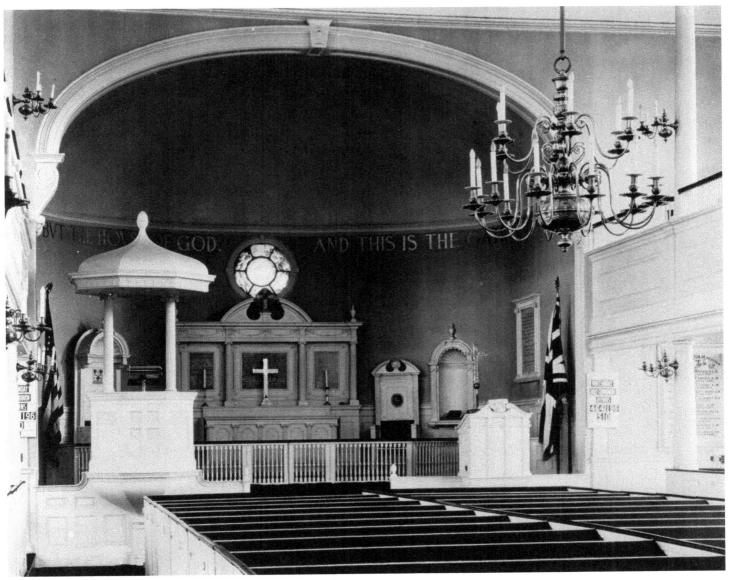

With origins dating to well before the Revolutionary War (and loyalist leanings during the war), St. George's Episcopal Church in Hempstead is among Long Island's oldest congregations. Located at 319 Front Street, the current church, seen here, was built in 1822 and is listed on the National Register of Historic Places.

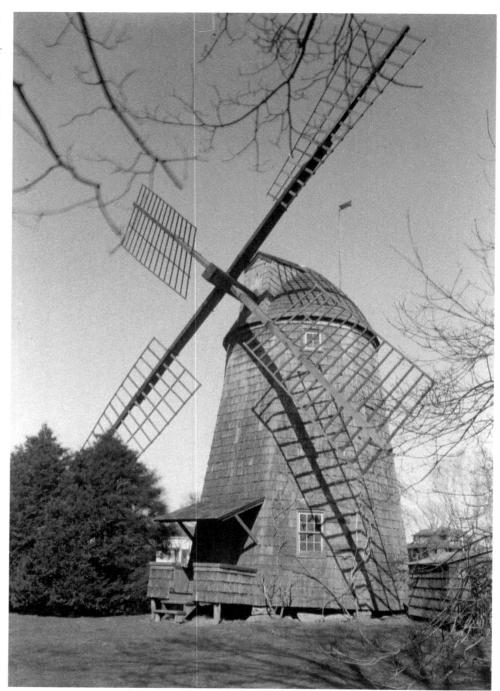

The Pantigo Mill, built in 1804 on Mill
Hill in East Hampton, was moved twice,
the last time in 1917 to the house of
Gustav Buek. The Buek residence had
an earlier and better-known occupant in
John Howard Payne, composer of the song
"Home Sweet Home," for which the house
has since been named. It was converted to
a museum in 1928.

WORLD WAR II AND POSTWAR PROSPERITY

(1940 - 1960s)

World War II transformed Long Island, and like the rest of the country, the Island did its share to support the war effort. Grumman turned out warplanes such as the TBF Avenger, which future president George H. W. Bush flew into combat. Women entered the workforce as never before, and many stayed after the war. When the soldiers came back, they wanted real peace and quiet. Long Island was a good place to settle, and the population boomed. Levittown became a model community for this new kind of lifestyle.

Major firms such as Grumman, Fairchild Camera and Instrument, and Sperry Rand Corporation all constructed factories on Long Island and produced many innovations in their respective fields. A few became instrumental in developing systems for NASA initiatives such as the Apollo Project, which landed a man on the moon. The affluence of New York City came to the suburbs in the form of major department stores such as Macy's that would come to be known as "anchor stores" for a new destination called the mall. Use of the once vaunted railroad system declined somewhat as more highways, with names like Wantagh Parkway, Southern State Parkway, and Long Island Expressway (which on most days could drop the Express part), were constructed or upgraded. The architect of this traffic system was Robert Moses, whose disdain for mass transit eventually tarnished his reputation as master builder.

Long Island has become known as an excellent place to live. Nassau is the tenth-wealthiest county in the nation. Quality of life based on community togetherness has become a staple, and tourism has increased. The once rich potato fields now share space with grapes for a developing wine industry. The North Fork in Suffolk County is known for fishing, the South Fork for golf, boating, and surfing. The tip of the Island at Montauk can be a mystical place of solitude.

While thousands of people continue to drive their cars, the LIRR has made a comeback. It is the busiest commuter system in North America, transporting nearly 300,000 commuters every day. Hustle and bustle is the norm to Long Islanders. It could be the economy, weather, or political turmoil besetting them, but the people roll with the punches. What the Shinnecock Indians, the entrepreneurial Dutch, the stern Puritans, and the European immigrants brought with them to Long Island remains ingrained in those who call it home.

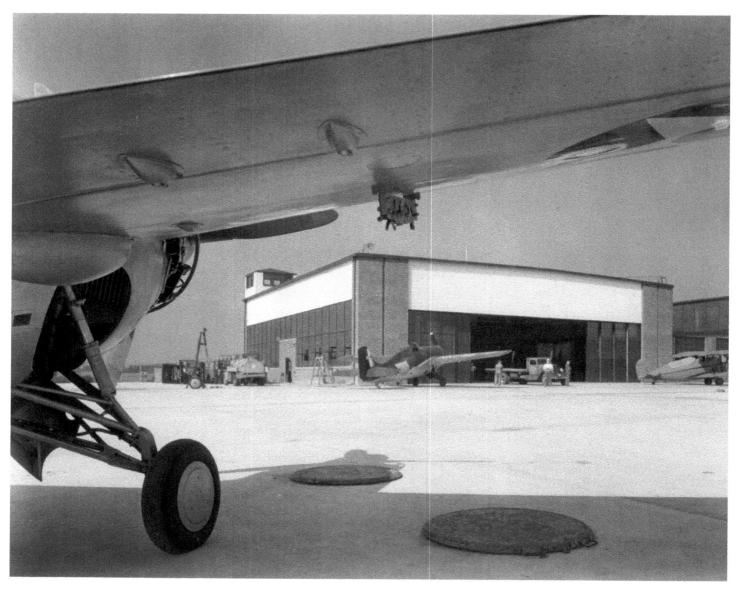

Grumman Aeronautical Engineering Company was a major airplane manufacturer founded in Baldwin in 1930 but located in Bethpage by the time of this 1940 photo. In its early years the firm built and tested commercial aircraft, but with the threat of war mounting, it shifted focus to the military. At center, near the hangar, can be seen one of its most famous aircraft, the F4F Wildcat fighter. Grumman, which later became Northrop Grumman, maintained a presence in Bethpage for many years after the war.

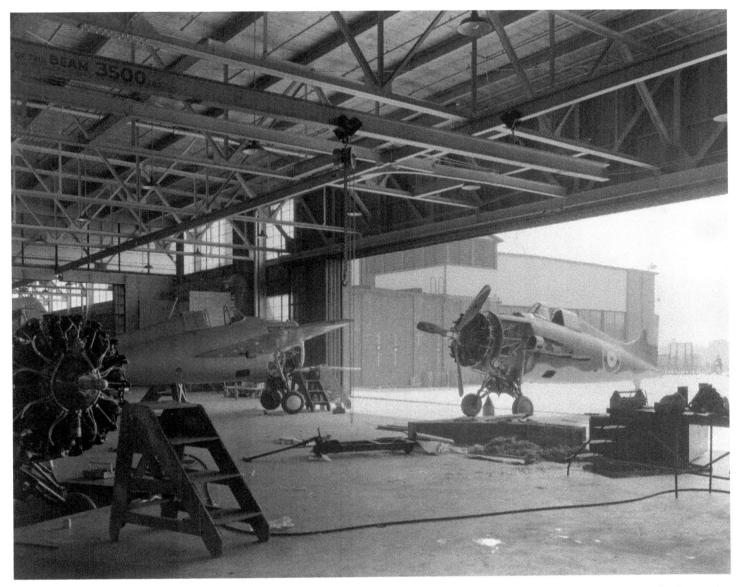

An interior shot of a Grumman hangar shows airplanes in various stages of assembly. At right a motor is mounted on a fuselage and is waiting for wings, at center a fighter is nearly completed, and at left a motor is resting on a hoist. In 1944 Grumman brought out the F6F Hellcat, one of the most highly effective of the World War II fighters.

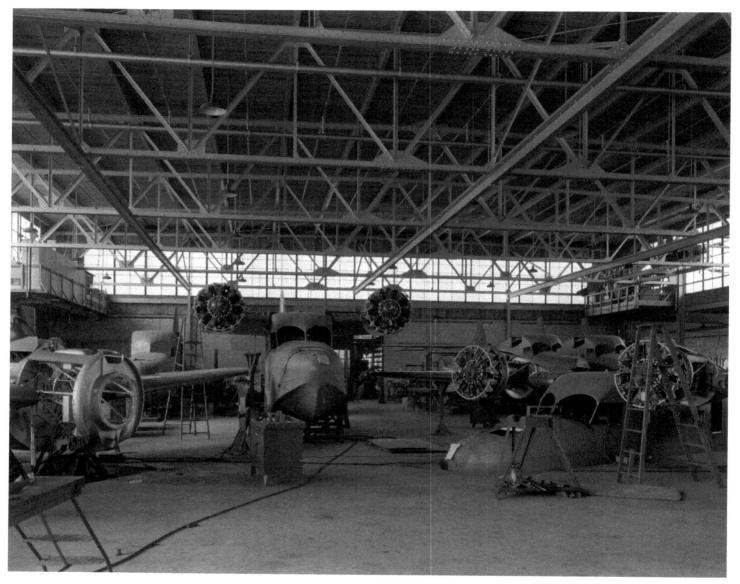

This interior shot of a Grumman hangar shows the full assembly operation. These aircraft are most likely of the JRF "flying boat" model used for coastal defense and submarine patrol. The photo was taken in October of 1940, more than a year before U.S. entry into World War II, and some of the aircraft were undoubtedly built to be sold. But even at this early date, war preparation was under way.

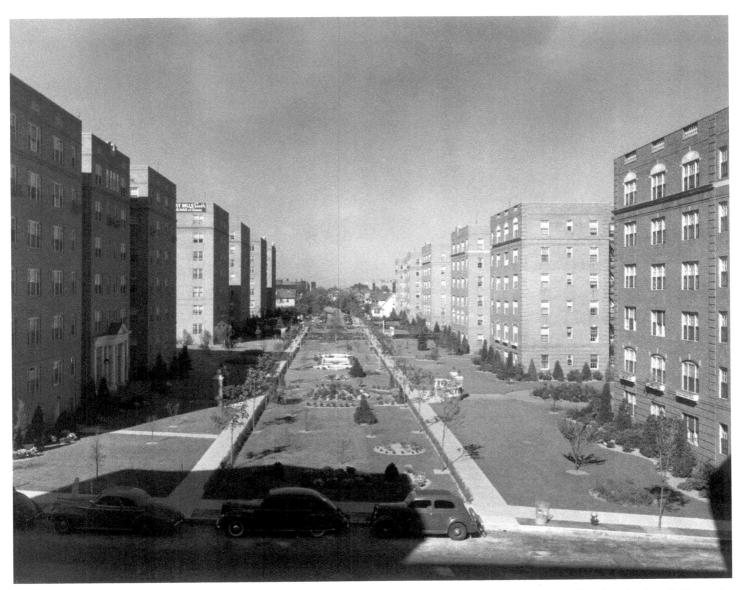

New York City maintained its population even though many families moved to Long Island. Because of the abundant land available on the Island, various industries expanded there and workers and their families followed. To keep up with the demand for living space, apartment complexes like this one photographed in Forest Hills in 1941 began sprouting in many towns.

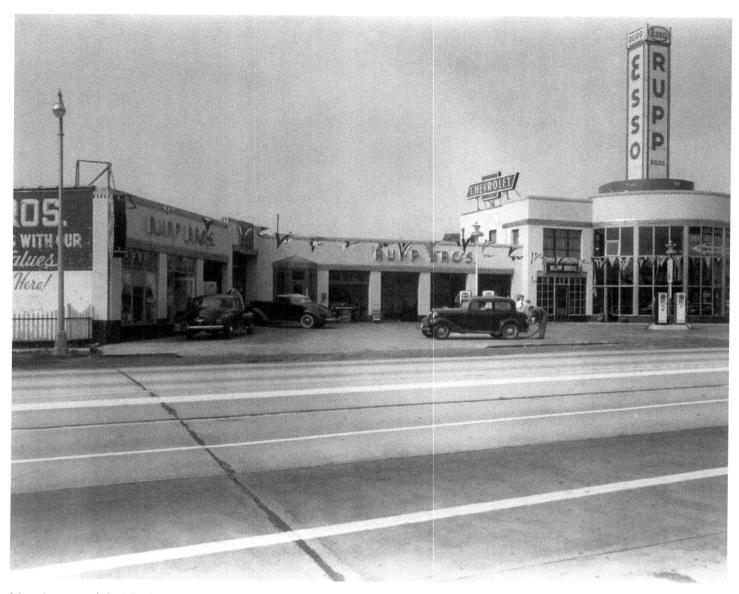

Motoring around the Island was essential, whether for work or play. Though rail travel was well established, America's love of the automobile was growing as the Depression eased and more people could afford one. Rupp Brothers service center in Lynbrook, sporting the Esso brand, has plenty of bays to cater to the public in June 1941—whether to fill her up, rotate the tires, or change the oil.

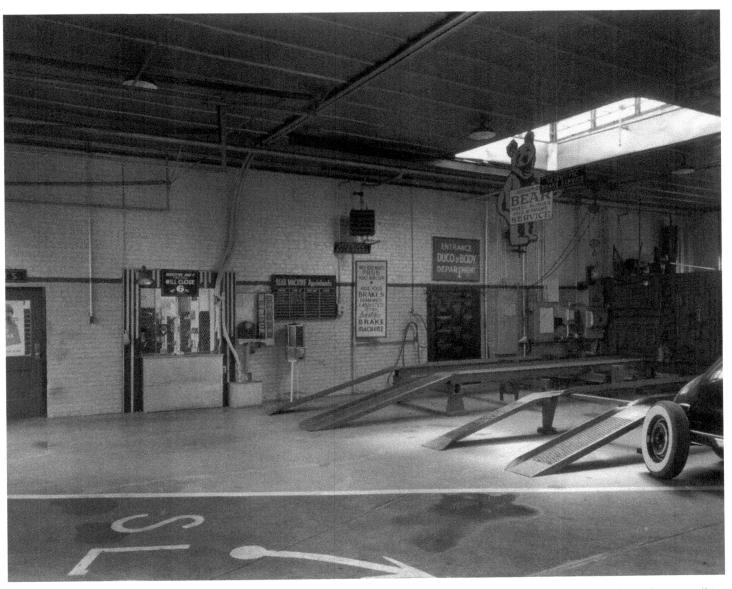

At Rupp Brothers Garage in Lynbrook, the parts department is at the rear, and two racks sit empty, waiting for a jalopy to roll in.

The bear sign found in countless garages across America hangs near the skylight.

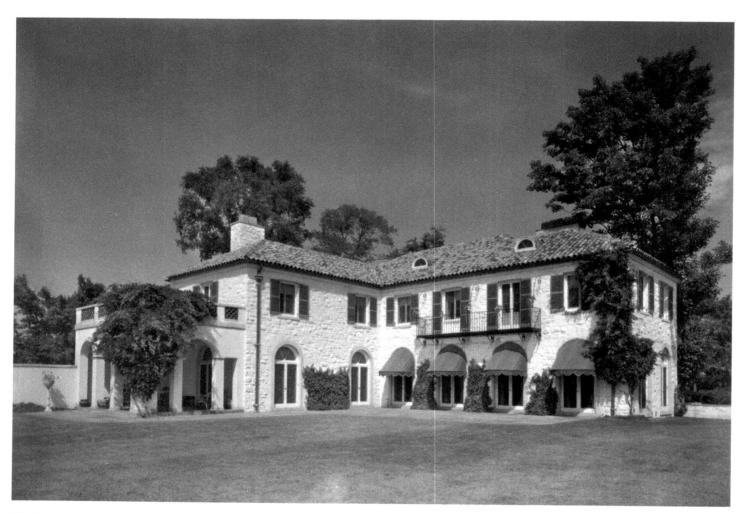

The home of Sarah D. Gardiner on Main Street in East Hampton is seen in 1942. The Gardiner family has roots on the east end of Long Island dating back to 1639 when Lion Gardiner purchased a 3,300-acre island in what would become Gardiner's Bay. The island has remained in family hands into the twenty-first century. It is legend that pirate William Kidd left some booty buried beneath its shores.

If walls could talk—this is broadcast pioneer William S. Paley's library at his house in Manhasset in 1942. Paley built the CBS radio and television empire, including the network news division he developed with correspondent Edward R. Murrow, whom he met in London during World War II. Paley had the genius to combine news broadcasting and advertising. Perhaps some of his planning took place here?

Mitchel Field received its name in 1918 to honor a former mayor of New York City, John Mitchel, who died while training for aerial combat in World War I. The field made significant contributions to aviation in the period 1918-1941. World War II made it more important. Here, troops are "dry firing" Thompson machine guns before advancing to the next stage of training, firing them on a range with live ammunition.

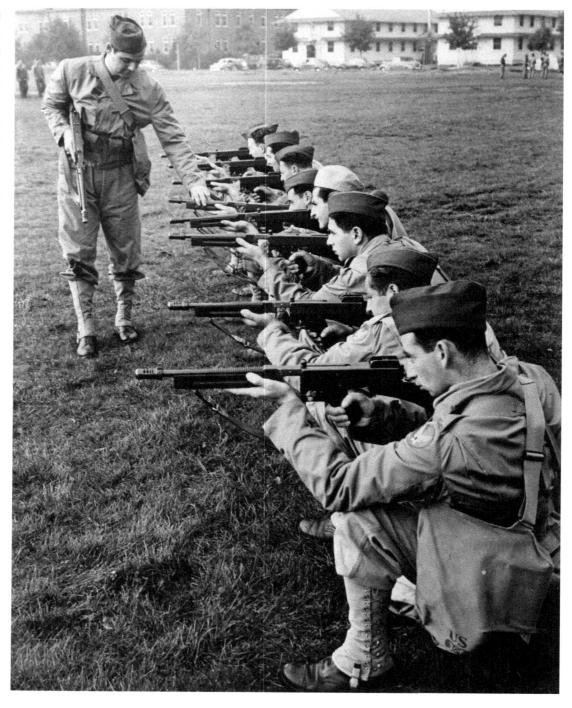

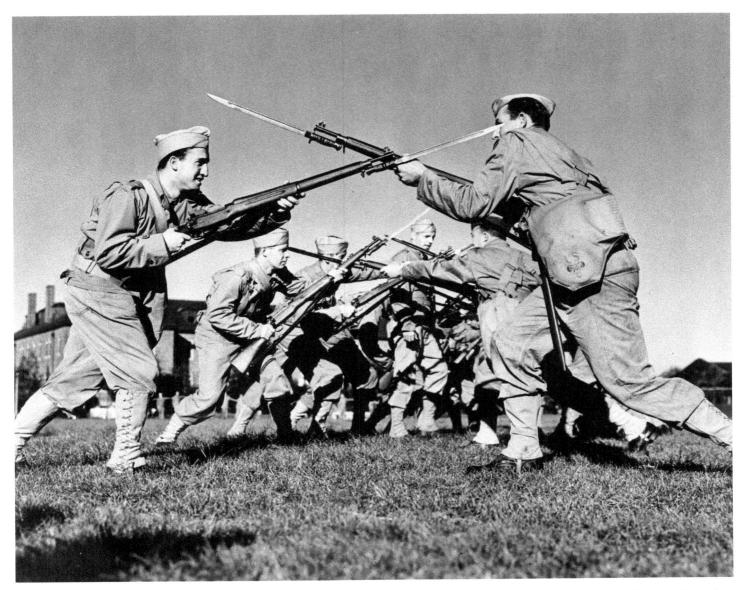

The troops at Mitchel Field were not ground infantry, but technicians for the air squadrons. However, this didn't mean they weren't combat ready. Here men sharpen their bayonet skills under the eyes of Captain Clifford W. Vedder (center).

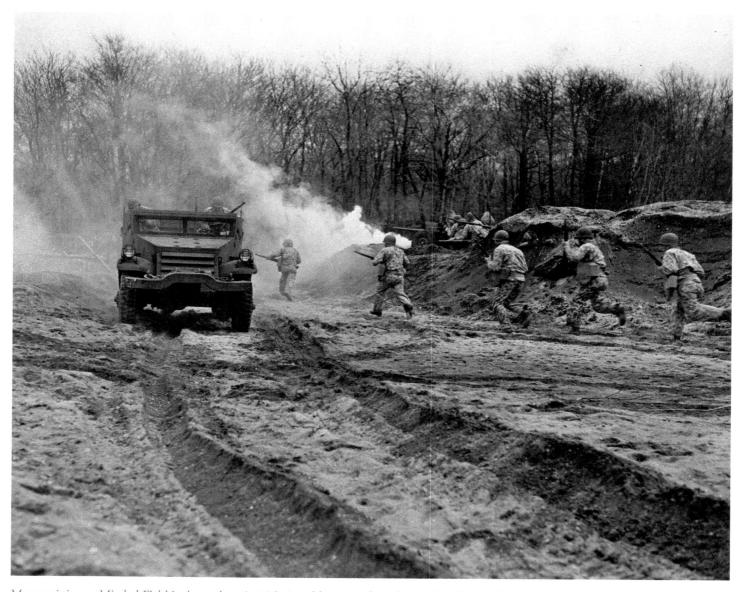

More training at Mitchel Field is shown here in 1943 as soldiers assault an "enemy" half-track. The simulated battle conditions are real enough to the men, as a smoke grenade covers one position while a squad bravely attacks the armored vehicle.

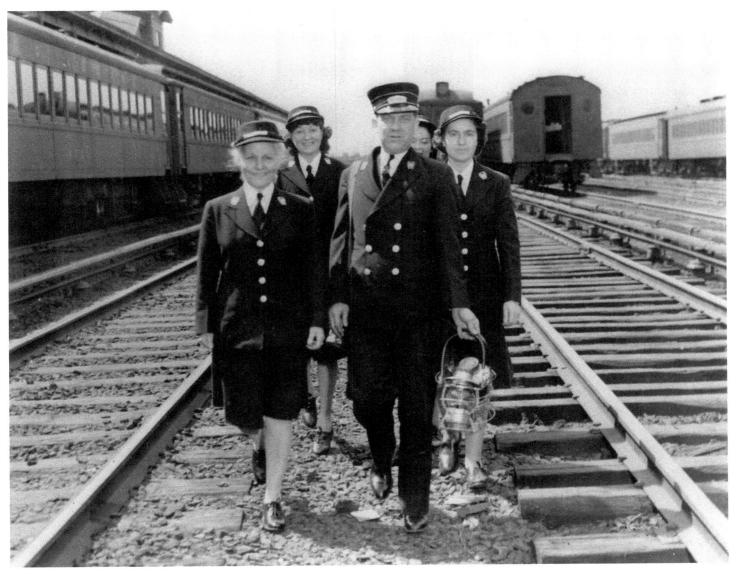

Women who joined the labor force during World War II weren't all literally "Rosie the Riveter" defense industry workers. Women entered many essential fields that had been the traditional domain of men. Here women trainmen, as they were called, return from their first run on the LIRR in 1943. An instructor brakeman, carrying the signature tools of his trade, flag case and lantern, accompanies them.

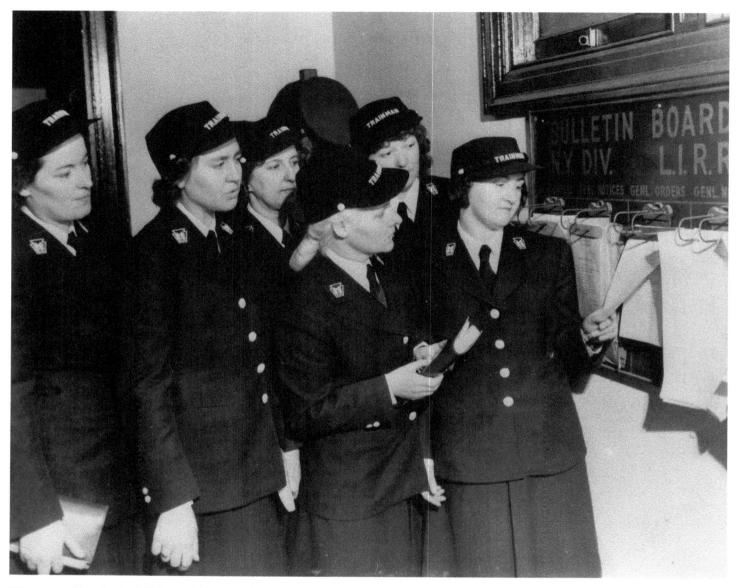

Women working for the LIRR check the crew dispatcher's bulletin board for their train orders. Serving the public during a time of crisis, filling an important job in a different kind of uniform, the lives of the women had changed forever.

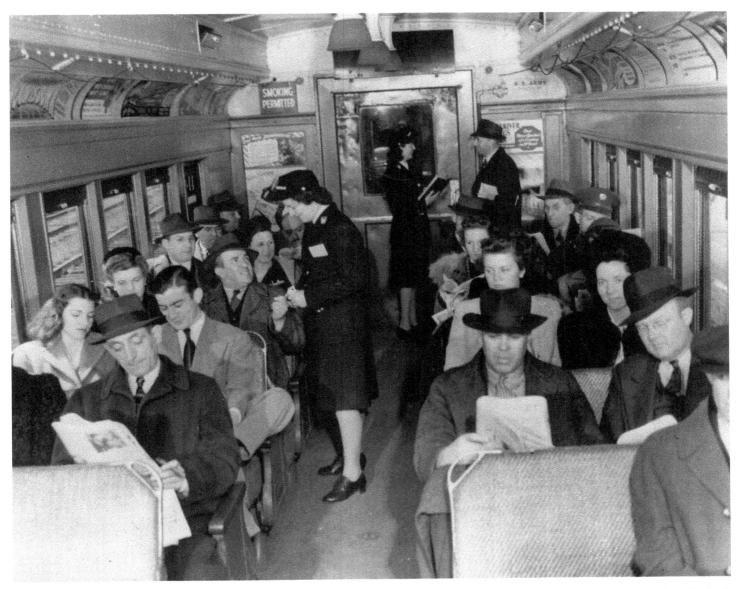

With their training completed, two women man the passenger coach. Florence L. Lawyer collects tickets while Marcella Craft gives timetable information to a passenger at the rear. The commuters are absorbed in their newspapers, and while a little ornate, the coach seems amazingly similar to what we ride today.

One would hardly know from this photo of the Stony Brook business district in June 1943 that there was a war on, were it not for the absence of men on the street. At the start of the decade the village had been given an architectural makeover by philanthropist Ward Melville of the Thom McAn shoe empire, with the town's columned post office as focal point.

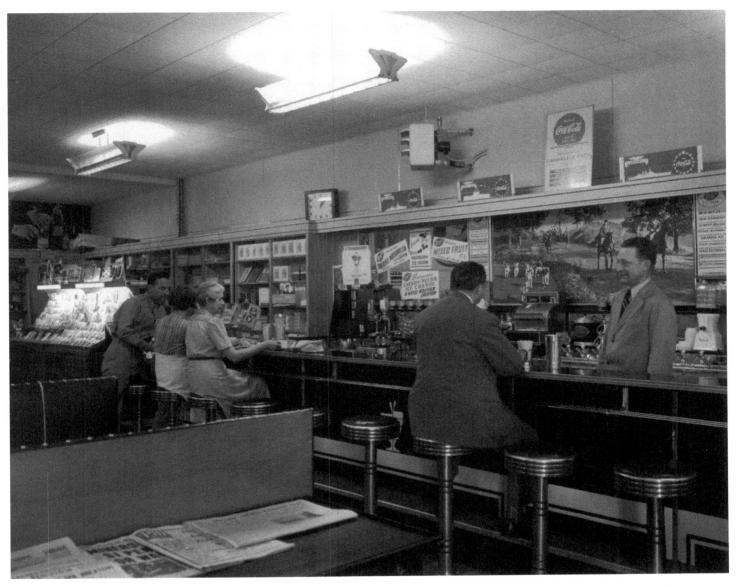

A soda fountain in Stony Brook in June 1943 has customers chatting and possibly ordering a "two cents plain." Newspapers with war news line the table in the foreground, but the patrons seem to just want to take a break and relax on an early summer afternoon. State-of-the-art lighting, heating apparatus (on the wall), and cash register accent the decor.

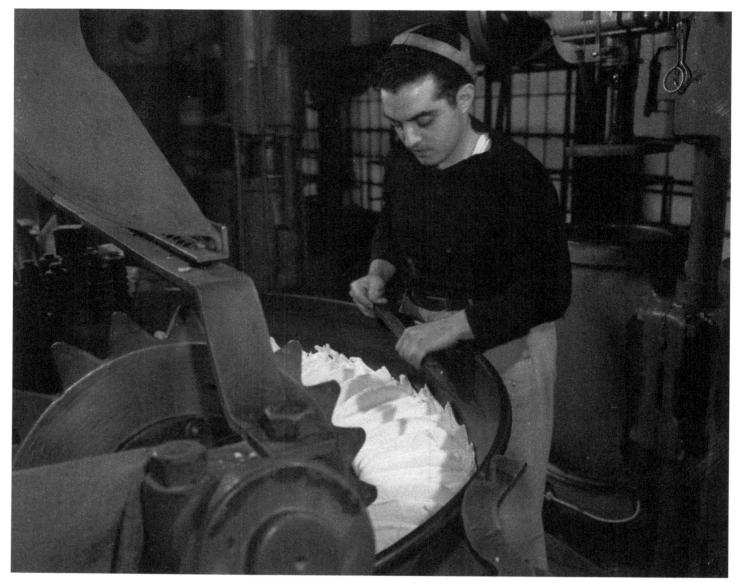

A worker at the Atlantic Macaroni Company in Long Island City puts pasta on a drying rack in 1943. Four partners were responsible for the start of the company in 1892. One decided to venture out on his own; in 1915 Emanuele Ronzoni started his now famous namesake company. The New York metropolitan area was the second-largest pasta market in the world, so there was room for competition.

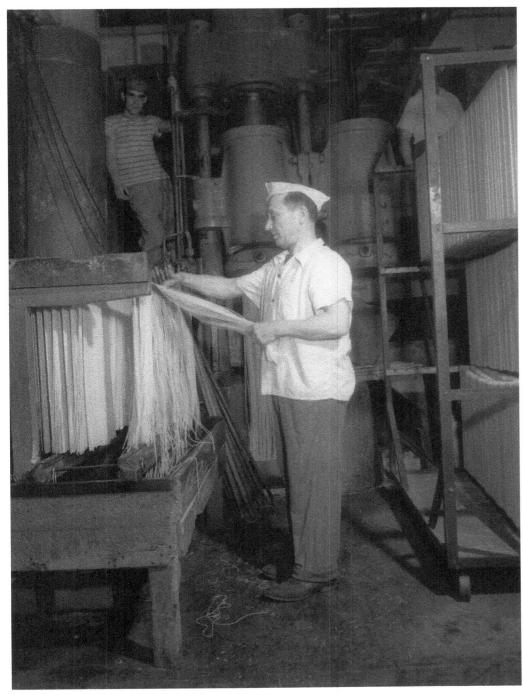

Another step in the process of drying pasta—in this case, spaghetti—is demonstrated at the Atlantic Macaroni Company. Food rationing was a necessity during World War II, and pasta was a staple food at a time when stretching meals was a patriotic duty.

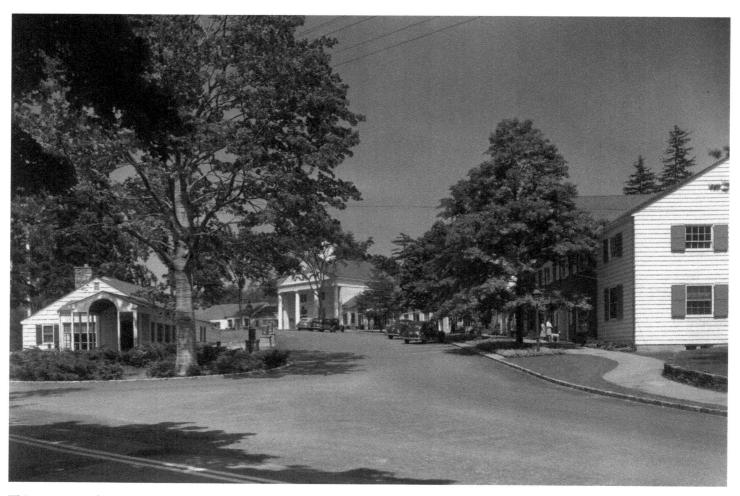

This street view shows a quiet, pastoral Stony Brook in 1943. Modest housing and spacious streets are characteristic of a number of suburban towns that dot Long Island.

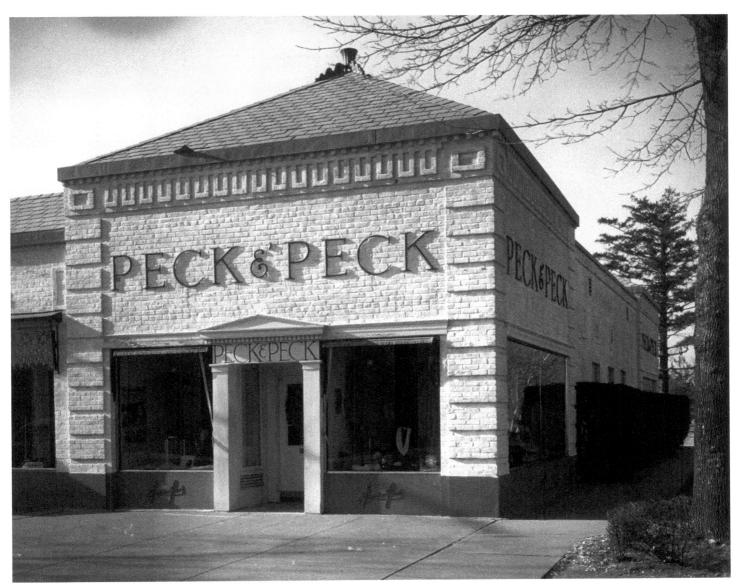

After Loeser's Department Store opened in Garden City during the 1930s, high-end shops from New York City followed. While Loeser's supplied wares for less affluent Long Islanders, specialty shops like Peck & Peck, a women's clothing retailer, offered more upscale brands. The store was located on Franklin Avenue, which became known as the "5th Avenue of Long Island" as trendy shops began to appear.

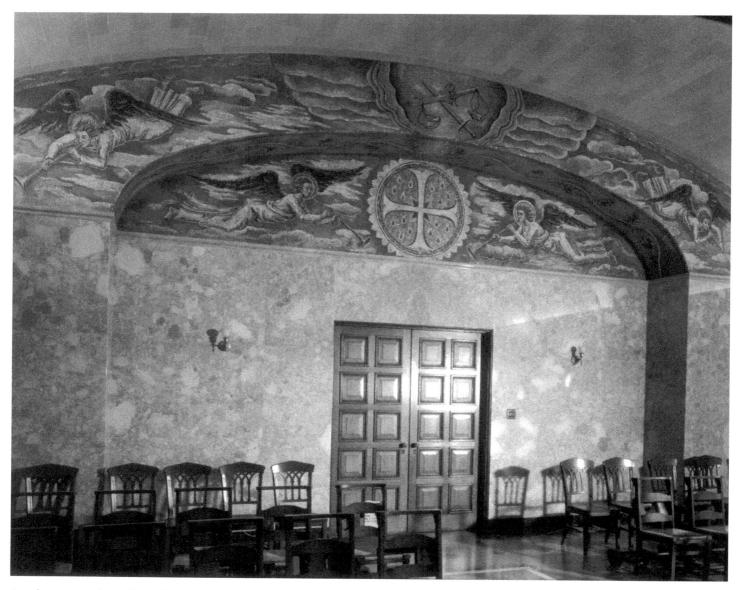

Angels trumpet above the archway and auditorium doors of the Seminary of the Immaculate Conception, located in Huntington. The Roman Catholic seminary was established in 1930 to prepare men for the priesthood. It continues its work today, offering master's degrees in theology and doctoral degrees in ministry.

This is the Stony Brook Museum complex as it appeared in 1943. It is now called the Long Island Museum and has been greatly expanded to include the Margaret Melville Blackwell History Museum, the Smith Carriage Shed, and an excellent art museum. It is now affiliated with the Smithsonian Institution.

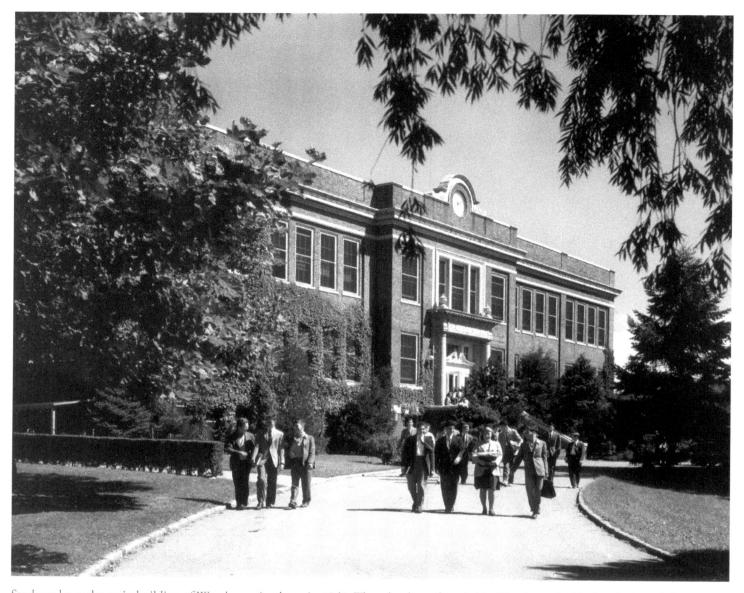

Students leave the main building of Woodmere Academy in 1943. The school was founded in Woodmere in 1912 and adopted the motto *Disce Sirvere*, or "Learn to Serve." In 1990 it merged with Lawrence Country Day School to form the present Lawrence Woodmere Academy.

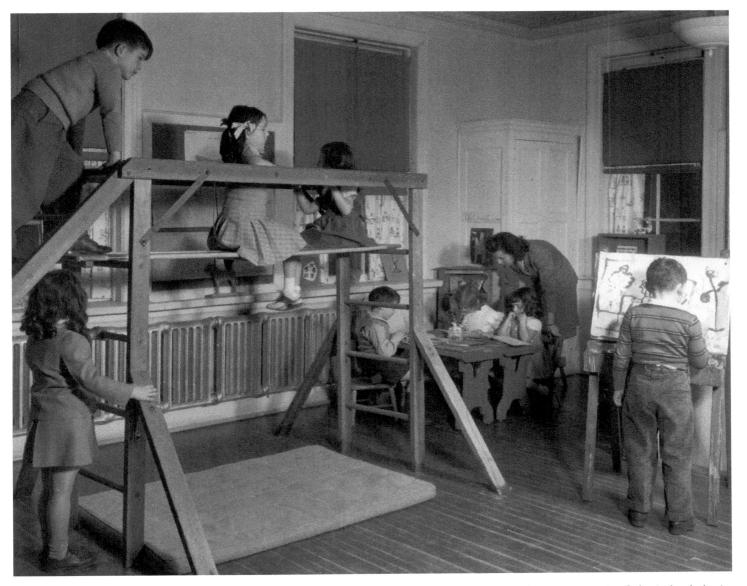

A teacher attends to her students in a kindergarten classroom at Woodmere Academy. The scene shows quite a mix of physical, scholastic, and artistic activity and resources.

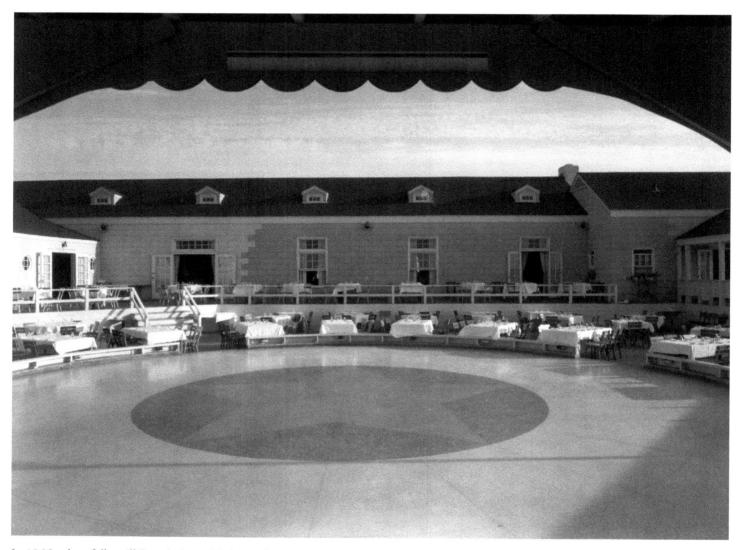

In 1946, when folks still "touch danced," the Surf Club at Atlantic Beach provided an outdoor venue. With men returning from Europe or the Pacific, dancing under the stars on a romantic evening was the continuation of the American dream. Couples got back to the routine of life, and started the baby boom.

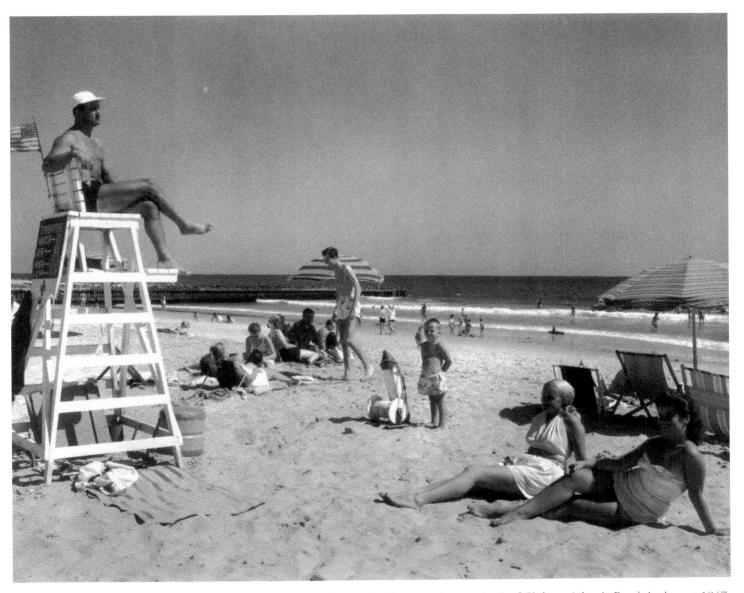

Frolicking on the beach is part of the culture of Long Island, as seen here at the Surf Club on Atlantic Beach in August 1947.

A relatively young community at the time, Atlantic Beach was developed by Stephen Pettit of Freeport in the 1920s.

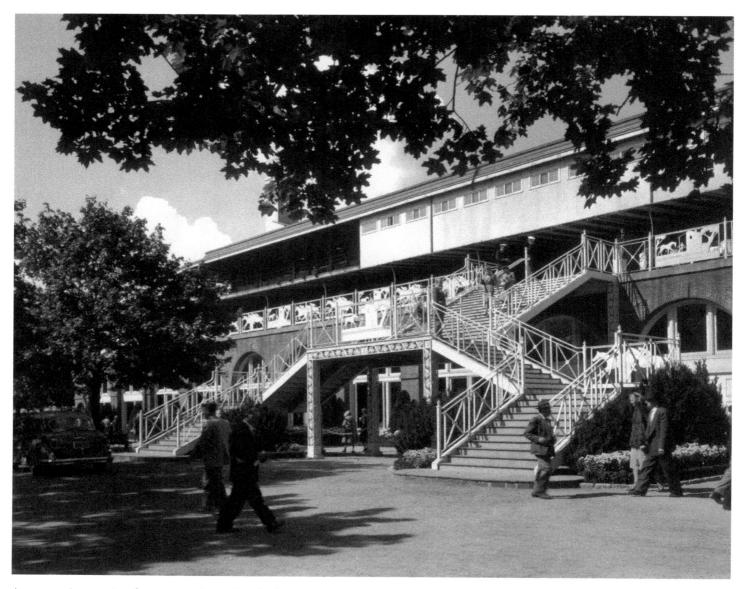

A summertime passion for many on Long Island is horse racing. The famous Belmont Park, which hosts the third leg of the Triple Crown of thoroughbred racing, is located in Queens. It opened in May of 1905 and is named for August Belmont II. Virtually every champion racehorse of note has run on this one-and-one-half-mile track, including Secretariat, who set the Belmont Stakes record of two minutes, twenty-four seconds in 1973.

Shown here in 1946 is the Meadowbrook Hospital on Hempstead Turnpike in East Meadow. Built in 1935, it became the Nassau County Medical Center in 1974, and the Nassau University Medical Center in 2001. The name changes illustrate the growing population of Long Island and the commitment to providing its residents with quality medical care.

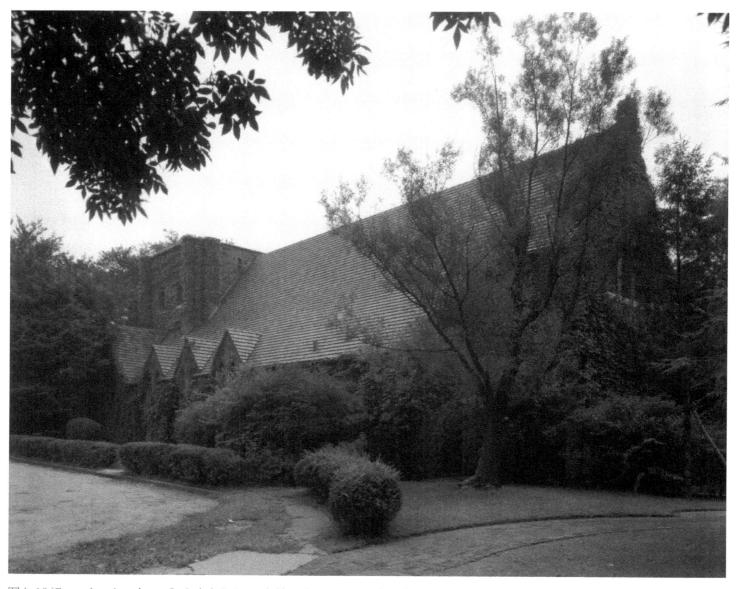

This 1947 exterior view shows St. Luke's Episcopal Church in Forest Hills. The congregation was formed in 1913 and worshipped in a wooden chapel until the present stone structure was erected. The design is English Gothic, and the first rector was William Lander.

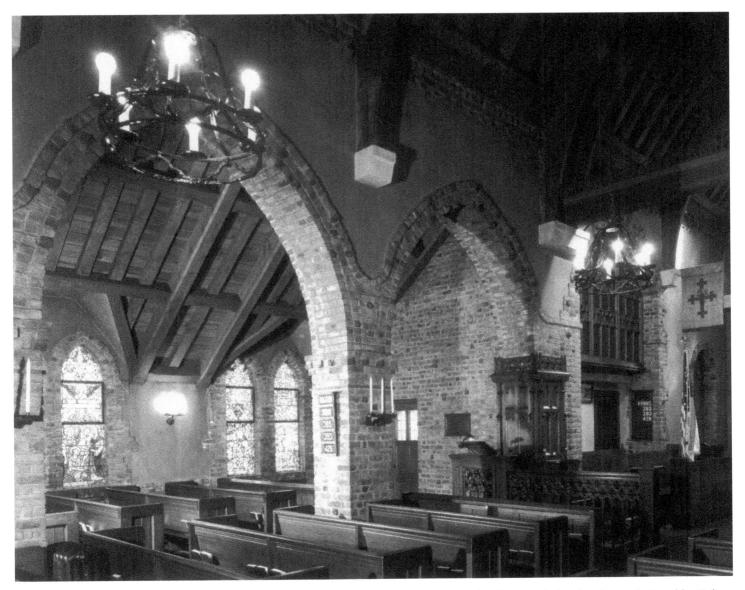

The interior of St. Luke's Church in Forest Hills looks like a medieval castle. Completed in 1924, the church was designed by Robert Tappan, a member of the congregation simultaneously involved with construction of the Cathedral of St. John the Divine in Manhattan. By 1949, when this photo was taken, there had been a mass movement to the suburbs from the city, and people wanted to celebrate their faith. Many varied denominations had found homes on Long Island since colonial times.

Syosset Gardens was typical of the housing developments springing up on Long Island. A "cookie cutter" house meant a new start in a grand place. Families now wanted fresh air and backyards for children to play in, rather than crowded city streets. The Island had the space and the affordability. By 1949 memories of bad times were fading, and all were eager for prosperity.

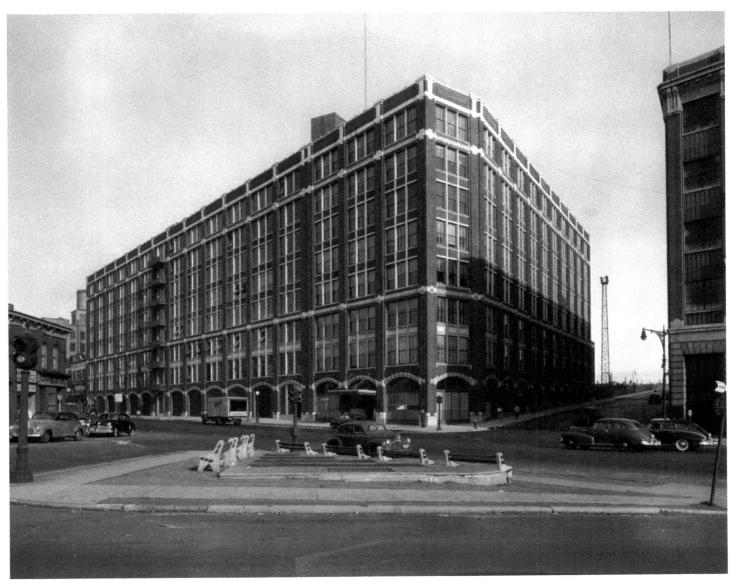

The pharmaceutical firm E. R. Squibb & Son took up an entire city block with this facility on Northern Boulevard in Long Island City.

By 1948, when this photo was taken, returning soldiers were eager for work and new careers.

In 1902 Franklin Simon and Herman Flurscheim opened a store in New York City to sell women's fashions and furnishings. The Franklin Simon store proved successful, and in 1932 a branch store opened in Greenwich, Connecticut, signaling a move into the suburbs. The Franklin Simon shop in Garden City is seen here in 1947. By the time the chain closed in 1979, there were 42 stores.

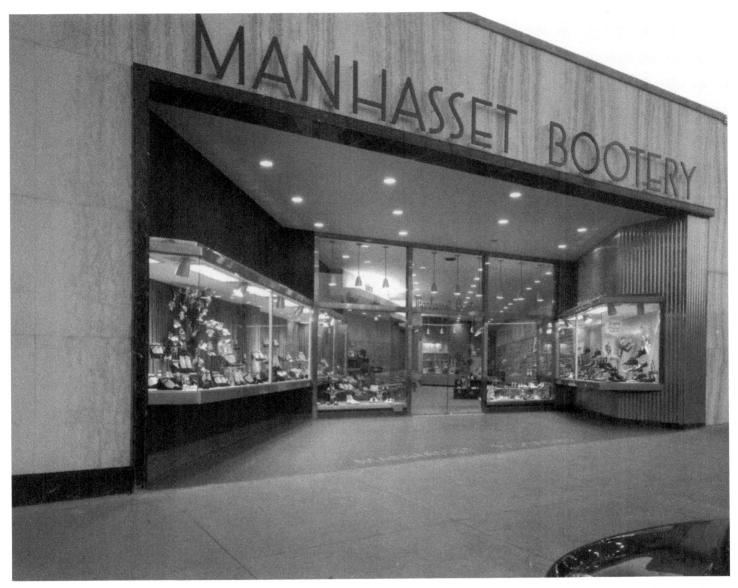

The Manhasset Bootery was located at 505 Plandome Road in Manhasset. Plandome Road was a main artery running parallel to Manhasset Bay, and dozens of specialty shops were located along it. The bootery appears to have a substantial selection of shoes for the entire family.

Located at 66 Colonial Drive in East
Patchogue, the radio station WALK
broadcast at 1370-AM and served Long
Island and the New York metropolitan
area. It was a 500-watt station whose
motto was "the greatest music ever made,"
and whose pioneer disc jockeys were Ed
Wood, Jr., and Jack Ellsworth. Like most
stations in the pre-format era, WALK
varied its programming from music to
news to local events. The station is seen
here in 1952.

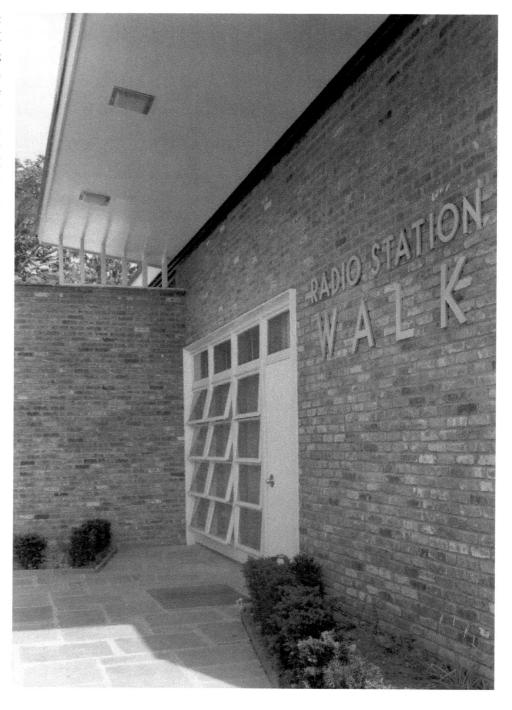

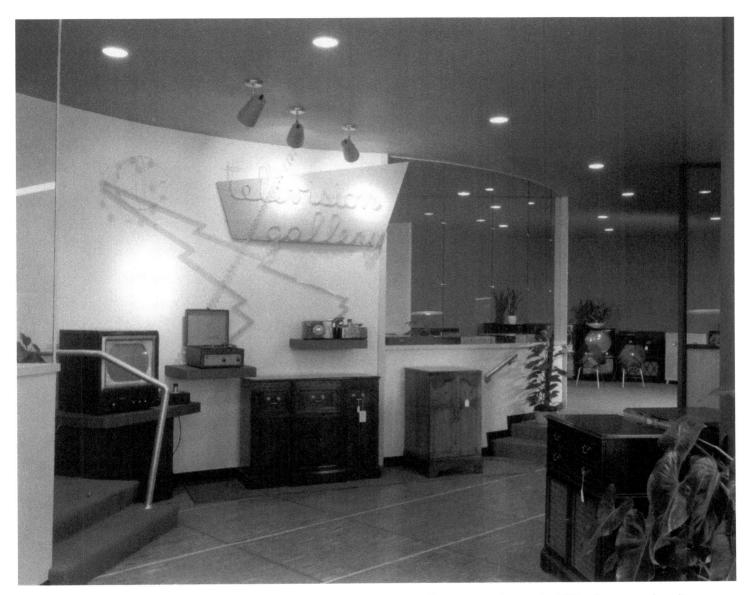

Stevens Radio on Steinway Avenue in Astoria has all the modern conveyances of home entertainment in 1950—large console radios, small table radios, a 78-rpm record player, and the infant product, a television set. In addition to WALK, Long Island radio stations such as WBIC, WLIE, WGSM, and WHLI were the places on the dial for news, sports, and music fare.

By the late 1940s, the expanding Macy's department store chain included a store in Jamaica, Queens, seen here with its selection of furs. Affluent people were building and buying homes in the area, and during the cold winter months the elegant ladies needed to keep warm.

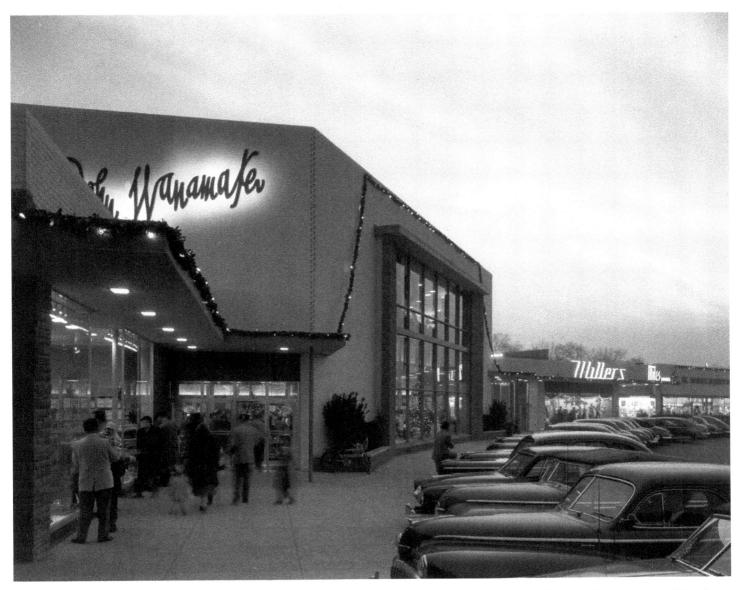

The Wanamaker department store at a shopping center in Great Neck is decorated for the holidays in this December 1951 photo.

The store bore the name of the family who pioneered the department store in the United States. With Long Island continuing to grow, the chain knew it could prosper.

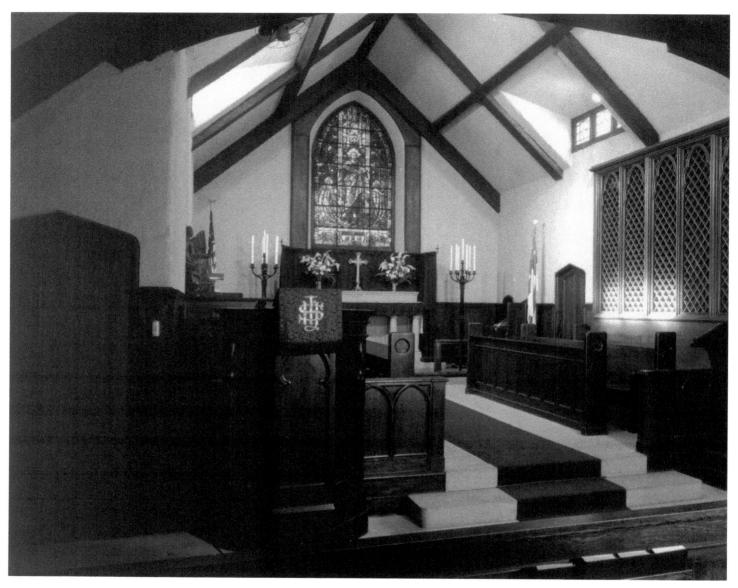

The Episcopal Church of the Advent, seen here in 1948, is located on Advent Street in Westbury. Built in 1910, it was designed by famed architect John Russell Pope, who also designed the Jefferson Memorial and National Archives Building in Washington. Its brush with fame occurred in 1914 when June bride Martha Bacon married financier George Whitney. Society pages were abuzz with news of a guest list that included such names as Morgan, Roosevelt, Vanderbilt, and Belmont.

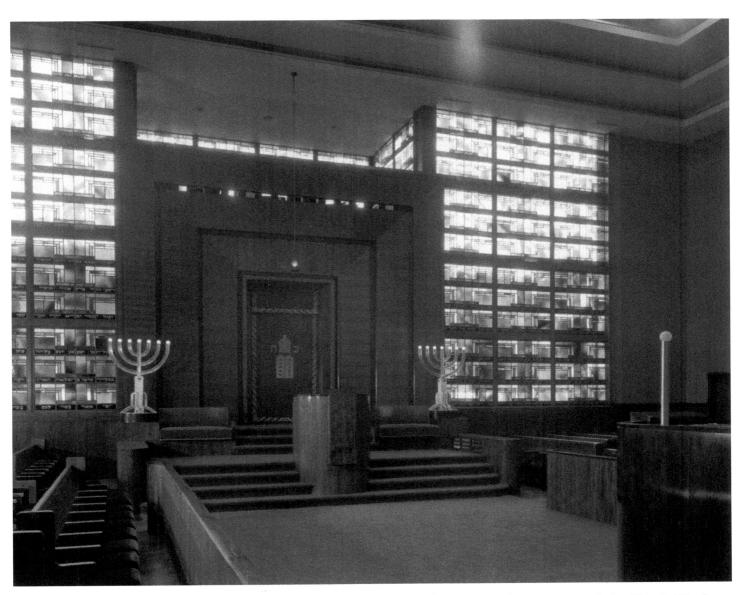

The Congregation Sons of Israel was established in 1927. Seen here in 1951, the synagogue on Irving Place in Woodmere has tripartite seating, meaning men on one side, women on the other, and a mixed seating area in the middle, so that all may worship together at traditional Jewish services.

This 1952 photo shows young Richard Mahler running to catch his ride to Fire Island School. His father is the lighthouse keeper at the Fire Island Light House in Suffolk County. If Richard had to do show-and-tell in class, all he probably had to do was say, "Look out the window."

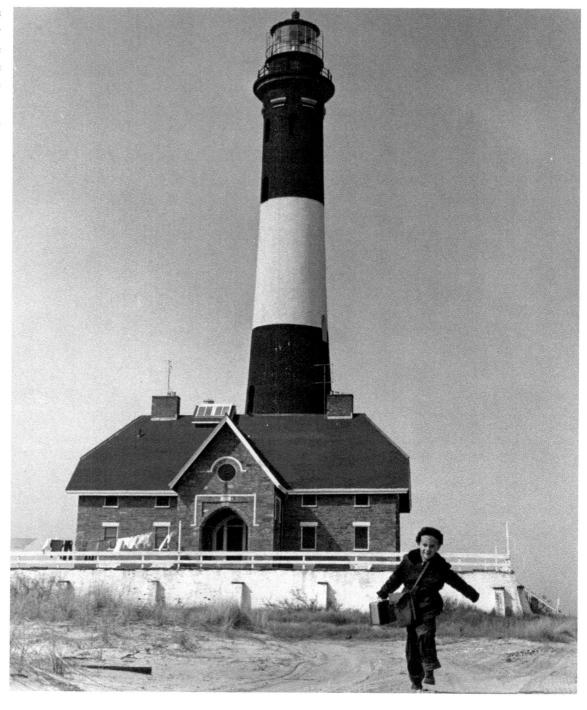

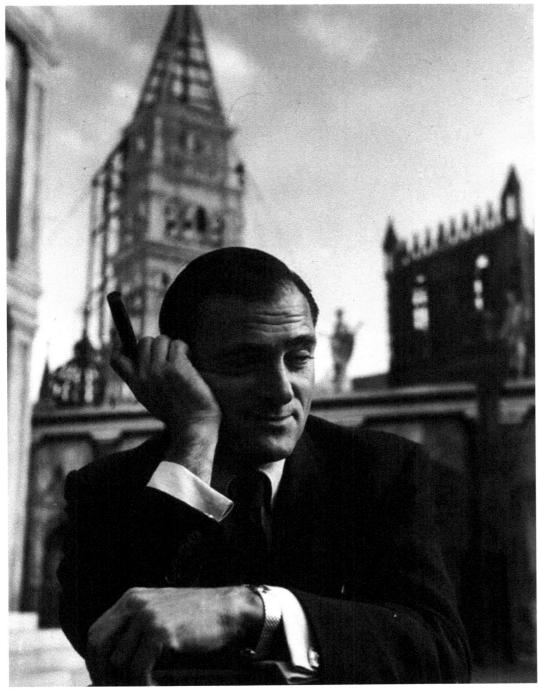

In 1952, when a new theater was completed at Jones Beach, Broadway impresario Mike Todd mounted the first extravaganza performed there, a production of the operetta *A Night in Venice*. Todd is shown here with the theater behind him.

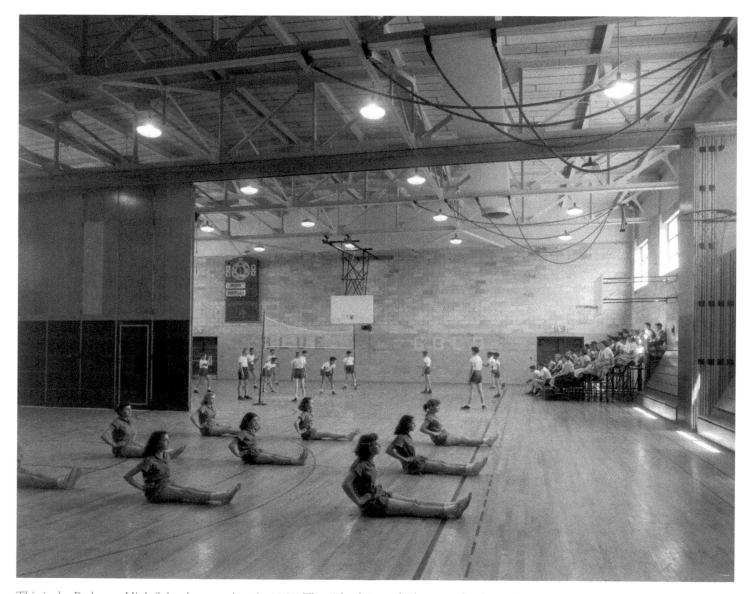

This is the Bethpage High School gymnasium in 1952. The girls, doing calisthenics, take their physical education separate from the boys, who are playing volleyball in front of a group of spectators.

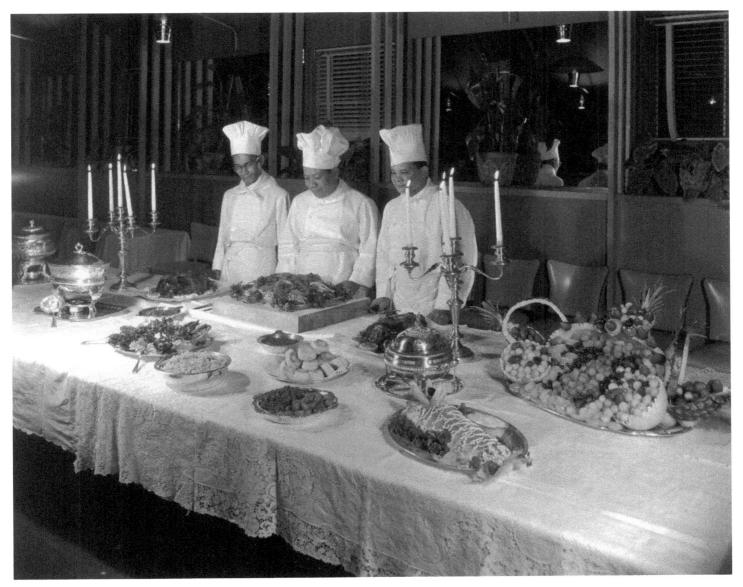

Here is one of the lavish banquet tables at Patricia Murphy's, a restaurant in Manhasset. The staff stands ready to carve the meat, ladle the gravy, and serve the side dishes. The photo was taken in June 1952, so this could be a banquet setting for a wedding.

The spacious dining room at Patricia Murphy's featured a cozy fireplace. The restaurant was located at the juncture of Northern and Port Washington boulevards and is remembered by many for its famous popovers. Murphy's was the place to go for that typical 1950s Sunday dinner where Mom and Dad would get dressed up and young girls would wear their patent leather shoes—the children feeling all grown up when the waiter took their orders.

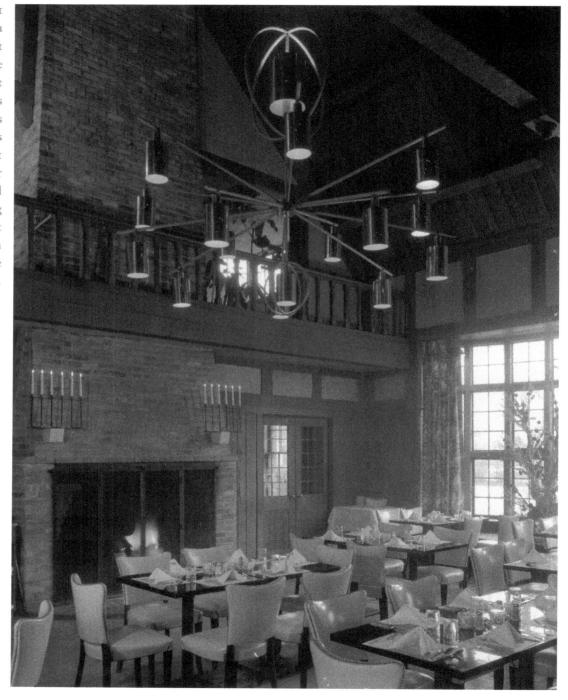

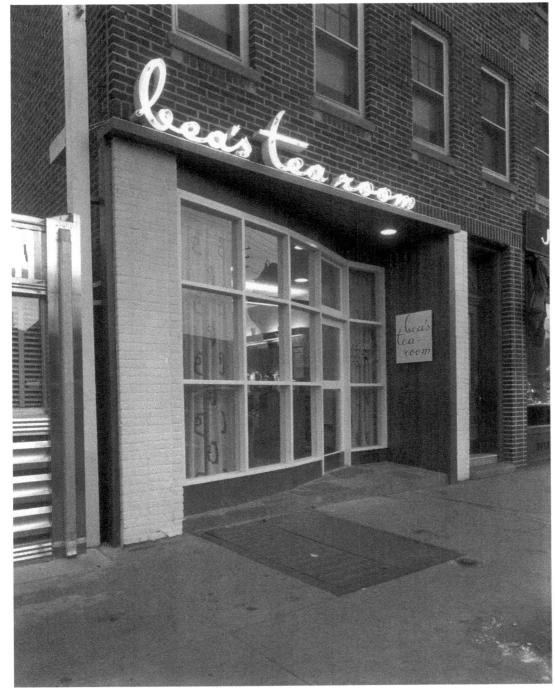

Seen here in 1952, Bea's
Tea Room was located in
Cedarhurst. It was a local
business where people could
stop, relax, take tea, and see
what the rest of the day would
bring. It brought a unique
flavor to the neighborhood.

Seen here in 1952, the Tennis Apartments were located on Dartmouth Street in Forest Hills, longtime home of the U.S. Open tennis tournament. Forest Hills was an early twentieth century planned community where one could walk to the clay-court West Side Tennis Club and perhaps encounter Margaret Olivia Slocum Sage, or Frederick Law Olmsted, Jr., two of the planners involved in creating Forest Hills. Most of the complexes were eventually demolished for more upscale development.

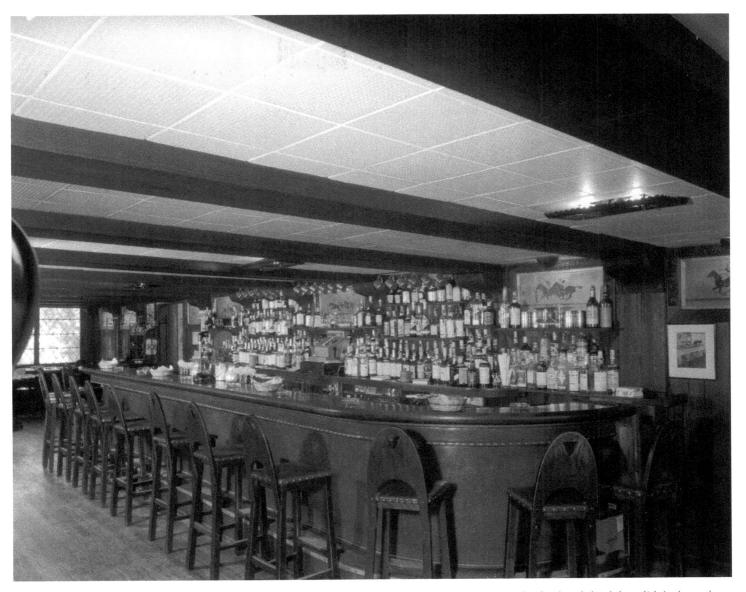

This is the well-stocked bar at the Blue Spruce Inn in Roslyn in 1953. It was a noted place for food and drink but didn't always have a quiet atmosphere. Some live jazz recordings were made there in 1965 by a quartet led by trumpeter Henry "Red" Allen.

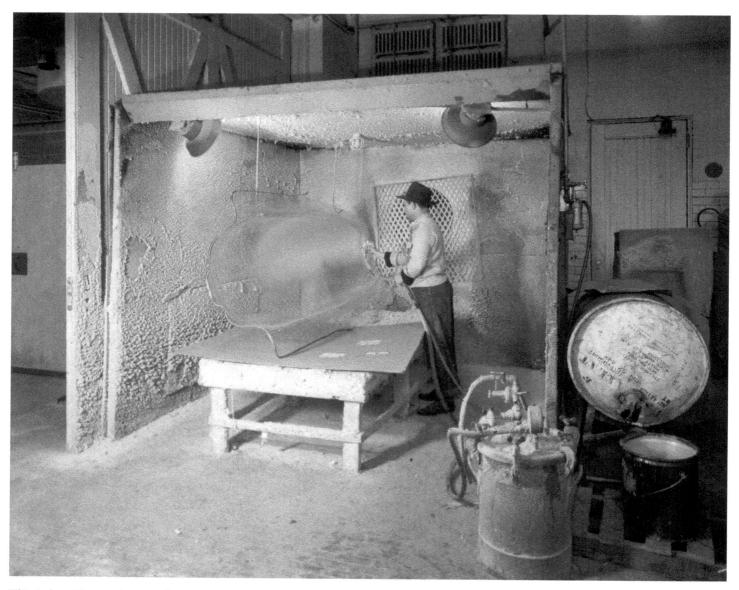

This industrial scene in 1953 shows a worker in the paint shop of the Steiner Plastics Manufacturing Company in Glen Cove. The firm produced canopies for Grumman jets being built for the military in nearby Bethpage, but Steiner was prosecuted for falsifying inspection approvals of a number of the canopies produced that year.

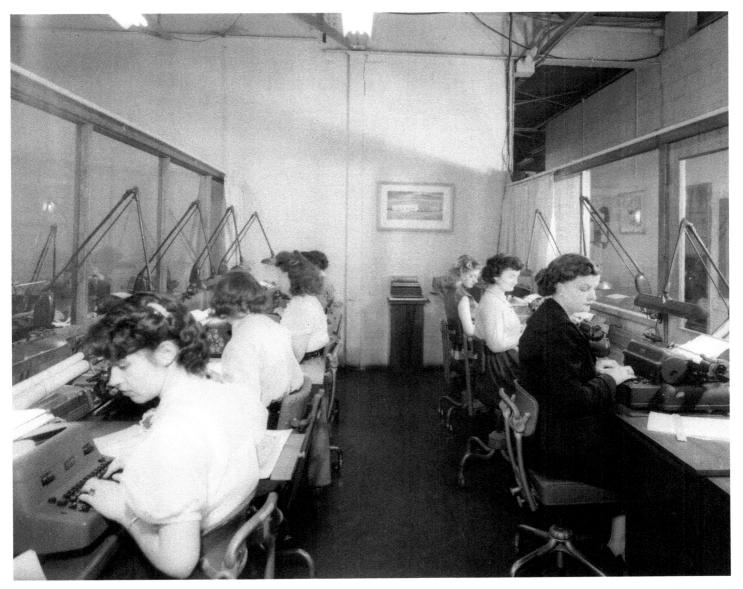

In 1954 the Corydon M. Johnson Company in Bethpage illustrated technical publications for modern industrial designs and provided other graphics-related services. Here the staff typists produce text for publications. Johnson was an air-mail pilot in the 1920s and was originally from Long Island.

Another group of workers, this one not all female, proofreads materials at the Corydon M. Johnson Company. The firm was very successful and paid its staff a good salary. Johnson's alma mater was the University of Virginia, and he and his wife sponsored a scholarship there for students of high academic standing who also did community service work.

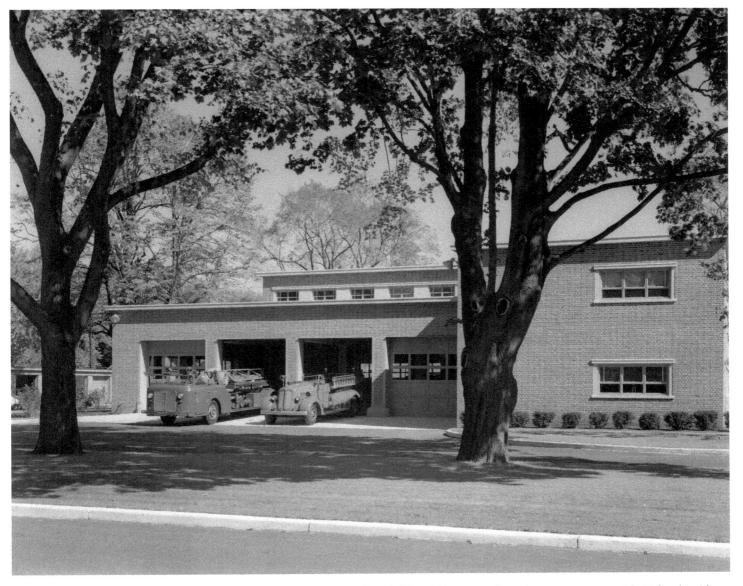

This 1954 image shows the Garden City Fire Department, founded in 1899 as a regular volunteer company with 31 local residents participating. The department was incorporated into the village government in 1920 as part of a real estate deal in which one Alexander T.

Stewart promised fire protection for all parcels of land purchased.

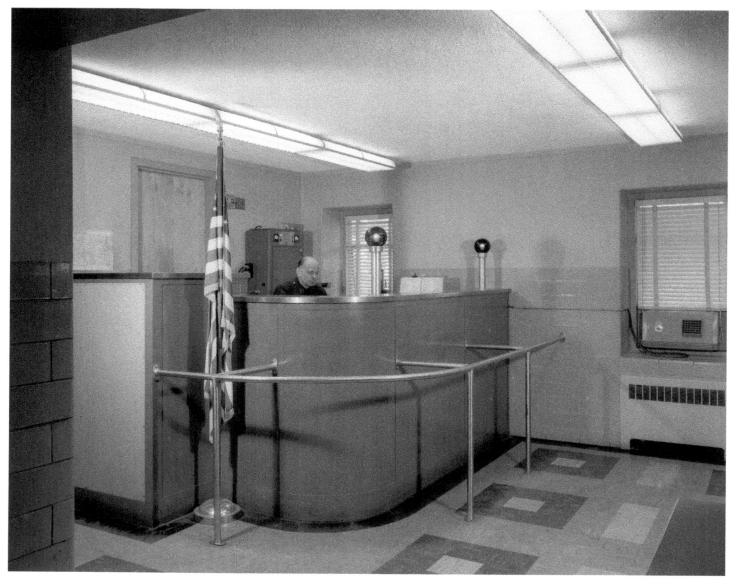

It appears to be a slow night for the desk sergeant at the Garden City Police Department in October 1954.

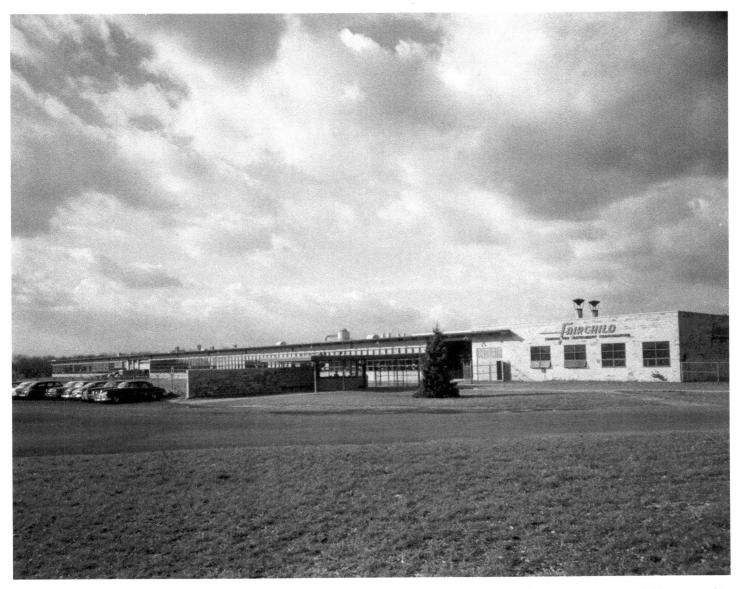

The Fairchild Camera and Instrument Corporation, seen here in 1953, was located in Syosset. Sherman Fairchild pioneered in development of the aerial camera. His many innovations, often on behalf of government agencies such as NASA, included the panoramic reconnaissance camera system and the three-inch mapping camera for the Apollo Project. With his backing, the Fairchild Semiconductor Company was formed in 1957 and would become a leading firm in the 1960s development of Silicon Valley.

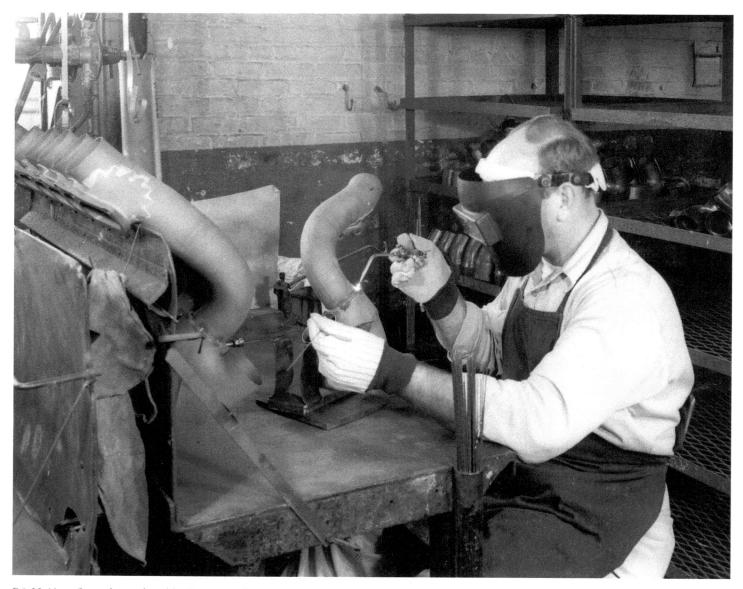

B&H Aircraft was located at 441 Eastern Parkway in Farmingdale. This 1954 image shows a welder sealing a joint on an exhaust manifold. The aircraft firm was one of many drawn to Long Island because of its skilled labor force and wide-open spaces.

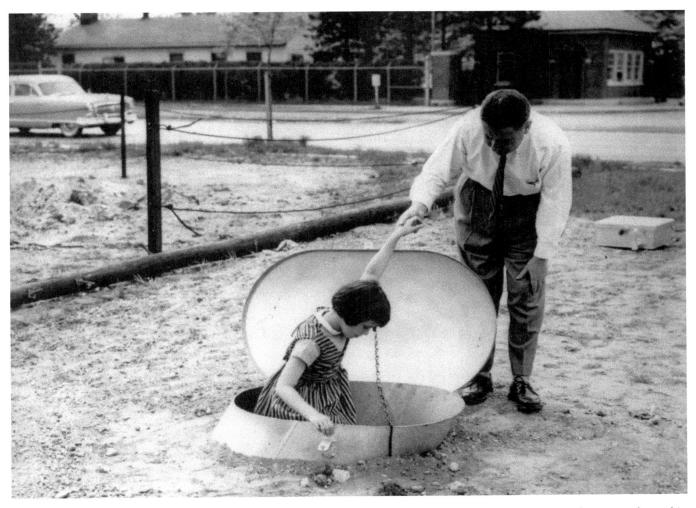

As the cold war brought pervasive fears of nuclear attack by the Soviet Union, the Walter Kidde Nuclear Laboratories, located in Garden City, developed fallout shelters. Here in 1955 a young child is shown how to climb down into a Kidde-designed shelter built into a Garden City backyard.

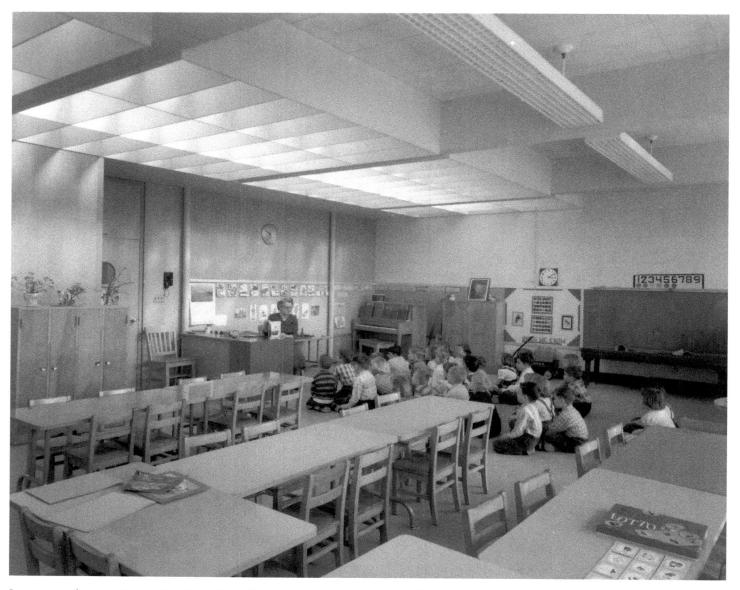

It appears to be story time at the Cherry Lane School at 474 Roslyn Avenue in Carle Place. The town was established by Silas Carle, and its school district was one of the smallest in the state of New York at the time of this 1956 photo.

These men are standing in front of an Adelphi College building in Garden City in 1957. Adelphi was the first college on Long Island, established in 1896 and located in Brooklyn until 1929. Initially coeducational, Adelphi became a school for women after 1912, and during World War II the school focused on nursing. With the advent of the GI Bill, Adelphi reopened its doors to male students.

Following Spread: Developed after World War II, Levittown came to represent the quintessence of postwar suburbia. This 1957 view shows the Levittown Center shopping center with its range of local merchants and national chains.

WOOLWORTH CO

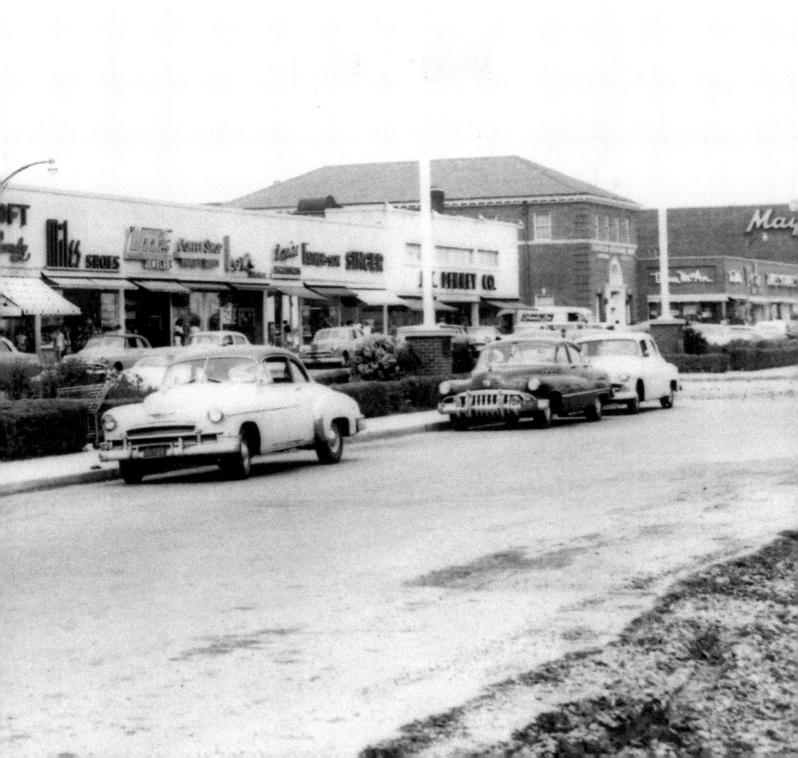

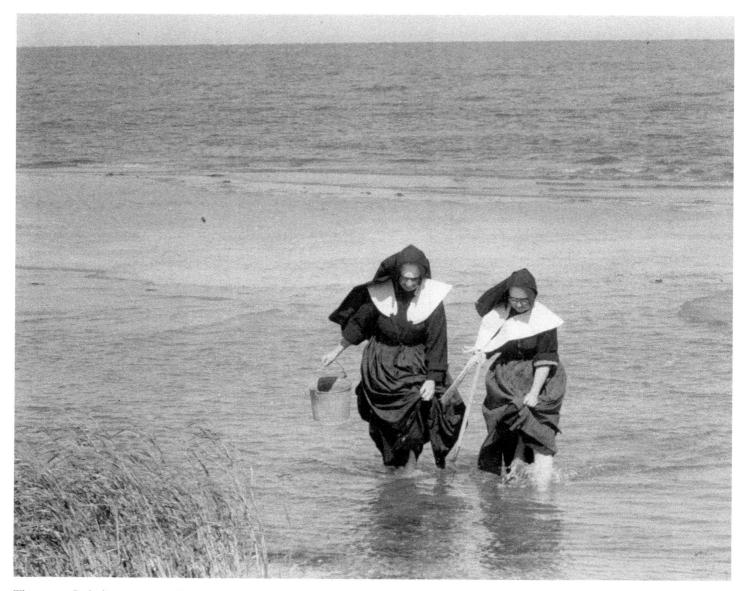

These two Catholic nuns were photographed clamming on a Long Island beach in 1957. Religious communities always found a haven on the Island. The St. Ignatius Jesuit Retreat in Manhassat goes by the name Inisfada, the Gaelic translation of "Long Island." At least two dozen Catholic Retreat Houses were established on Long Island, such as St. Gabriel's in Shelter Island and the Peaceful Dwelling Project in East Hampton. The ocean and peaceful shores provide a good landscape for introspection.

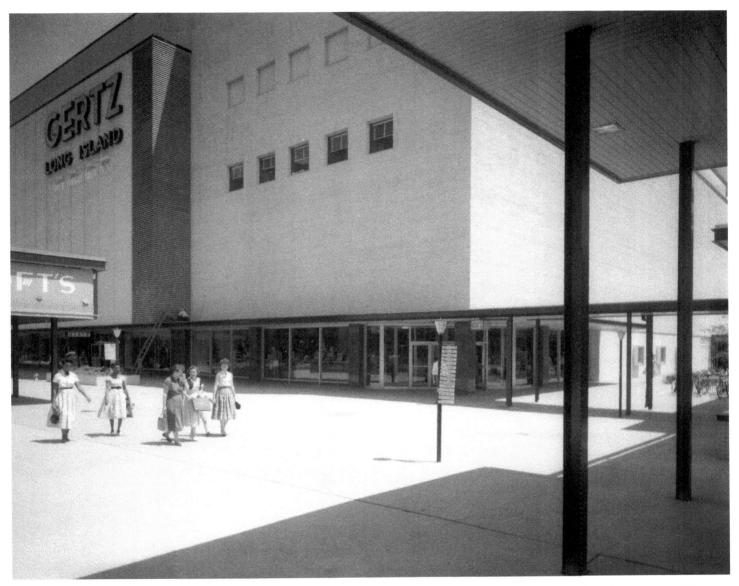

During a three-month period in 1956, the first three modern shopping malls on Long Island opened, including the open-air Mid-Island Plaza (now Broadway Mall) in Hicksville. Seen here in July 1957, Mid-Island had ten stores—including the Gertz department store, a family-owned business based in Queens. At five stories, this particular Gertz store was said to be the tallest suburban department store in America. Gertz eventually operated eight stores on Long Island.

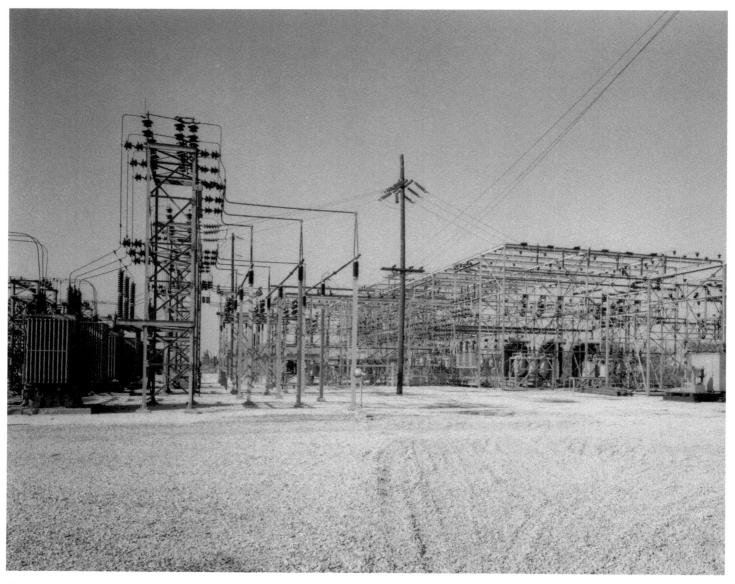

The Long Island Lighting Company was formed in 1911 to supply electric and natural gas power, installation, and servicing for the entire Island. Shown here in 1956 is one of hundreds of substations used to supply electricity to local areas. One can imagine how storms and hurricanes could wreak havoc on these isolated power stations.

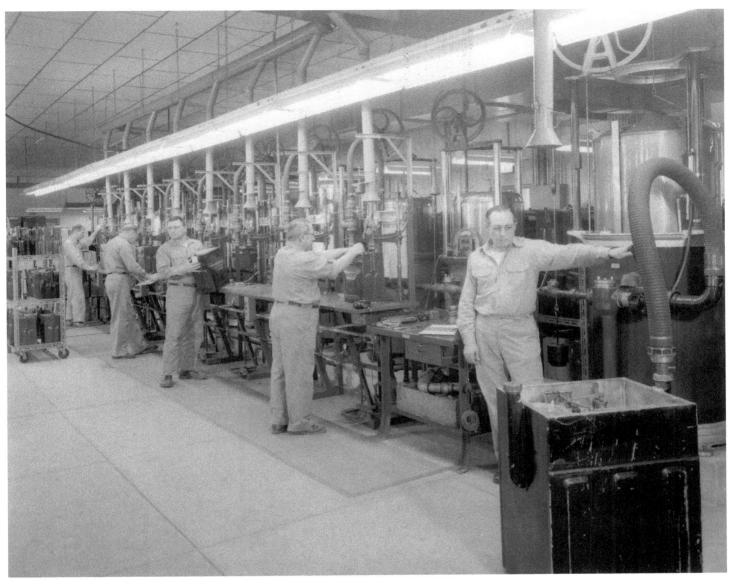

Here in a Long Island Lighting Company plant in Garden City, workers are testing electric and gas meters to be installed in residents' homes, businesses, and industrial sites. In 1957 the company provided the power to run the Island but also supplied economic power by employing thousands of Long Islanders.

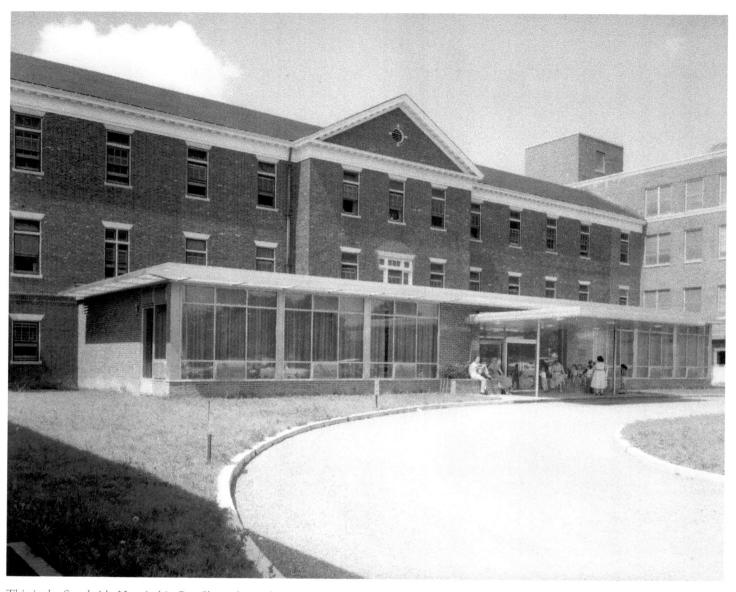

This is the Southside Hospital in Bay Shore, located at 301 East Main Street, in 1956. The oldest and largest community hospital on the Island, it was established in 1913 in Babylon, then moved to Bay Shore in 1919. The facility seen here opened in 1923.

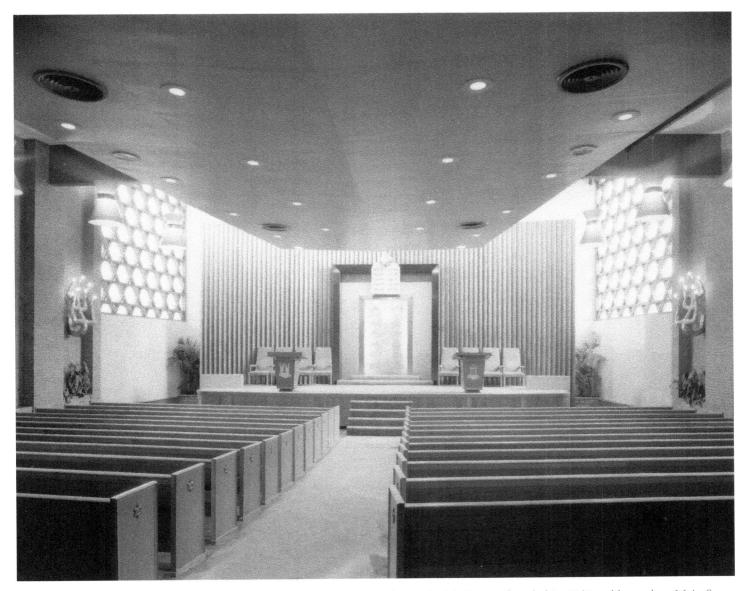

This interior view shows the temple of the Hewlett–East Rockaway Jewish Centre, founded in 1949 and located on Main Street in East Rockaway. Many Jews moved from New York City to Long Island through the decades. HERJC's mission statement describes it as "a warm, vibrant, traditional-egalitarian Conservative congregation." In December 1957, the month before this photo was taken, Eleanor Roosevelt spoke to the congregation.

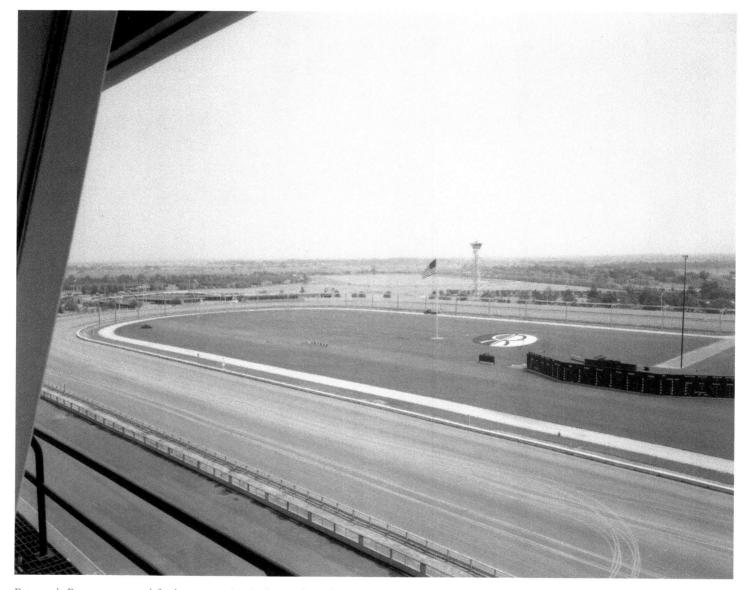

Roosevelt Raceway opened for harness racing in September of 1940. Located on the Meadowbrook Parkway in Westbury, the famous track sometimes drew crowds of 50,000 and introduced the mobile starting gate, a landmark innovation. Great horses such as Albatross and Niatross raced at Roosevelt, as did great sulky drivers such as Carmine Abbatiello. Despite years of success, rising land values and the establishment of offtrack betting led to the racetrack's closing in 1988. It is seen here in 1958.

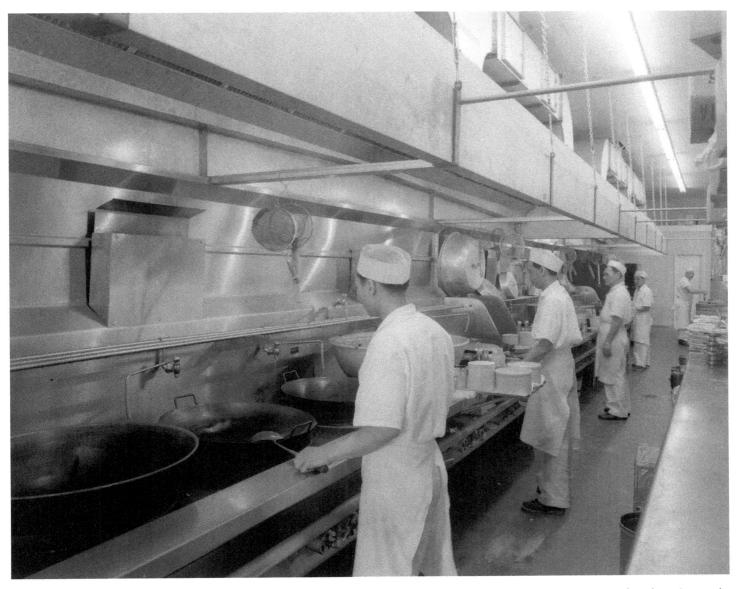

At Gum Wah, a business on Old Country Road in Westbury, workers in the sizeable kitchen prepare meals in large iron woks in this 1960 image.

This 1961 photo shows the stately reception area of the Franklin National Bank in Franklin Square, which opened in 1926. Under the later guidance of Arthur T. Roth, the institution fostered the philosophy of user-friendly banking with such innovations as drive-up windows and issuance of the nation's first bank credit card. He wanted easier financing for business and mortgage customers in order to build a stronger community. In 1974, by which time Roth was no longer with the firm, Franklin National Bank collapsed.

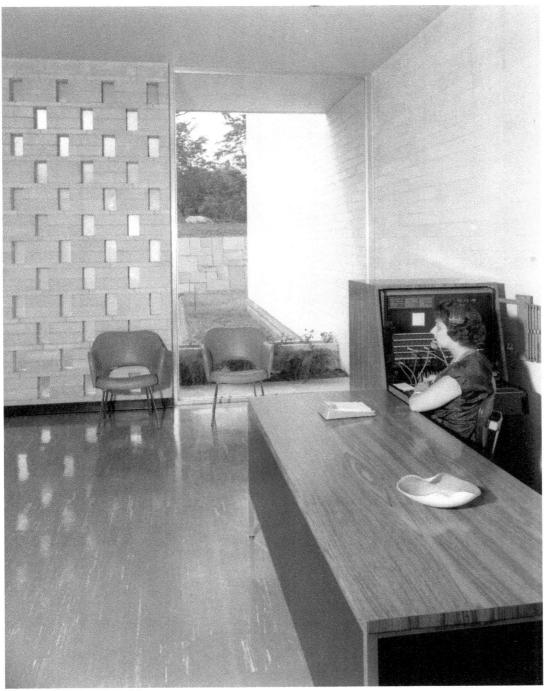

A large employer located in Syosset was Singer Sewing Machine Company. This 1961 photo of the reception area shows the switchboard operator at her desk. The facility was located on Underhill Road.

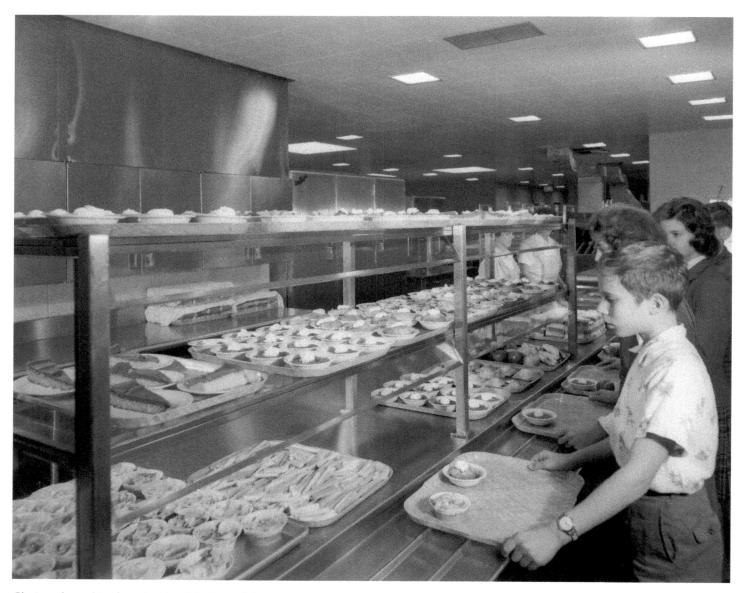

Choices abound in the cafeteria of the Harry Thompson Junior High School in Syosset. By 1961, the baby boom was creating the need for more schools. Thompson was constructed on land donated by Manhattan financier Edward Tinker. The school adopted as its motto the words "Patience, Respect, Integrity, Dignity, Empathy."

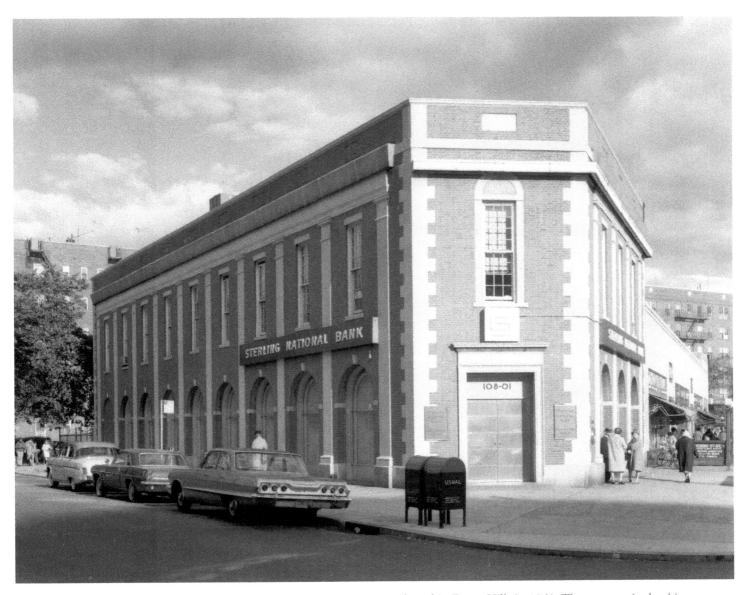

Cars line the curb outside the Sterling National Bank on Queens Boulevard in Forest Hills in 1963. The community banking concept gained a firm foothold on Long Island. The businesses were billed as banks for the "little guy" and served the needs of the immediate community. Institutions such as the Dime, Ridgewood Savings, and Long Island Savings Bank were all local enterprises until eventually swallowed up by larger institutions, becoming victims of their own success.

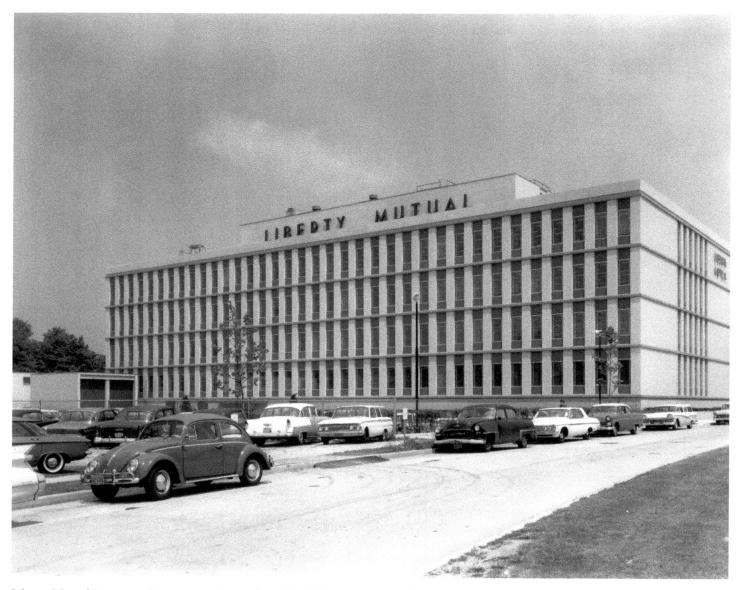

Liberty Mutual Insurance Company was located on Merrick Road in Lynbrook in 1963. The Company was established in Boston in 1912. When developers erected housing developments and firms established factories and businesses, someone had to insure them, and Liberty Mutual led the way. They insured the establishments and employed people, which ensured the growth of Long Island.

This is a 1964 photo of the Sephardic Temple on Branch Boulevard in Cedarhurst, one of the "five towns" which also include Lawrence, Inwood, Hewlett, and Woodmere.

Leisure time needed to be spent wisely. The Douglaston Golf Range on Northern Boulevard in Douglaston had just what the doctor ordered, especially on Wednesday. Originally called the North Hills Country Club, it became a municipal course in 1965, around the time this photo was taken. The golf range was built at the point of highest elevation on the Island, giving duffers a grand vista overlooking the ocean.

Seen here in 1967, the sprawling estate of financier E. F. Hutton was located on Hickory Lane in the Laurel Hollow section of Syosset. In 1920 he married Marjorie Post, heiress to the cereal company fortune, a union that ended in divorce but did produce a child who became the actress Dina Merrill. Hutton died in 1962, but the E. F. Hutton company name would remain prominent into the 1980s, particularly due to a series of widely viewed television commercials declaring "When E. F. Hutton talks, people listen."

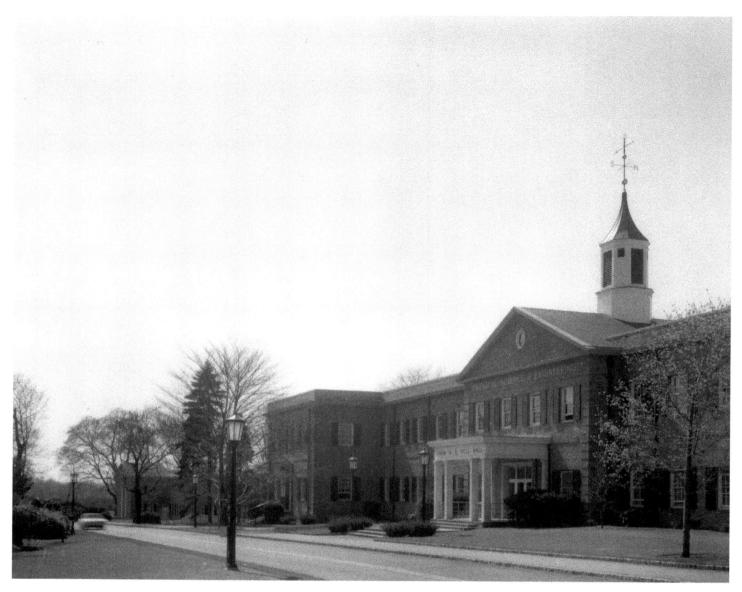

Seen here in 1965, the carillon above Pell Hall on the campus of C. W. Post College in Brookville chimes every 15 minutes. Originally the estate of the Post family of breakfast cereal fame, the buildings were converted into classrooms in 1954 and housed liberal arts, management, and nursing programs. Today C. W. Post is the largest campus of what is now Long Island University. Among its distinctions, the school has the only equestrian program on the Island.

NOTES ON THE PHOTOGRAPHS

These notes, listed by page number, attempt to include all aspects known of the photographs. Each of the photographs is identified by the page number, a title or description, photographer and collection, archive, and call or box number when applicable. Although every attempt was made to collect all data, in some cases complete data may have been unavailable due to the age and condition of some of the photographs and records.

II VI	Oyster Ponds The Brooklyn Historical Society v1972.1.88 HUNTINGTON'S MAIN	5	ENGLISH PRESBYTERIAN MEETINGHOUSE The Brooklyn Historical Society	12	HORTON'S POINT LIGHTHOUSE The Brooklyn Historical Society v1972.1.191	18	STEAM-POWERED EXCAVATOR The Brooklyn Historical Society v1972.1.187
VI	STREET The Brooklyn Historical Society v1972.1.209	6	v1972.1.58 JAMES M. BAYLES RESIDENCE The Brooklyn Historical Society	13	TIDE MILL The Brooklyn Historical Society v1972.1.89	19	RIDGEWOOD WATER WORKS The Brooklyn Historical Society v1972.1.153
x	ROAD The Brooklyn Historical Society v1972.1.197	7	v1972.1.163 INEBRIATES HOME IN BAY RIDGE The Brooklyn Historical	14	GARDEN CITY HOTEL The Brooklyn Historical Society v1972.1.170 OLD DUTCH	20	KEEPER'S HOUSE The Brooklyn Historical Society v1972.1.149
2	F. P. SMITH GROCERY STORE Freeport Memorial Library 94.721.D/Volume 2	8	Society v1972.1.2 STONY BROOK The Brooklyn Historical Society		REFORMED CHURCH The Brooklyn Historical Society v1972.1.396	21	EPISCOPAL CHURCH The Brooklyn Historical Society v1972.1.120
3	SHINNECOCK INDIANS Library of Congress LC-USZ62-119203 COASTLINE NEAR	9	v1972.1.31 WINDMILL AT GOLDSMITH'S INLET The Brooklyn Historical	16	ROAD STATION The Brooklyn Historical Society v1972.1.201	22	LIRR STATION IN BRIDGEHAMPTON The Brooklyn Historical Society v1972.1.13
	Osborn's Neck The Brooklyn Historical Society v1972.1.54	10	Society v1972.1.41 ASYLUM IN YAPHANK The Brooklyn Historical Society	17	SADDLE ROCK GRIST MILL The Brooklyn Historical Society v1972.1.11	23	METHODIST CHURCH IN BRIDGEHAMPTON The Brooklyn Historical Society v1972.1.14

v1972.1.34

24	NORTHPORT HARBOR The Brooklyn Historical Society v1972.1.95	33	GROUND-BREAKING CEREMONY Freeport Memorial Library 974.721.D/Volume 1	44 45	QUENTIN ROOSEVELT Library of Congress LC-USZ62-61807	56	STEAMBOAT DOCK AT PORT JEFFERSON Library of Congress LC-USZ62-117341
25	PAPER MILL The Brooklyn Historical Society v1972.1.143	34	ROUGH RIDERS AT CAMP WICKOFF Library of Congress LC-USZ62-62101	46	FORT LAFAYETTE Library of Congress LC-USZ62-118283 ROCKAWAY Library of Congress	58	WALT WHITMAN HOUSE Library of Congress HABS NY,52-WEHI,1-2
26	WOODBURY RAILROAD STATION The Brooklyn Historical Society v1972.1.15	36	OLD FIELD POINT LIGHT Library of Congress LC-ppmsca-09071	48	LC-USZ62-97112 LONG ISLAND YACHT CLUB Library of Congress	59	EAST HAMPTON BEACH The Brooklyn Historical Society v1972.1.395
27	DELAPLAINE FAMILY HOUSE The Brooklyn Historical Society v1972.1.848	37	AMAGANSETT BEACH The Brooklyn Historical Society v1972.1.335 EXCELSIOR HOOK AND	49	LC-USZ62-48387 FLAGPOLE Library of Congress LC-USZ62-53890	60 61	Homes in Oceanside Library of Congress LC-ppmsca-12050 Garden of Frances
28	WOODEN BRIDGE ON VALLEY STREAM POND		LADDER Freeport Memorial Library 974.721.D/Volume 1	50	GROVE STREET TROLLEY Freeport Memorial Library 974.721.D/Volume 2		JOHNSTON PARIS Library of Congress LC-USZ62-94882
	The Brooklyn Historical Society v1972.1.23	39	BENSON HOUSE Freeport Memorial Library 974.721.D/Volume 2	51	OYSTER BAY Library of Congress LC-USZ62-97438	62	Laurelton Hall Library of Congress LC-USZ62-94964
29	EPISCOPAL CHURCH ON SHELTER ISLAND The Brooklyn Historical Society	40	SAGAMORE HILL Library of Congress LC-USZ62-93845	52	Motor Launch Library of Congress LC-USZ62-974338	63	FOREST PARK Library of Congress LC-USZ62-45754
30	v1972.1.76 House in Bay Ridge New York State Archives NYSA_A3045-78_D47_	41	TENT CITY AT ROCKAWAY Library of Congress LC-USZ62-77205	53	SHIP IN OYSTER BAY Library of Congress LC-USZ62-97445	64	THE WALLACE BUILDING Freeport Memorial Library 974.721.D/Volume 3
31	BrY2 WEED'S HARDWARE AND PHOTOGRAPHIC	42	BEACH AT ROCKAWAY Library of Congress LC-USZ62-100328	54	BELLE TERRE Library of Congress LC-USZ62-98348	65	THE SEA GULL Freeport Memorial Library 974.721.D/Volume 2
	SHOP Freeport Memorial Library 974.721.D/Volume 2	43	PRESIDENT THEODORE ROOSEVELT Library of Congress LC-USZ62-97317	55	GATHERING AT MONTAUK Library of Congress LC-USZ62-116378	66	MUSIC PARK Library of Congress LC-USZ62-103389
32	FREEPORT POST OFFICE Freeport Memorial Library 974.721.D/Volume 2				2222 1100/0	68	Laborers Library of Congress LC-USZ62-78008

69	PAUL PECK Library of Congress LC-DIG-hec-01378	80	NATIONAL RED CROSS PAGEANT REHEARSAL Library of Congress LC-USZ62-136037	91	American Chicle Library of Congress LC-USZ62-102969	101	OLYMPIA ICE CREAM PARLOR The Brooklyn Historical Society
70	HARMSWORTH CUP			92	CORNERSTONE OF		v1973.6.197
	Library of Congress	81	FRANCES STARR AND		FREEPORT HIGH		
	LC-DIG-ggbain-10788		BIJOU FERNANDEZ		SCHOOL	102	MEMBERS OF
			Library of Congress		Freeport Memorial Library		AMERICAN LEGION
71	Women's Golf		LC-USZ62-136039		974.721.D/Volume 1		Post 342
	CHAMPIONSHIP						Freeport Memorial Library
	PARTICIPANTS	82	CAMP UPTON	93	WELWYN ESTATE		974.721.D/Volume 3
	Library of Congress		Library of Congress		Library of Congress		
	LC-USZ62-121145-2		pan 6a33417		LC-USZ62-94874	103	
							Library of Congress
72	DUCK FARM	84	BOWNE HOMESTEAD	94	LIFE-SAVING STATION		LC-USZ62-85273
	New York State Archives		The Brooklyn Historical		Library of Congress		
	NYSA_A3045-78_Dn_LpY4		Society		LC-USZ62-113116	104	HOME OF WILLIAM
			v1974.6.30				ROBERTSON COE
73	Women's Political			95	GLEN COVE		Library of Congress
	UNION TENT	85	BRITISH DIRIGIBLE		EXPERIMENTAL SEA		LC-USZ62-88467
	Library of Congress		Library of Congress		FARM		
	LC-ppmsca-02921		LC-USZ62-48516		New York State Archives	105	
					NYSA_14297-87_4321		Library of Congress
74	SAVAGE'S HOTEL AND	86	MONTAUK				LC-USZ62-94965
	CASINO		LIGHTHOUSE	96	OYSTER DREDGER		••
	Library of Congress		New York State Archives		New York State Archives	106	HAYGROUND
	LC-USZ62-92258		NYSA_A3045-78_Dn_LpM		NYSA_14297-87_4264		WINDMILL
			O				Library of Congress
75	TRUCK FARM	87	QUAKER MEETING	97	CREWMEN UNLOADING		LC-G612-T-13680
	New York State Archives		House		OYSTERS	407	U Have
	NYSA_A3045-78_Dn_		The Brooklyn Historical		New York State Archives	107	HICKS HOME
	LpX7		Society v1974.6.32		NYSA_A3045-78_10374		The Brooklyn Historical Society
76	N		V19/4.U.32	98	WILLIAM STEVENS		v1972.1.368
76	Newton's Garage	88	WHITTIER INN	98	New York State Archives		V1)/2.1.300
	Library of Congress LC-USZ62-94999	88	The Brooklyn Historical		NYSA_14297-87_4257	108	CONSERVATION
	LC-03202-94999		Society		N 13A_142)/-8/_42)/	100	DEPARTMENT FOREST
77	LYNBROOK STATION		v1973.6.196	99	SCIENTIST AT		FIRE TRUCK
//	Library of Congress		V197 3.0.170	99	BAYVILLE BRIDGE		New York State Archives
	LC-USZ62-114406	89	ENRICO CARUSO		New York State Archives		NYSA_14297-87_4195
	EC-03202-114400	05	Library of Congress		NYSA_14297-87_4292		1 131 142 / / - 0 / _ 41 / /
78	Home GUARD UNIT		LC-USZ62-61529		IN 13A_1429/-0/_4292	100	MAN FILLING FIRE
76	Freeport Memorial Library			100	AWAITING BREMEN	109	EXTINGUISHER
	974.721.D/Volume 3	90	TRAIN YARD	100	FLYERS		New York State Archives
	7/1./21.D/ Volume J		New York State Archives		Library of Congress		NYSA_14297-87_4198
79	WILLIAM FAVERSHAM		NYSA_A3045-78_Dn_LqX		LC-USZ62-22707		111011_112//-0/_11/0
, ,			1		LO COLOL LL/O/		

AND FAMILY Library of Congress LC-USZ62-136034 110 Jones Beach Pool

Library of Congress LC-USZ62-100185

New York State Archives Library of Congress LC-USW33-000361-ZC CONCEPTION NYSA B1836-04 8203 HABS NY,30-HEMP,1-1 Library of Congress 134 TRAINING AT MITCHEL LC-G612-48752 112 COMMUTERS 122 THE PANTIGO MILL FIELD BOARDING TRAIN AT Library of Congress Library of Congress 145 STONY BROOK HABS NY,52-HAMTE,6-1 LC-USW33-022638-C WOODSIDE MUSEUM New York State Archives Library of Congress 124 F4F WILDCAT NYSA_A3045-78_Dn_LpY7 135 WOMEN TRAINMEN LC-G612-43659 Library of Congress FIGHTER 113 HIGHWAY SYSTEM Library of Congress LC-USW3-34172 146 WOODMERE ACADEMY LC-G612-38631 Library of Congress Library of Congress LC-USZ62-77072 136 CHECKING BULLETIN LC-G612-T-4401 125 GRUMMAN HANGAR BOARD 114 FORT NECK HOUSE Library of Congress Library of Congress 147 TEACHER AND LC-G612-38632 Library of Congress LC-USW3-34170 STUDENTS HABS NY,30-MASAP,1 Library of Congress 126 GRUMMAN HANGAR #2 137 WOMEN MANNING LC-G612-T-50077 115 CHRYSLER-PLYMOUTH Library of Congress PASSENGER COACH LC-G612-38633 DEALERSHIP Library of Congress 148 SURF CLUB AT LC-USW3-34168 Freeport Memorial Library ATLANTIC BEACH 974.721.D/Volume 3 127 FOREST HILLS Library of Congress APARTMENT COMPLEX 138 STONY BROOK POST LC-G612-51604 116 WILDWOOD STATE Library of Congress OFFICE LC-G12T-41289 PARK Library of Congress 149 SURF CLUB BEACH Library of Congress LC-G612-T-43646 Library of Congress LC-USZ62-93256 128 RUPP BROTHERS LC-G612-T-51494A SERVICE CENTER 139 SODA FOUNTAIN 117 THE CONKLIN FAMILY Library of Congress Library of Congress 150 BELMONT PARK LC-G612-T-40489 House LC-G612-T-43670 Library of Congress Library of Congress LC-G612-T53903 HABS NY,52-AMGA,1-1 129 RUPP BROTHERS 140 ATLANTIC MACARONI GARAGE INTERIOR Library of Congress 151 MEADOWBROOK 118 BETTER 'OLE TEA LC-USW3-14921 Library of Congress HOSPITAL LC-G612-40490 Porch Library of Congress Library of Congress 141 DRYING PASTA LC-G612-49689 LC-USZ62-127023 130 GARDINER HOME Library of Congress Library of Congress LC-USW3-14909 152 St. Luke's LC-G612-42580 119 FIRST EPISCOPAL CHURCH 142 STONY BROOK STREET CONGREGATIONAL IN FOREST HILLS 131 PALEY LIBRARY Library of Congress CHURCH Library of Congress Library of Congress LC-G612-43638 Library of Congress LC-G612-51620 LC-G612-42324 HABS NY,52-CEN,1-1

133 BAYONET TRAINING

143 PECK & PECK

CLOTHING STORE

Library of Congress

LC-G613-46634

Library of Congress

144 SEMINARY OF

153 INTERIOR OF ST.

Library of Congress

LC-G612-T-55215

LUKE'S

IMMACULATE

121 St. George's

132 TROOPS TRAINING AT

MITCHEL FIELD

Library of Congress

LC-USW33-000339-ZC

EPISCOPAL CHURCH

120 ELDRIDGE MILL AT

GREAT NECK

Library of Congress

HABS NY,30-GRE,1-2

111

JONES BEACH

BOARDWALK

154	SYOSSET GARDENS Library of Congress LC-G612-54623	165	MIKE TODD AT JONES BEACH Library of Congress LC-USZC4-4348	175	GARDEN CITY FIRE DEPARTMENT Library of Congress LC-G613-66238	186	LONG ISLAND LIGHTING COMPANY Library of Congress LC-G613-68316
155	E. R. SQUIBB & SON Library of Congress LC-G612-52819	166	BETHPAGE HIGH SCHOOL GYMNASIUM Library of Congress	176	GARDEN CITY POLICE DEPARTMENT Library of Congress	187	LONG ISLAND LIGHTING COMPANY PLANT
156	FRANKLIN SIMON STORE		LC-G613-T-61708		LC-G613-66247		Library of Congress LC-G613-70175
	Library of Congress LC-G612-51025	167	PATRICIA MURPHY'S RESTAURANT Library of Congress	177	FAIRCHILD CAMERA AND INSTRUMENT CORPORATION	188	Southside Hospital IN Bay Shore
157	Manhasset Bootery Library of Congress		LC-G613-T-61746		Library of Congress LC-G613-64661		Library of Congress LC-G613-69433
	LC-G612-53722	168	DINING ROOM AT				
158	WALK RADIO STATION		Patricia Murphy's Library of Congress LC-G6113-58560	178	B&H AIRCRAFT Library of Congress LC-G613-66066	189	HEWLETT-EAST ROCKAWAY JEWISH CENTRE
	Library of Congress LC-G612-61656	169	BEA'S TEA ROOM Library of Congress	179	FALLOUT SHELTER Library of Congress		Library of Congress LC-G613-71756
159	STEVENS RADIO Library of Congress LC-G613-58088	470	LC-G613-61549	180	LC-USZ62-83211 CHERRY LANE	190	ROOSEVELT RACEWAY Library of Congress LC-G613-72700A
	LC-G013-70000	170	TENNIS APARTMENTS	100			EC-G013-7270011
160	Macy's DEPARTMENT		Library of Congress LC-G613-62686		SCHOOL Library of Congress	191	Workers IN A
	STORE				LC-G613-68809		KITCHEN
	Library of Congress LC-G612-51649	171	Blue Spruce Inn Library of Congress LC-G613-63596	181	ADELPHI COLLEGE Library of Congress		Library of Congress LC-G613-T-75507
161	WANAMAKER				LC-G613-T-71416	192	FRANKLIN NATIONAL
	DEPARTMENT STORE	172	STEINER PLASTICS				BANK
	Library of Congress LC-G612-60424		COMPANY Library of Congress LC-G613-63301	182	LEVITTOWN CENTER Library of Congress LC-USZ62-121069		Library of Congress LC-G613-76711
162	THE EPISCOPAL					193	SINGER SEWING
	CHURCH OF THE	173	CORYDON M.	184	Nuns CLAMMING		MACHINE COMPANY
	ADVENT Library of Congress LC-G612-54384		Johnson Company Library of Congress LC-G613-T-65172		Library of Congress LC-DIG-ppmsca-01948		Library of Congress LC-G6113-77138A
				185	GERTZ DEPARTMENT	194	HARRY THOMPSON
163	THE CONGREGATION SONS OF ISRAEL Library of Congress LC-G613-60326	174	CORYDON M. JOHNSON COMPANY #2 Library of Congress LC-G613-65185		STORE Library of Congress LC-G613-T-71041		JUNIOR HIGH SCHOOL Library of Congress LC-G613-78822
164	FIRE ISLAND LIGHT HOUSE Library of Congress					195	STERLING NATIONAL BANK Library of Congress LC-G613-T-79427

Library of Congress LC-DIG-ppmsca-09037

196 LIBERTY MUTUAL INSURANCE COMPANY Library of Congress LC-G613-79199

RANGE Library of Congress LC-G613-T-80635

198 DOUGLASTON GOLF

199 E. F. HUTTON'S
ESTATE
Library of Congress
LC-G613-81347

200 PELL HALL ON C. W.
POST CAMPUS
Library of Congress
LC-G613-T-80369

197 SEPHARDIC TEMPLE Library of Congress LC-G613-79859

HISTORIC PHOTOS OF LONG ISLAND

The largest island in the continental United States, Long Island comprises Brooklyn, Queens, Nassau, and Suffolk counties. With a rich history that has included American Indian tribes such as the Massapequa, Shinnecock, and Quogue, among others; colonists from England and the Netherlands; and immigrants who arrived by way of Ellis Island; Long Island thrives today on its wealth of industry, agriculture, natural beauty, and the contributions of its nearly eight million residents. Those very attributes are showcased in this volume, *Historic Photos of Long Island*.

From the lighthouse at Montauk, to the growth of the Long Island Rail Road, to the factories of Long Island City, the breadth, contrasts, and vitality of the Island through a century of its life shine forth in the black-and-white images collected here. Windmills and tide mills, potatoes and oysters, aviators and fishermen—all are a part of the Island's history, and all are represented vividly among the nearly 200 images seen in *Historic Photos of Long Island*.

Joe Czachowski grew up in Newark, New Jersey, and attended Kean University, leaving after one year. He worked in Belleville, New Jersey, for 20 years in quality control before the company relocated. Awarded a grant to continue his education, he graduated in 2000 with a BA in history. Following his wife's passing, he returned to school and graduated in 2003 with a master of arts in liberal studies. He worked as a graduate assistant on an oral history project dealing with Vietnam veterans and used his interviews to make a documentary film as his thesis, titled *Vietnam: Much Confusion, the Search for Relief.* He now teaches at Kean University and at Ocean County College. He resides in New Jersey with his son Kevin.

He has written *Historic Photos of Jersey Shore* and *Historic Photos of Hoboken*, both available from Turner Publishing.